BREAKING
THROUGH

BREAKING

THROUGH

My Life
in Science

KATALIN
KARIKÓ

CROWN
NEW YORK

Published in the United States by Crown, a division of
Penguin Random House LLC, New York.

CROWN and the Crown colophon are registered
trademarks of Penguin Random House LLC.

All photos are courtesy of the author.

Hardback ISBN 978-0-593-44316-3
Ebook ISBN 978-0-593-44317-0

Printed in Canada on acid-free paper

crownpublishing.com

2 4 6 8 9 7 5 3 1

FIRST EDITION

Book design by Barbara M. Bachman

CONTENTS

———

ON HER FINAL DAY OF SECOND GRADE, MY DAUGHTER, SUSAN, came home from her public school in suburban Philadelphia, sat down at the table, opened her backpack, and pulled out a pencil and piece of paper. She began to write, her brow furrowed in effort and concentration, an expression I would see again and again as she grew.

I asked Susan what she was writing. Without looking up, she answered, "I'm saying thank you to Mrs. Wilson for teaching me so much this year."

I stared at her. Susan kept her eyes on the page, forming her letters carefully. Her hand moved steadily across one line, then she started a new one.

I didn't do that, I thought.

I never did that. Never once did I write to any of my teachers to thank them.

It is my hope, then, that this book can serve as a long-belated thank-you. Let this be one way to tell those who took the time to educate me—all my teachers and mentors from my earliest days in Hungary right through to the world-renowned experts in cardiology, neurosurgery, and immunology who allowed me to work by their side—that everything they did mattered.

From teachers, I learned the basics, my foundation.

From teachers, I learned how to take the next step: to question, to wonder, to explore, to think for myself.

From teachers, I learned how to go beyond even that: to use what I knew to make my own contribution.

It was the work of teachers that allowed this child of two laborers in postwar communist Hungary to understand the world . . . and then, in her own way, to help change it.

One doesn't grow up in an agricultural community—or, for that matter, become a biologist—without developing a healthy appreciation for seeds. Seeds are potential. They are promise. They are sustenance. Seeds are the difference between a bleak future and a bountiful one. Planting a seed is, in every case, an act of conviction, and of hope.

So thank you to my own teachers. Thank you to educators everywhere. You are planting seeds.

BREAKING
THROUGH

PROLOGUE

A WOMAN SITS DOWN AT A LAB BENCH. FROM THE OUTSIDE, the scene may not look like much. The stool she sits on—inexpensive, a little creaky—rolls along the hard floor. The counters are made from something hard and durable—steel, maybe, or epoxy—and are covered in paper to absorb spills. There's some equipment near her—a bench-top centrifuge, a stack of square plastic assay trays, a vortex mixer, a hot plate, an incubator. To the untrained eye, these things may resemble the ordinary appliances sitting on counters in most American kitchens. *Something for heating, something for cooling, something for freezing, for mixing, for cleaning.*

Perhaps a nearby window lets in a bit of natural light; maybe not. Above the woman's head, fluorescent lights are humming. The scene contains nothing glamorous.

Maybe the woman is the first to arrive. It's still early, and the sun is just appearing on the horizon. She reaches for a pipette, a reagent bottle. She begins.

She'll sit for hours without getting up. She may just sit for forty years.

If you were watching the scene from the outside, you'd grow bored, and quickly. And who could blame you? *She's*

just sitting there. From the inside, though, it's a different story.

The woman's body may be still, but her mind is whirling, filled to overflowing with big ideas. She glimpses a line from the work she's doing to breakthroughs that may someday change lives. She does not know if she herself will make these breakthroughs or if someone else will. She does not know if she will live to see them. These questions don't matter.

The work, the *doing,* is all that matters.

The woman makes progress one step at a time. She measures, she pipettes, she pours, she starts up the centrifuge. She focuses, trying to notice everything. The work is tedious, but this is not tedium. The truth is, she feels like a detective, like Columbo—her eye about to land on that one tiny detail that's going to crack the case wide open.

Forget how the scene might look to an observer. The woman knows that *this*—this nondescript lab with its metal rolling seat and humming lights on an ordinary day—is filled with possibility.

THE CELL, TOO, IS different from how we often imagine it.

If you've made it through a basic biology class, you know about the cell: the fundamental unit of life, the building block of everything alive. Chances are, you also know the cell's rough architecture. For eukaryotes, which is to say nearly every living thing you've ever laid eyes on—and plenty more you'd need a microscope to see—that architecture goes something like this: A plasma membrane surrounds a gelatinous liquid called cytoplasm, in which various organelles float. At

the center of the cell is a nucleus stuffed full of DNA. Going by the way some textbooks present the cell, one can almost imagine that it's a bit like a backyard pool, with inflatable toys bobbing around, just waiting for something to happen.

This couldn't be further from the truth.

Every cell is like a sci-fi city that never sleeps. It thrums with activity. Nearly all of your cells contain staggeringly sophisticated factories that manufacture thousands of products via round-the-clock assembly lines. Labyrinthine transportation systems make even the most complex human highways look hopelessly obsolete. Packaging and shipping centers run more efficiently than DHL, power plants generate vast amounts of energy, and waste-treatment centers ensure nothing unnecessary hangs around and nothing goes to waste.

Inside your cells, complex codes are encrypted, sealed, shuttled, decrypted, and then broken down. Only with the touch of that one special key do locked gates open and close. Surveillance networks watch for invaders . . . and pounce when they find one. It's an incomprehensible amount of biological activity, and it's going on all the time, in every one of your trillions of cells.

Since you've begun reading this book, your cells have pumped, hauled, stacked, transported, transcribed, decoded, constructed, destroyed, folded, blocked, received, and expelled. Through these actions, you've breathed, digested, and sent oxygen and nutrients to every remote corner of your body. You've made electricity, interpreted vibrations in the air. You've thought, perceived, contracted muscles, and detected and fought off legions of pathogens you'll never see.

You have, in other words, been alive.

I tell you all this because understanding my story, understanding *me*, requires that you first understand something else: that what may, to some, look like stillness—that quiet woman at her bench, those floating pool toys—is sometimes the opposite.

Sometimes a complex and satisfying life—or the complexity of life itself—can look, to others, like nothing at all.

PART

ONE

—

A Butcher's

Daughter

THERE IS A STORY MY FAMILY LIKES TO TELL: A MOMENT I cannot remember. I am a toddler, still chubby-cheeked, with a blunt blond bob. I am standing in the yard of my childhood home. In front of me, my father has begun butchering the family pig. This is his work, his vocation. He is a butcher. It's how he earns his livelihood, and it's how he keeps us alive. He's been doing this work professionally since he was twelve years old.

The dead animal lies on its back atop a platform of bricks, which keep it from getting muddy. My father singes the fur with a handheld wood burner, similar to a blowtorch. He slices open the long belly of the animal, reaches into the cavity. He scoops out innards, working carefully so as not to puncture the organs. Lumpy intestines glisten. Then he lifts a hatchet and hacks the animal into two equal halves at the spine. Now what lies in front of me seems less like an animal, a being, and more like a product. At last, he begins dividing the carcass into bright red cuts of muscle.

This scene is too much for my sister, Zsuzsanna, three years older than me. Zsóka, as I call her, is not squeamish. This is postwar Hungary, after all. Squeamishness is a luxury afforded to no one—let alone a hand-to-mouth laboring fam-

ily like ours. But whatever it is that has captivated *me* in this moment does not seem to have the same effect on my sister.

Still, I *am* captivated.

My parents used to chuckle, remembering the way I looked then: my wide eyes taking everything in—the whole complex topography of an animal's interior. All those disparate parts that for so long worked together to keep this one creature alive. All the mystery and wonder they seemed to hold, visible at last.

This, for me, is how it begins.

WHILE I CANNOT REMEMBER those early moments seeing my father work, I recall, precisely, the world that surrounded them, the landscape of my childhood.

Kisújszállás: central Hungary, the northern great plain region. Clay soils. Sweeping grasslands. A medium-size agricultural town of roughly ten thousand people. We aren't as isolated as some towns; we're a stop on the railroad, for one thing. Also, Route 4, a primary route to Budapest, goes through town. There are a few paved streets, though my family's road is made from packed dirt.

Our home is simple, small. It is constructed, literally, from the earth that surrounds it: clay and straw, pressed into adobe walls, whitewashed, then covered with a thick roof of reeds. The reeds, as I remember, have faded in the sun. They look like a shaggy gray wig.

We live in a single room. The house is larger than this one room, but for most of the year, the other rooms are too cold for anything but storage. We live where the heat is.

In a corner of the room is the source of that warmth: a saw-dust stove, the cheapest possible way to generate heat. It's constructed from sheet metal, about a half meter across, like an ordinary metal barrel with a central cylinder that is packed with sawdust. We collect that sawdust from a nearby wooden toy factory, carrying it home from the factory with the help of horses. Once home, we store the sawdust in the barn, in a pile taller than my father. In the summer we check the pile regu-larly to make sure it hasn't started generating its own heat; sawdust is known to spontaneously combust.

The sawdust stove grows hot enough that my mother sometimes uses it as an extra cooktop. When it really gets going, the exterior metal glows red. Zsóka and I long ago learned to keep our distance, lest we burn our skin. It's our job, though, to fill the insert container with sawdust every morning. This is hard work, and it must be done carefully. Like many of the things we do, it isn't a chore—at least not in the sense that people use the word now. It's not something that our parents *ask* us to do, not a favor we're doing for the family. It's simply what *must* be done. If we don't do it, our family will freeze.

At the center of the room is a large table. Here we prepare and eat meals, sometimes gathering extended family for bois-terous celebrations. At this table, my sister and I do homework and read, help our mother roll out fresh pasta from flour and eggs.

Each night, my father stands at the head of the table, doling out dinner servings to each of us. He served in the army dur-ing World War II and cooked for hundreds of soldiers on the front line, rationing foods with precision. I can still see him

today: He ladles pasta into his own soup bowl. "Soldiers during the war on the front lines!" he hollers. Then he reaches for my mother's bowl. "Soldiers during the war in the back country!" Then he reaches for my bowl, then my sister's, giving us kids the smallest servings. "Soldiers during peacetime," he says quietly.

Then he laughs and serves us all a little more. Times might be hard now, but he's known worse. Every adult has.

Nearby are the beds where we sleep: mine and Zsóka's, our mother and father's. The beds are so close, we can reach out to touch one another during the night.

Outside is not only my father's smokehouse (where sausages hang, dripping thick globs of fat, stained orange from the paprika, onto the floors) but also the barn, where, already, a new pig is growing. Next year's meat. In the yard, chickens peck the earth, and we have several gardens. In the main garden, we grow food for our family: carrots, beans, potatoes, and peas. Dinner is made from whatever happens to be ready for harvest (flavored, like the sausages, with paprika—always lots of paprika). Zsóka and I have a garden of our own, too. Every spring, we place seeds in the ground. Our fingers are still clumsy, but we are gentle as we work. Gently we cover these seeds with soil, then—weeks later—watch shoots push their way into open air and stretch toward the sun. We also grow fruit. We have apple, quince, and cherry trees, plus a grape arbor and pergolas.

And there are flowers, too: blue hyacinths, white daffodils and violets, and great bursts of roses, which together make this humble homestead feel a bit like Eden.

Someday, decades in the future and an ocean away from

here, in a land I haven't yet heard of called Philadelphia, I'll settle down in a home on a wide suburban street. There I'll go in search of flowers to plant, and it is only when I struggle to find white daffodils that I will understand what I'm doing: searching not just for any blooms, but for *these,* the flowers I knew as a little girl, the ones I can remember my mother planting and tending.

Outside of town lie fields of corn. We plant this corn ourselves, using hoes to soften the soil and cut the weeds. We thin the plants, pull weeds from the soil, fertilize the ground with cow manure, and then harvest the crops. We give the kernels to the animals, then use the cobs to fuel the kitchen stove.

Everything is like that: Nothing goes to waste. We shake walnuts from trees, eat the nuts, and burn the leftover shells as fuel.

It will be years before plastic becomes a part of my life, years before I understand the concept of garbage, the idea that some things are so useless they can simply be thrown away.

WE DON'T HAVE A cow, but our neighbor does. Every morning, my sister or I run over to the neighbor's home with an empty jug. We fill the jug with milk still warm from the udder and serve it for breakfast. Leftovers become kefir. When we rinse the last milk from glasses, we pour the cloudy water into a pot for the pig, who devours everything greedily.

As we scurry around, getting ready for the day (the indoor air so cold our breath is sometimes visible), we listen to a small radio. Each morning, an announcer tells us whose "name day" it is. Every day of the year, a different name, a different person

in our lives to celebrate: February 19, *Zsuzsanna;* November 19, *Erzsébet. Good morning,* the voice on the radio might say. *It's October 2, which means it's the name day for Petra. The name comes from a Greek word that means stone, or rock.* . . . Then, when we arrive at school, we know whose name day it is, and we wish them a happy one. It's a good system. How many of us really know the birthdays of the people in our lives? But if you know someone's name, then you know their name day, and can wish them well.

FOR THE FIRST DECADE of my life, we use an outhouse. At night—especially in winter—we pee in a chamber pot. Nearly everyone I know, at least in these early years, does the same.

There's no running water of any kind in our house. In the yard, we—like all the families on our street—have a well. Sometimes, I lean over the edge, staring down into the darkness, feeling the cool, wet air on my skin. In the summer, this well becomes our refrigerator. We lower our food to the water's edge to keep it from spoiling. In the winter months, the whole house becomes our refrigerator (in the coldest months, we store eggs beneath our beds to keep them from freezing).

We use our well water for animals or for watering plants. This water is too hard for bathing and washing, and it isn't potable, so each day my father walks to a nearby street pump, carefully balancing two thick buckets on a wooden rod. Zsóka and I follow him, carrying water home in smaller containers. Once a week, we heat this water, pour it into a shallow tub, then bathe in it.

At the community pump, neighbors exchange gossip, dis-

cuss the day's news, share everyday joys and frustrations. This pump is, for me, the original watercooler, the first chat room.

Occasionally, a man rides up our street on a large horse. He bangs a drum loudly, calling us all outside to hear whatever announcement he's brought from the authorities. This is another, more official news source—what some communities call a griot or a town crier.

"Next Tuesday," the man might bellow, "there will be a preventive vaccine campaign for chickens! Keep your chickens indoors on that day so that they each might receive their vaccine!"

We make note of the information, then carry this news to the water pump when we go. Everyone repeats the announcement, in case anyone missed the man's visit: *Did you hear the news? Chicken vaccines. Yes, next Tuesday. Keep your chickens indoors.*

And, sure enough, when Tuesday comes, students from the veterinary school enter our yard. Zsóka and I catch our chickens in the hatch and hand them over, one at a time, to the man who will inoculate them—my first-ever vaccination campaign, I suppose.

SCIENCE LESSONS ARE EVERYWHERE, all around me.

I climb trees and peer at birds' nests. I watch hard eggs become naked hatchlings, mouths wide and begging. The hatchlings grow feathers and muscles, leave their nest, begin pecking the ground. I see storks and swallows take flight, then disappear when the weather grows cold. In the spring, they return and start the cycle all over again.

In the smokehouse, my sister and I collect fat drippings with a spoon. We drop the fat into a pot; when summer comes, my mother calls a woman to the house. She's ancient, this woman, carrying knowledge passed down through generations. Under this woman's direction, we melt the fat, then mix it with sodium carbonate, using a precise ratio she alone seems to understand. Then we pour the mixture into wooden boxes padded with a dishcloth and wait for it to harden into soap, which we slice with a wire. We use soap bars for bathing and shave some into flakes for laundry.

Looking back, I understand now that this local "soap cooker lady" was the first biochemist I ever met.

Another lesson: One summer, our potatoes are infested with a pest, *Leptinotarsa decemlineata*, known in the United States as the Colorado potato beetle. The insects lay eggs, and larvae explode across the garden, eat away at stems, and turn entire leaves to lace. They'll destroy the whole crop if we do nothing. My parents put me on potato beetle duty. I scour the plants, plucking insects one at a time, dropping each into a pot. Each bug is about half an inch long with a spotted head and dramatic black and white stripes on its backside. The bugs themselves don't especially bother me, but when I miss one, it lays clusters of eggs, from which erupt disgusting pink larvae, wriggling and sticky. I pluck those, too.

The work is tedious and sometimes gross. But it provides me with an early education not only in entomology but also in ecosystems. For here, too, nothing goes to waste: I feed these pests to the chickens, who are delighted with the bounty. Potato beetles feed the chickens, who in turn feed us: a lesson in the food chain that becomes, quite literally, a part of me.

—

THERE'S NO END TO the work to be done. My sister and I carry water to chickens and gather their eggs. On the rare occasions when our family chooses to cook one of our precious chickens, we chase that bird down with a broom and scoop it up. We wash dishes and clothes by hand. Twice a week, my grandmother, who lives a half-hour walk from our house, cuts bunches of flowers from her garden—*labdarózsa* (snowball bush), *török szegfű* (sweet Williams), *rózsa* (roses), *dália* (dahlias), *szalmavirág* (strawflowers), *tulipán* (tulips), *kardvirág* (gladiolus), and *bazsarózsa* (peonies)—then hauls them to sell at the market. We help her cut and prepare these flowers for sale.

Even if my grandmother hadn't told me the names of these flowers, I would have learned them by heart. In fifth grade, I receive a book about the flora of Hungary; the book features gorgeous watercolor illustrations by Vera Csapody, a Hungarian woman botanist and artist. I am obsessed with this book; hour after hour, I turn the pages, memorizing the bright bursts of colorful petals, the spindly root threads emerging from rotund bulbs, and the precise variegations and striations of leaves.

IN OUR ONE ROOM, we have a bit of electricity; this affords us a couple of electric lights, as well as a record player and radio. My parents love music, and my mom often puts on a record while preparing dinner or baking. She can bake anything, and her cakes are exquisite: moist, delicious, and immaculately

decorated. One of my favorites is lúdláb, goosefoot cake, a sponge cake layered with cream filling and raisins and covered with chocolate glaze.

Zsóka is better in the kitchen than me. By the time she's ten years old, she can bake entire cakes by herself. I'm clumsier in the kitchen, and less interested. Early on, we fall into our respective roles: I start the fire, she does the cooking, then I do the dishes.

Father also loves music. He's fond of Imre Bojtor, an operatic tenor, and Magyar nóta, a form of traditional Hungarian song. My father has a terrific voice and a gift for melody; he can sing beautifully and play the violin and the zither. He's always belting out some tune or another.

He's tried, on many occasions, to give my sister and me his gift for music, but neither of us has the ear; we can't carry a tune, and our fingers are clumsy on the violin strings. We enjoy listening to music, though. Like everyone we know, we love a band called Metro, led by the singer Zorán Sztevanovity, who is a bit like a Hungarian Roy Orbison. But making music? We just can't seem to do it. At some point, our father gave up and continued making music without us.

My father has other gifts, too. He can multiply two-digit numbers in his head, giving you an accurate answer immediately. My sister and I test him throughout our childhoods, and he almost never makes a mistake. This, too, is a lesson for me, one that goes well beyond mathematics: Intelligence and education are not the same thing. A person may lack prestige or a diploma but nevertheless have a swift mind.

For much of my life, I assume that everyone knows this,

that this fact is so obvious it isn't something that needs to be learned. Only later, when I begin to work in academia, will I come to understand this isn't the case—not at all.

WHEN I AM NINE years old, my parents buy a crumbling, hundred-year-old mud-brick house. It is too decrepit to live in but can be taken apart, board by board, so that its parts may be saved for a new home.

Over the course of one summer, my sister, father, and I do exactly that. We collect all the nails that affix the slate to the roof. These ancient nails are made from bronze and are far sturdier than any of the cheap aluminum nails we can get in the store. My sister and I hammer each one straight so that they can be reused. We also take slate tiles from the roof, clean them, and place them in neat piles for later. We sand old boards, then lay them down again. In a big pit, we mix clay with straw and water; this becomes the mud that my father will use to cover and smooth the walls. Because I am the smallest, I climb onto the roof and wedge myself into the hardest-to-reach places. I nail down ceiling boards, smoothing mud over them, just as my father showed me.

By the time we finally move into this house, when I am ten, there isn't an inch of it that I don't know by heart.

But is all of this really work? Or is this just life?

Certainly, we children have hours of play—on our packed-dirt street, there are many kids our own age. In the summer, we play shop. Since I am the little one, I play the customer, while my sister and the other girls her age are the merchants.

Or we play school—they are the teachers, I the pupil. I work on the assignments they give me with painstaking care, as if it were a real school.

We play in snow in the winter, and when big rains fall in the summer, we splash through the water-filled ditches in our street.

But I, and likely every child I know, couldn't tell you the exact place where work ends and play begins, where responsibility and pleasure cleave. The boundaries between these things are hazy, indistinct. We toil and we enjoy. We contribute and we receive.

And of all my early lessons that prepared me to be a scientist, that one, I think, is the most important of all: that work and play can bleed into each other, become one and the same, until the very idea of their distinction feels meaningless.

IMAGINE A STOREFRONT, a small butcher shop in a quaint Eastern European downtown. A winter morning. Children are gathered outside, their faces pressed to the glass of the display window. What are they looking at?

Move toward them, your feet stepping over cobblestones, and see for yourself. Inside the shop, someone has created a snowscape: a winter scene, not unlike a gingerbread house. But rather than being made from baked goods and confection, this display is constructed entirely from meat. There's a snow-covered roof, made from white lard. A fence made of sausage links. Icicles formed from the slow drip of beef fat.

My father, the butcher, has created this scene, along with the shop owner.

I never saw this window myself, though as a child I loved to imagine it. My father described it for me, explaining how children came from all over Kisújszállás to gaze at it. I could picture the whole scene, almost as if my own nose were pressed to the window, my own breath forming translucent circles on the glass.

By the time I came along, the shop no longer made such displays.

My father began apprenticing as a butcher at age twelve. He had attended school for a while, but by 1932 had finished his compulsory sixth-grade education. That's when he started learning to butcher from a local master. Later, he would leave home, for Budapest, to learn more about this trade. *If you know how to provide people with meat,* his mother had told him, *you will never starve.*

This reasoning was neither hyperbole nor paranoia. This was the aftermath of World War I, when famine swept across the entire European continent. Hungary, on the losing side of the war, had been devastated in every way a country can be. Throughout my father's childhood, starvation nipped at his heels, just as it nipped at everyone's.

My father: János Karikó. That's the name by which I always knew him, anyway, although he'd been born with a different name entirely. Karikó had been his mother's maiden name. She'd married a fellow named László Balogh, who, like so many Hungarians, fought in World War I. He left Kisújszállás in 1917, never to return. Soon after he left, my grandmother went to work for a wealthy family. This family had young adults, including a son who happened to be approximately her age.

Then, in 1920, my father was born.

I'll reiterate: Her husband left for the war in 1917, and her baby was born in 1920. You can do the math.

My grandmother's legal in-laws, the Balogh family, wanted no part of this scandalous child, born out of wedlock. Neither mother nor child, they believed, deserved the Balogh name. Similarly, my father's *biological* family—my grandmother's employer—wanted nothing to do with them, either. So, ten years after my father was born, my grandmother changed my father's name to Karikó.

Never mind that he was already enrolled in school, that his friends and teachers knew him as Balogh, or that this is the name by which he knew himself. Karikó it would be.

It was a lesson my father picked up early: Things can shift suddenly. It's important to stay nimble.

IN BUDAPEST, AS A teenager, my father learned his trade well. He returned home happily at age eighteen, settling into his job at what seemed like an ideal butcher shop, right in the center of Kisújszállás.

My father loved that shop. The shop owner wanted only the best for his customers—not only in meat cuts but in everything. Before the man had opened the business, he had traveled to Italy, seeking the most beautiful hand-painted tiles, with which he decorated the shop walls. The man knew quality when he saw it, and my father did quality work.

Together, they ran a strong business. They selected only the finest meats and sliced and wrapped and tied their products with care. They treated customers well and earned loyalty in

return. That's how things were back then, my father insisted: People took pride in their work. I could *hear* that pride as my father told me these stories. But I also heard wistfulness.

That's because by the time my father described any of this to me, the world was very different.

IN 1940, SHORTLY BEFORE World War II broke out, my father had to enlist in the Royal Hungarian Army. By the time he returned to Kisújszállás, nothing was the same.

In the years immediately following World War II, Hungary saw some brief experiments with democracy. But by 1947, the Communist Party had openly assumed power. The Party nationalized manufacturing, education, banking, and transportation systems. It collectivized land. It seized homes that were deemed too grand, forcibly removing homeowners and moving in multiple families. Private businesses became public property. The butcher shop where my father worked, the store that he loved, was seized.

All that work. All that care. It vanished practically overnight.

For most of the eleven-year period after the war, Hungary's leader was Mátyás Rákosi, a fervent Stalinist and totalitarian (he would proudly declare himself "Stalin's best pupil"). These were dark times. Rákosi filled communities with secret police. He encouraged people to spy on their neighbors, to report them for crimes against the Party. He presided over mass arrests, sham trials, and the executions of political "enemies." An estimated hundred thousand citizens were imprisoned; still more were sent to forced labor camps.

Oh, and one other change from this time: The Party seized what farm animals remained after the war, strictly prohibiting the domestic slaughter of pigs or cattle. To raise meat privately or to butcher it became a crime that carried severe prison sentences.

Meat—my father's vocation—was now a state monopoly.

My father—whom the community had taken to calling, affectionately, "Uncle János"—began to work in the butcher shop of our local agricultural collective. There were many such collectives across the country. Each collective pooled its land and labor, growing and harvesting crops (such as corn, wheat, or rice), or raising and butchering animals as a common entity. Some portion of the collective's harvest would be rationed among members; other portions were bartered for crops (apples or sugar beets) grown by other collectives.

Officially, my father now did his work for the collective only. But the truth was, the collective didn't meet families' food needs. There were often shortages. Whatever the rules, people needed to eat.

In homes everywhere—not only in Kisújszállás, but throughout the country—people continued to keep farm animals, but they did so out of sight. My father went underground. He continued butchering animals privately, but for a few years after the war, he did it in secret, working only for families he trusted, usually under the cover of night. This was dangerous; one had to be careful. You never knew who might be watching.

To minimize risk, children watched the street while the processing took place. If anyone approached, the kids ran to warn the adults so that they could hide the evidence.

Often, my father worked through the night. He'd begin his work in the darkest hours so that by dawn's first light, everything would appear as normal. Then, with the illegal part of his day over, my father would head in to the collective, where he would start his *official* duties.

Here, at the collective, he met my mother.

My mother was a practical woman, unsentimental and for good reason.

One of the earliest stories I know about my mother's side of the family happened in 1934: Her great-grandparents were murdered. I cannot tell you much more than this. I can't tell you who committed the act or why. All I know is that the lives of Károly Szász and his wife ended abruptly and violently, and that we all learned to live with not-knowing.

Skip a generation. My mother's grandfather Ferenc Oros (the son-in-law of the murdered couple) fought in World War I. In 1916, soon after he left for the front, his wife, my great-grandmother Zsuzsánna Szász, received notification that he'd been killed. Devastated by the news of her husband's death far away, she killed herself with a gun, leaving behind five children, who ranged in age from eight to fifteen. One of them was my mother's mother, then eleven years old.

You can imagine everyone's shock when, after the war ended, Ferenc Oros walked through the door, as alive as a person could possibly be. The notification of his death, it turns out, had been sent in error.

Move down yet another generation. My maternal grandmother, Zsuzsánna—I called her Nagymama—married my grandfather and settled down on a small farm outside Kisújszállás. They planted crops and raised geese, and they

had three daughters: my aunt Erzsébet, born in 1926; my mother, Zsuzsánna (yes, this is my mother's name, and my grandmother's, and my sister's, and my cousin's, too), born in 1929; and the baby, my aunt Ilona, in 1938.

But what my grandfather *really* wanted, apparently, was *sons*. He wanted sons so badly that when Ilona, the third daughter, was born, he packed up and left. My grandmother, now a single mom with three daughters and a whole lot of geese, eked out a living on the farm as well as she could. She sent her daughters to school in town, an hour's walk, brutally cold in the wintertime and often dangerous. Still, my mother attended school until eighth grade—a strong education for a girl in her circumstances. Then in 1943, when she was fourteen years old, my mom got a job in town, at the Zöldy pharmacy. By now, though, just a generation after the First World War, yet another world war had begun.

In the autumn of 1943, my grandmother sold her geese and moved the family to town, imagining that there might be safety in numbers during wartime. Soon after, the Germans invaded Hungary. Then Russian troops arrived to fight the Germans. Because Kisújszállás lay on the route between Russia and Budapest, it saw relentless fighting.

During the worst of it, my mother (who continued working at the pharmacy through all of this) hid out in a bunker, along with her sisters and my Nagymama, in a neighbor's cellar. When they emerged, cautiously, they saw their new home burning.

By the time the fire was out, all that remained was a small, detached outbuilding. It had been intended for animals, and it was filthy. But that's where they moved, fixing it into a home

as best they could. This is where my grandmother would re-
main for the rest of her days.

Well . . . mostly. Not long after her house burned down, the
Russian soldiers told my grandmother they needed a cook.
They now occupied a large home in town and asked her to
move there so she could cook for the high-ranking officers. I
say they "asked," which may be factually correct, but it's not
as if she had a choice. One didn't say no to the Red Army in
those days.

As it turned out, the Russian officers treated her well. They
were very, very kind to her, she always said, very respectful. A
relief. History, of course, is filled with similar stories that went
a different way entirely.

Years later, my mother would describe to me a memory
from that time. She was fifteen years old, heading to work at
the pharmacy, as she did every day. She passed a broken Rus-
sian tank that had been abandoned on the street. Lying next to
it was a dead soldier. My mother looked at him. She saw he
was her age, maybe even younger.

A boy, she would say of this dead soldier of war, represent-
ing an army that had caused so much devastation. *He was just
a boy.*

History, of course, happens to children, too.

All of this had already unfolded by the time my mother ar-
rived at the agricultural collective where she and my father
met. There she worked in the office, keeping books, tracking
inventory, and calculating surpluses, debts, and exchanges.

My mother may have stopped attending school after eighth
grade, but she was sharp, with a quick sense of humor. She
was great with details, ambitious, and hardworking. She read

often, all kinds of books. Throughout her life she especially loved biographies and nonfiction, and she had a deep curiosity that would allow her to adapt to sweeping changes well into the twenty-first century. (By eighty, she'd be something of a tech whiz. She could program her TV to record her favorite channel even as she watched another show. There was nothing she couldn't find on the internet, and she'd call me daily to inform me of all the news that had unfolded that day while I worked away in my lab.)

My father noticed how smart she was, and how beautiful. He fell for her hard and quick. In a romantic gesture that was typical for his larger-than-life energy, he cut out an enormous lilac bush at the back of his family's home, then carried it over to my mother's. He left the plant at the gate, blocking the exit so that my grandmother, my mother, and her siblings couldn't come out, something my parents would laugh about again and again.

My parents married just months after they met; courtships were shorter in those days. I can remember my father joking that on their wedding day, everyone in the church talked about how handsome the groom was. But I look at their wedding picture and am struck by how lovely my mother was—in her features I see both softness and strength. She would need that strength; still more challenges lay ahead.

MY FATHER WASN'T IDEOLOGICAL. He was irreverent by nature. He found humor wherever he could and made people laugh, no matter what was going on in the outside world.

In postwar Hungary, statues of communist leaders were

everywhere. In the collective's butcher shop, for example, there was a statue of Rákosi. The man was bald (people actually called Rákosi "the bald butcher," though they didn't mean the kind of butcher my father was). Given the man's famous baldness, and the fact that the butcher shop at the collective was always cold, my father once constructed a hat from a bandanna—the sort of thing one might make for a child—and placed it atop the head of the statue. When people came in and asked why the statue was wearing such a thing, my father quipped, "It's cold in the butcher shop. He needs to be warm." People laughed; if there had been any tension, it was already broken.

But beneath this joking, I suspect, was real concern. The economy under communism was faltering. The standard of living had fallen precipitously. Basic goods—flour, sugar, bread, meat—needed to be rationed. All too often there were shortages. Hungry bellies were not uncommon.

My father also resented that when the communists took over, everything started to seem functional, utilitarian, and cheap. He didn't like that the Party had taken property from ordinary citizens. Although he himself didn't have anything worth taking, he did know right from wrong. Sometimes, walking with us in town, he stopped to gaze at a beautiful house, one that had been put up by a master builder. He'd stare at it and explain the details of its construction: the nuances of the beams and nails and joints and joists that had been used. "In four hundred years," he'd tell us, "this house will still be standing right there." Then he'd shake his head. "And they just took it away. They kicked out the man who built it by hand and allowed strangers to move right in."

My father also hated meetings at the collectives, believing them a waste of time. At one meeting, he might be told to sing—sometimes literally—the praises of a particular leader. Then, at some future meeting, he'd be told that that very leader was now considered a disgrace.

It was too much to keep track of: who's out, who's in, who's good, who's bad. *We don't even know those people*, he said. Here in Kisújszállás, people were eking out livings with their hands. They had mouths to feed. The world might have been locked in an ideological battle, but my dad's attention stayed local. And he knew what was important.

He'd shake his head. "Let's just go home," he'd say to his neighbors. "Our families are waiting."

IN OCTOBER 1956, a year after I was born, something historic happened in Budapest. It began with a small group of protesters, many of them students, marching toward the parliament building in open opposition to the Communist Party. After years of dictatorship and economic stagnation, these people wanted reform. They carried a list of demands, among them the withdrawal of the Red Army from Hungary, a return to multiparty democracy, a free and open press, and the total reorganization of the Hungarian economy.

The protesters had reason to hope. Stalin had died a few years before. Rákosi, his "best pupil," had been demoted and ultimately fled to the Soviet Union. Hungarian labor camps had closed, political prisoners had been released, and the head of the secret police had been arrested. New leadership in Hun-

gary seemed to be genuinely trying to improve standards of living. Meanwhile, Poland, another Eastern Bloc country, had elected a reformist government and had successfully arranged for the withdrawal of Soviet troops.

Things were looking up.

You can watch videos of the Hungarian protesters online: They are young, smiling, confident. Their sense of optimism appears to have been infectious; before long, the crowd swelled to hundreds of thousands. No other country inside the Soviet sphere of influence had ever stood up to Moscow like this.

Soviet tanks moved in. There were skirmishes at first, then widespread violence. The Red Army opened fire on the protesters; thousands were killed or wounded. In the wake of the 1956 uprising, tens of thousands of Hungarians were arrested; 22,000 would be sentenced and imprisoned. Hundreds were executed, and hundreds of thousands fled the country entirely. Some were executed at the border as they tried to escape. At least 170,000 were placed in refugee camps—mostly in Austria, but eventually in countries all over the world.

The rebellion was crushed. It would be decades before people spoke of it openly.

In some ways, what was happening in Budapest probably seemed a million miles away from Kisújszállás. But my father had lived through a lot by this point. He knew how abruptly things could change—how violence could erupt, apparently without warning, even in quiet communities. So he organized a local watch: a group of neighbors who would patrol the community, nonviolently, serving as a visible presence to would-be troublemakers who might take advantage of any un-

rest. Their message: *Don't let violence come here.* They also served as an early-warning system to community members in case trouble did arrive.

He carried no weapons. He made no assumptions about how potential conflict might unfold or who might instigate it. He didn't make speeches or demands. He had no intention of overthrowing anyone. Nor, though, was he attempting to preserve anyone's power. He wanted only to help keep his community safe. But during those difficult days, to be out on the streets at all was tantamount to instigating rebellion.

My father was arrested, accused of agitating against the Party. He was given seven months suspended prison time. And in February 1957, just a couple of months after the revolutionaries were crushed by the Red Army, my father received a letter:

FARMERS' CO-OPERATIVE OF KISÚJSZÁLLÁS

KISÚJSZÁLLÁS, FEBRUARY 9, 1957

KISÚJSZÁLLÁS—TELEPHONE 49

SUBJECT: TERMINATION

CASE NUMBER: 17/1957

Karikó János
Kisújszállás

According to Article 29, paragraph "c" of the Hungarian Labor Code, your employment will be terminated starting February 11, 1957 . . . Reason: The Board of Directors of the Farmers' Co-operative of Kisújszállás, at their meet-

ing of February 8, 1957, decided this way because the Farmers' Co-operative, as such, in the process of socialism building, is also engaged in organizational and educational work. In this work all employees must be involved.

Since the addressee proved that he was not suitable to live up to this task, even inciting against our system, I had to decide this way.

Elek Vigh
Dir. Pres.

It's not just that my father lost *this* job. Being terminated by the Party meant that *no* employer could hire him. My father couldn't work any official job. The Party was making an example of my father, vilifying him for what they deemed disobedience. My father begged the cooperative leaders to reconsider, pleading that he had two young children to feed. They were unmoved.

My father, now a political pariah, became a day laborer. During winter, he continued to be called to private homes to process their pigs, make sausage, and smoke the meat to preserve it. During summer, he worked in the fields and did construction. He worked on a new school building in town, laying bricks and covering the walls and ceiling with mud— something he was very good at. In the spring, he also left home to shear sheep, traveling for several weeks at a time. These were all temporary jobs, without much stability. But the fact that people in Kisújszállás continued to hire him, even after his punishment by the Party, is how I know for sure that my father was beloved in our community.

And it was during these years that the wisdom of his mother's plan back in 1932—if he became a butcher, he'd never starve—was borne out. We didn't starve.

Years passed. By the time my father got a job again, in a pub, it was 1961. Our family often accompanied him when he went to work. Sometimes, if he was finishing up a meat processing job, my mom even opened the pub for him. There, Zsóka and I helped clean tables, replenish cigarette stocks, and recycle old bottles. Using tubing, my sister and I transferred wine from large containers to one-liter bottles. Sometimes we tasted the wine to see if it had turned to vinegar. This would never happen today, but I swear: Back then it was utterly normal for a child of nine to taste wine!

Yes, there was hardship in those years. But it wasn't *just* hardship, and in fact it wasn't even *mostly* hardship. Even during the leanest, most difficult years, I always had so much.

MY OWN NAME DAY, Katalin, is November 25. On that day, the air was always brisk. Even today, even in America, when I feel the temperature start to dip, I remember the excitement I felt knowing that my name day was approaching.

A week before any family member's name day, we'd all head to the smokehouse. We'd work together to make enough sausages for everyone. Just a handful of ingredients: garlic, salt, pepper, and red paprika. *Grind the pork, blow air into the intestine that forms the sausage's casing, fill it with meat, then twist it again and again to form links. Smoke the sausages, then let them rest.*

On the day of the big event, twenty family members might

crowd into our one room: my grandmother, aunts, uncles, and cousins. As my mother finished cooking, someone would pour shots of alcohol for the adults, usually pálinka, a traditional fruit spirit common in the Hungarian countryside.

We'd learned long before that there were public conversations and private conversations; in the outside world, one never quite knew who was listening, or what that person might do. But here, with family, people spoke more freely, about anything, about *everything*, and always with big laughter. Amid the chatter, my mother would serve the sausages. We'd scoop piles of meat from a big pot, passing around a dish of grated horseradish that had been grown in our garden. The air around our table would swirl, fragrant and savory. As we ate, rich, meaty juice would squirt everywhere. After the meal, my mother would bring out all sorts of pastries, and we'd all eat a little more. My father would take down his violin from the top of the cabinet. Maybe he'd pass it around to other family members who also could play. They'd sing.

I'd look at these people who had survived so much. I'd listen to their stories—wars and hunger and blacklisting—and would think to myself with a kind of wonder: *I have parents. I have a roof over my head. I have shoes on my feet and food on the table.*

After dessert, we kids would push back our chairs and go outside and chase each other around the yard. Our bellies were full, the air was fresh. We inhaled the scent of leaves and dirt, felt cold wind on our faces. Music poured from inside the house. There was nothing more, in moments like that, a person could need, or want.

I look back now at the life we knew and am flooded with

gratitude. I'm happy that I was born where I was. I'm happy that that was my life. I imagine that my parents sometimes longed for something different, something easier. But for me, I got everything I needed. And even more than that.

I WAS *KISH KARIKÓ* when I started school, "the little Karikó." Never mind that I was a tall child, always taller than my peers, taller, even, than many children several grades above me. At school, I was Zsóka's little sister, following in her footsteps, sometimes literally.

Everyone knew and loved Zsóka, and they treated me well. From the start, it was clear that school, this place of learning, was my place, too.

In Kisújszállás, there was an elite school that specialized in music, as well as an ordinary school. My parents had hoped I might attend the exclusive school. But qualifying for the elite school, even the elite primary school, required some demonstrable musical talent. You had to be able to sing or to play an instrument. Despite our father's best efforts, neither Zsóka nor I had such talents, so it was ordinary school for us. (I'm pretty sure this means I failed my first-ever entry exam.)

Nevertheless, I adored it—everything about school—right from the start.

I basically danced off to school that first day, trotting behind Zsóka and her friends toward the two-room building in the center of town. School, like home, had whitewashed walls, which had been done by students' parents (it took a village, so to speak). I loved that building, loved everything inside it: the hard wooden benches and pots of ink into which we dipped

our pens (I tried so hard not to form blotches on the page, and when I did, I wrote my work over again). I loved the posters and maps tacked to the walls. I loved the dark-blue coats we wore over our street clothes during the school day—not quite a uniform, but not so dissimilar to one, either. These coats were like a signal to the world, and to us: Learning was serious business.

At the front of the room was a blackboard, and in the back of the room, a giant coal stove to keep us warm in winter. Around the back of the schoolyard were outhouses. Even here, at school, there was no running water.

OUT THERE IN THE wider world, an ideological showdown was under way: communism versus the West. Across the Eastern Bloc, countries like mine were trying to prove the superiority of socialism over capitalism. A very good way to do this was by educating children.

I tell you this: I had a strong education. Very strong.

Things were tricky, though. Between 1940 and the early 1950s, the Hungarian population had flatlined. Nearly a million Hungarians had died during the war, and in the years that followed, population growth remained stagnant. In 1953, partly in response, Hungary outlawed abortion and embarked on a series of pro-birth policies. In the mid-1950s the population began to rise, including in Kisújszállás.

And yet. Here, as elsewhere in the country, families faced so many shortages. When a woman did have a baby in those years, the public celebration was often tempered by real anxiety: *How will she squeeze in yet another mouth to feed? How will*

she afford the clothes, the books, the shoes, all those expenses, all those many things a child needs?

For the school, the baby boom presented a different sort of challenge: There were *a lot* of students. There wasn't nearly enough room for all the children, so the school day was held in two shifts, morning and afternoon. Even then, there were more than fifty kids in my class, all lined up in tidy rows—so many students that the government had to call teachers out of retirement. This is how it happened that my second-grade teacher, Margit Nagy, had also been my mother's teacher and my grandmother's.

Perhaps fifty kids in one classroom sounds like madness, sheer chaos. Who could learn a thing under such circumstances? But we remained quiet, saving our energy until we could burst out the door during breaks and at the end of the day.

ANOTHER WAY TO INVEST in children is through a robust healthcare system.

We had good doctors in town, and they often made house calls, arriving by motorcycle. They distributed antibiotics when necessary, vitamins, everything a child needed to grow strong. And some health efforts were broader than this.

I was in kindergarten when the teachers lined up our whole class and marched us out of the school, through town, to a doctor's office. There we stood in a long line, girls in dresses and boys in shirtsleeves. One by one, we approached the medical team, who offered us a teaspoonful of liquid: a drop of the Sabin polio vaccine.

Polio, as every mother could have told you at the time, was a cruel and contagious virus—and children, especially, were at risk. Outbreaks were terrifying, and cases were unpredictable. Children might experience no symptoms whatsoever or they might show symptoms typical of any number of other viruses: fever, headache, fatigue, stomach upset. Sometimes, though, polio moved stealthily into the nervous system. There it caused paralysis, breathing challenges, even death.

There seemed to be no logic to this virus. Why did some kids escape unscathed, while others never walked again? Why did some have only a mild fever, while others remained paralyzed for the rest of their lives?

Parents had never known a world without fear of polio. So when a polio vaccine finally became available (first with the Salk vaccine, which required an injection, and then the Sabin vaccine, which was easier to administer), the Party took an active role in getting it to Hungarian children. Their efforts were, by all measures, extraordinary. By the time I was fourteen, in 1969, the country had already seen its last case of wild polio—fully ten years before the United States, and fifteen years before the UK.

Still, for some local families, this wasn't soon enough. The younger brother of a classmate of mine *did* get polio. For the rest of his life, he walked only with difficulty, his leg in a brace. My mother also had strong memories of polio from her days working in the pharmacy; she remembered relatives of infected children entering the pharmacy to get medication. After they left, the owner made my mother scrub everything with bleach until her skin cracked and her knuckles bled. The family of the pharmacist lived in the same building, he ex-

plained, and he had a young son. He needed to protect the boy.

He was afraid. Everyone was.

THERE WERE SO MANY vaccine efforts in those days. I remember getting a BCG vaccine at school, to protect against tuberculosis. It was a two-clinic regimen. At the first clinic the vaccine was injected, at the second the doctors scratched our skin. If our scratch hadn't turned red, we needed another shot. We stood in line and compared our scratches. *Did yours turn red? Oh, look at my skin, it's not red at all. What about yours?*

It wasn't just vaccines that we had access to. Sometimes the whole school, or entire classes, would walk en masse to the dentist or to the pediatrician or to get our lungs x-rayed to find those with tuberculosis. Nobody resisted, nobody argued, nobody suggested that healthcare and education should be compartmentalized or that vaccines had no place in schools. There was a sense that we were all in it together. This was how we looked out for one another.

In 1963, when I was in third grade, Kisújszállás saw a different viral infection: foot-and-mouth disease, which threatened our cattle. While humans themselves weren't at risk, they could be vectors. If the virus moved through town, our animals might die. And if they died, what would we eat?

We took this virus as seriously as one that threatened our own health. To keep the virus from spreading, the whole community stayed home for several weeks. Those who cared for cows at the agricultural cooperative near the outskirts of town slept at work; they were not allowed to leave to see their fami-

lies, lest they carry the virus back into town. For weeks it went on like this. Total lockdown.

Even when life finally resumed, we had to be careful. For a long time, upon entering school or a store, we had to disinfect our shoes by stepping into a tray filled with bleach-soaked sawdust. We washed our hands in disinfectants, which left our fingers smelling like chlorine for days!

In 1968, when I was thirteen, there was a worldwide flu pandemic. This pandemic—which I've since learned was caused by an H3N2 strain of the influenza A virus, known then as the Hong Kong flu—wasn't nearly as bad as the 1918–19 flu pandemic, which was still present in some people's memories. But it wasn't mild; it would kill somewhere between one million and four million people globally before it was gone.

Yet again, we restricted our movement, limiting our contact with others. We scrubbed. We disinfected. I suppose the Party encouraged this, but nobody complained about government overreach. This was a virus; it had no ideology, no political agenda. If we weren't careful, it would spread. Then we would all suffer. Those were just the facts. That's how viruses work.

COMMUNITIES ALSO CAME TOGETHER during harvest season. Sometimes, there was more harvest than there were hands to pick. That's when the local agricultural cooperative would call on schoolchildren to help. Our whole school climbed onto a bus or a truck, then headed into the countryside, where we assisted in the picking of tomatoes, potatoes, sugar beets, paprika, or corn.

We missed school for other reasons. If there was a shortage of coal, we might get an entire week off from school for a "coal break," returning only when the building could be heated. We'd do our schoolwork at home, studying for several hours each day.

And I missed school, again and again, simply for being sick.

I wasn't a healthy child. I was weak, nothing but bones and skin. Every time I fell, I seemed to break a bone.

I broke my collarbone at the age of five. Then, at eight and nine, I broke a series of bones in one hand. By the time that hand had healed, I fell again, this time on the opposite hand. They removed the cast from the first hand and promptly added a cast to the other.

I had anemia, so they gave me iron pills.

I had no appetite, so they made me drink some terrible, bitter liquid I can still taste today.

I had pain in my torso, so they took my appendix out.

I got many respiratory infections, so they removed my tonsils.

The tonsillectomy was my first hospitalization. I was eight years old and frightened, and I missed my parents. The hospital was so big. Home was so far away. I lay in a metal bed, looking at the medical staff through glass windows and dreading the moment—a moment that to my horror came again and again—when they'd return to my bedside to get a sample of my blood.

I loathed having my blood drawn. I hated the feel of it, the look of it, the very idea of it. Nurses had to strap me down to stick the needle in my arm. I'd watch the dark blood filling the

needle, and I'd feel like I was trapped inside a nightmare. For many years after, I fainted even when I saw others' blood being taken. (I could never, I'm certain, be a doctor.)

A few years later, I'd be hospitalized again, this time with hepatitis A. I vomited and clutched my stomach, as my skin and the whites of my eyes turned yellow. I was placed in isolation. In the rooms around me were adults with dysentery and other diseases. Sometimes they moaned. I lay in that room for three weeks, all the while longing for someone to comfort me, to wrap their arms around me and tell me I would be okay. This was all I ever wanted when I got sick.

My mother worried about me; I know this. She loved me, she wanted me to be healthy, and she was frightened when I wasn't. She'd seen a lot in her lifetime, after all. To her, a child's survival could not be taken for granted.

When things are scary, people long to exert some sort of control, to *fix* things. Unfortunately, the only thing my mother really knew how to fix in this situation, the only thing that felt within her control, was *me*. So that is where she focused her efforts.

I can still hear her voice: *It's because you are a picky eater. It's because you won't eat your vegetables cooked, you only want them raw. It's because you won't put a hat on when it's cold.* It didn't matter that I was throwing up or that I was in pain or that I had a fever. It's because I was doing something wrong. I wasn't taking good enough care of myself, wasn't eating right, wasn't dressing warmly enough. If only my mother could get me to do the right thing, all my troubles would vanish . . . and with them, all her fears.

Although I eventually gained weight, at age sixteen, I've

had health struggles my whole life. I always tried to take care of myself, exercising and eating healthfully. Still, as I got older, my health problems only grew more complex. My knees hurt. My back hurt. My joints swelled with painful arthritis. I'd have lumps removed from my breast, then later I'd be diagnosed with cancer. It was a tumor on my parotid gland. When the doctors removed it, the neurons in that area became confused, making my face sweat profusely every time I eat.

Through all of that, my mother's voice stayed with me— *it's because you don't . . .*

But I tried to learn from this. I try to learn from everything.

I am, by nature, matter-of-fact. But when I became a mother, and my own daughter got sick, I'd remember how I felt in those long-ago moments. I'd remember how it felt to have my mom insist that the problem was *me*, that there was something I should be doing differently, even as I was doing the best that I could. Then I'd lean in and I'd hug Susan, and I'd tell her everything I once longed to hear: *Can I kiss where it hurts? Can I give you a hug? Here, my love, let me comfort you now, let me give you everything I didn't get when I felt bad.*

Sometimes, I think, that is the best we can do: to learn from the world we've been handed and then try to leave things a little bit better for the next generation.

IN ELEMENTARY SCHOOL I got my first official introduction to science. I joined a chemistry club run by our teacher. We constructed chemical elements from playdough, then assembled them into molecules using toothpicks. We oversaturated

salt solutions, then dipped a string into the mixture and watched crystals form. (Years later, at the University of Pennsylvania, I'd look at the bottom of a long-forgotten bottle that once held a highly concentrated salt solution, noting the crystals formed, and I'd think back to those afternoons in Kisújszállás, in chemistry club.)

Sometimes a biology teacher took us out for walks; we'd look at gardens and trees, shrubs and herbs and flowers. I remember standing at a small local pond, gazing at water lilies as the teacher described the air-filled stems that allowed the leaves to float. It seemed a kind of magic, a genius of nature.

Although officially, the ideology of socialism was part of the school curriculum—many schools had the words IN THIS SCHOOL WE ARE BUILDING SOCIALISM posted on their exteriors—that's not the part I remember. Perhaps this is because my teachers had largely been educated in the precommunist system. They focused not on political philosophy but rather on topics. They allowed me to learn widely and broadly, and I did.

We were graded on a scale of 1 to 5, with 5 the highest possible score. Early in my schooling, I earned mostly 4s—not bad for the daughter of laborers with sixth- and eighth-grade educations, but hardly best in class.

I was fine. That's the word I would use. *Fine*.

I don't consider myself especially smart. Over the years, I have met many people born with what seemed to be a photographic memory, a gift for learning effortlessly. One of my elementary school classmates could hear something once and remember it forever. That wasn't me; it has never been me. But even as a young child, I understood something critical:

What I lacked in natural ability, I could make up for in effort. I could work harder, put in more hours, do more, and do it with greater care.

Even in first grade, in second grade, I worked so hard. I tried to do everything correctly. If it wasn't right, I started over again.

I worked.

I worked.

I worked.

And it turns out that the brain is malleable. What we practice, we strengthen. I practiced being an excellent student—it was an active practice, the way an aspiring athlete might shoot baskets. Like an athlete, I got better. School became more natural to me. By third grade, I had dived so completely into school that I earned straight 5s all the way, and I never looked back.

Nor, I'll say, did I ever stop practicing.

ONCE, IN ELEMENTARY SCHOOL, we were given a history assignment: to interview an older community member, someone who stood out as a local hero. Each of us was to take an oral history, gather the subject's memories, then write a laudatory essay based on what we had heard. I was tasked with interviewing a veteran, a man about my father's age.

My father asked the name. When I told him, I saw something dark cross my father's eyes. "That is a bad man," he said. I almost never heard my father's voice like that. Hard. Angry.

"That man was cruel," my father continued. "He is a bullshit man, and this interview will be bullshit."

I still don't know what my father knew about this man, or what he'd seen. But I took this in. Then I did what I had to. I interviewed the man, collected his memories, and wrote my glowing essay. But I did so having learned a truth: That some tasks are bullshit. That my subject was a bullshit man. That sometimes bullshit men are lauded as heroes.

BY SEVENTH GRADE, I began participating in chemistry, biology, and geography competitions. There were competitions in other subjects, too—a girl named Ilona in my grade won some important history competitions; we eyed each other from a distance in school. But for me, it was chemistry and biology. By eighth grade, I became the best biology student in Kisújszállás . . . and then, from there, the best in the county. My father worked in the pub then, and sometimes my teachers stopped by for a drink. They'd tell him what a good student I was, what a big deal this competition was. It made me happy to make him so proud.

Winning the county competition meant that I was invited to Budapest, to represent the county at the national biology competition. The event was scheduled during a rare family vacation. My mother had received from the trade union a trip to Harkányfürdő, a water park with pools. I'd been so excited about this vacation. Still, there was no question about what I would choose.

I went to the biology competition in Budapest without my family.

It wasn't the first time I'd traveled alone. Like virtually every young person in Hungary then, I had been a member of

the Young Pioneers, an organization like the Scouts that was coordinated by the Party. One summer, I'd gone to a Pioneer camp, taking the train alone to get there, then walking several kilometers until I found the camp at the edge of the forest.

But this biology competition wouldn't be out in the middle of nowhere; it was in Budapest, a big city. I'd been to Budapest just once before, when I was five. Now I was fourteen, waving goodbye to my father through a train window. My parents had assured me that officials from the competition would be waiting for me on the other end. There were no cellphones then; there was barely any telephone system at all. Until my return, a week later, my parents couldn't be sure whether I'd made it to Budapest or, if I had, what had happened to me there.

At the biology competition, kids came from every corner of the country, probably fifty to sixty of us in total. We stayed in a brand-new dormitory at a school for the blind while its students were home for the summer. I was fascinated by the fact that everything, everywhere, was written in Braille. I remember running my fingers over the bumps of the Braille letters, trying to decipher this mysterious language—a tactile alphabet unlike any I'd seen before. Each day, judges tested us on factual knowledge: how much blood was in our system, the names of all the different bones, how much we knew about plant biology. One day, they took us to a meadow in the hills of Buda; they told us to collect all the different plants whose names we knew. We were to attach each plant to a piece of paper and label it. I knew so many plants! From my parents, I'd learned the names not only of the plants that we grew in our garden but also of the weeds that snuck their way in. I spent all those years cutting flowers in my grandmother's gar-

den. I'd also learned about plants at Pioneer camps, during school field trips, and during the countless hours I'd spent looking at my Vera Csapody book with the botanical watercolors.

That day's win helped me qualify for the final. In the end, I earned third place, making me officially the third-best biology student in the whole country. Me, Kish Karikó! The skinny butcher's skinny daughter from the little town of Kisújszállás!

I can still remember the other finalists—their names and even their prizes. A girl named Katalin Pénzes took first place, winning a week's vacation in Czechoslovakia. András Berta, the son of a university professor, won second place. He got a Sokol radio. For my third-place win, I got a Smena-8 camera; I used it to document our lives, something I've never stopped doing. We winners even gave a radio interview to the kids' program *Harsan a kürtszó* (*Bugle Call*), which I was so excited to hear back in Kisújszállás.

Another thing I remember from that competition was that one contestant's family had their own car. Their very own car! This seemed absolutely remarkable. Elsewhere in the country, I would soon learn, cars were becoming a bit more mainstream; between my toddlerhood and this moment, car ownership in Hungary had increased tenfold, a sign of changing times. My parents would never own a car, though I would, eventually. In those days, though, a family car was still a bewildering luxury, frankly unimaginable.

By this point, we were in our new home, the one that our family helped rebuild. This house was state-of-the-art, in a prime location on a paved street right near the center of town. At last, we had indoor plumbing and more electrical power.

We also set up a small television set. It flickered, and some-times we had to adjust the antenna to get reception. There was one channel when we got the TV, and by the time I finished high school, there would be two. But it all felt so modern then!

Hungary was changing. And so, as it turned out, was I.

THREE INFLUENCES FROM
MY HIGH SCHOOL YEARS

One

"What do you think, Karikókati?" The teacher in front of me, the one who has just posed this question, has a serious face, but his eyes are bright and curious. He is Albert Tóth, my high school biology teacher, dressed impeccably, as always, in a colorful pullover. He also runs a biology club after school for students like me.

We are discussing Albert Szent-Györgyi, the Hungarian scientist who first isolated vitamin C, and whose breakthrough research into cellular respiration laid the groundwork for the identification of the Krebs cycle. Szent-Györgyi would go on to win the Nobel Prize in Physiology or Medicine in 1937. The question Mr. Tóth just asked me is about a quote from Szent-Györgyi: *In studying life, you keep diving from higher levels to lower ones until somewhere along the way life fades out, leaving you empty-handed.*

We have been discussing, among other things, molecular biology, the way life depends on, and is transmitted by, genetic material. DNA and RNA are the building blocks of life, es-

sential to life, yet they themselves are not alive. They break down into molecules, then into atoms.

Where, then, is the line between life and the inert blocks that make it possible?

What do I think?

I like that Mr. Tóth doesn't merely teach us facts. Nor does he try to tell us what he thinks about these facts. Instead, he wants to know what *we*, his students, think about them.

Perhaps more important: He wants *us* to know what we think.

Mr. Tóth, like all my teachers, knows my family; he'd once stood guard while my father butchered his family's pig in secret. He knows about my father being blacklisted, about my family's humble beginnings. Mr. Tóth organized the biology club when I was in primary school, and he was the head of the jury of the local biology competition when I was in eighth grade. In his eyes, I am more than the child of a butcher, more than Kish Karikó. I am a future scientist. Never mind that I don't personally know any working scientists, Mr. Tóth believes I'm capable of becoming one. He believes I can think for myself about big ideas.

Mr. Tóth is all about big ideas. Between classes and biology club, he's introduced students to the work of not only Albert Szent-Györgyi but also the famous criminologist Cesare Lombroso, Hungarian biologists, and ecologists such as Pál Juhász-Nagy, Pál Jakucs, Bálint Zólyomi, Gábor Fekete, and Elek Woynárovich, who become like heroes to us. In Mr. Tóth's class, we're expected to read not only textbooks but also published journals such as *Búvár* (*Diver*) and *Természet*

Világa (The World of Nature), as well as books by working scientists. We don't merely *read* these things, we must also teach them. Class presentations ensure we understand the subjects well enough to explain them to others.

We talk about applied science, too: global challenges such as natural disasters and population explosions, a new theory about greenhouse gases trapping heat in the earth's atmosphere, the importance of nature conservation. Hungary's first-ever national parks are being established, including the nearby Hortobágy National Park, so of course we take field trips, too. Our high school even has a small science museum, with such artifacts as a 165-year-old Nile crocodile, a mammoth tooth, a rock collection, a petrified wood sample, and a rose of Jericho. Mr. Tóth wants to be sure we understand that biology isn't something that sits inside a textbook. Biology is everywhere, all around us, inside us. It's the way the whole world works, and it's fascinating.

What do I think?

I don't recall today how I responded to his question. What response would have been adequate to the mystery and complexity at the heart of all life? What I remember, instead, is leaning forward in my seat—always the first bench, always near the window, always next to my friend Anikó—and thinking this: *Someday I, too, will be a scientist.*

BEFORE THE YEAR IS out, our class will write a letter to Szent-Györgyi in America. We don't have the scientist's address, and can't think of a way to find it, so we address the envelope with only two lines:

ALBERT SZENT-GYÖRGYI
USA

It is a stab in the dark, a wild gamble, and I'm not sure any of us believe our letter will ever arrive. But months later, we receive a letter back. It is a personal letter, from Szent-Györgyi himself, and it arrives with a copy of his book *The Living State*. He's inscribed it "To the enthusiastic cultivators of science in Kisújszállás."

By then I have no doubt: This great scientist is talking to me. *Cultivator of science.* Oh, yes. That I am.

Two

A different book, yet another one that Mr. Tóth introduces me to. This one, roughly three hundred pages in length, feels like it was written for me. Maybe even *just* for me—as if the author had created it for an audience of one, and I were that one.

The book is *The Stress of Life*, by Hans Selye. I am only a teenager, with so much still ahead, but I swear: For the rest of my life, no book will affect me quite as personally, or as meaningfully, as this one.

The book is an exploration of what Selye, an endocrinologist, has named "stress."

Today, as I write, the concept of mental and bodily stress seems obvious. We know what it is, what it feels like, and the way it shows up in disparate parts of the body. But before Selye came along, it did not exist as a biological concept.

Selye was a medical student in 1925—just eighteen years old and brimming with textbook facts about anatomy and dis-

ease progression—when he observed something odd. It was the same thing that anyone looking up symptoms on the internet today would surely notice: The same set of symptoms appears in many different diseases.

Aches? Painful joints? Fever? Intestinal upset? Loss of appetite? Coated tongue? Feeling blah? Could be anything at all—a temporary virus, a chronic illness, or a terminal disease.

Why, Selye wondered, had no one ever investigated "the syndrome of just being sick"? What exactly *were* these symptoms that are shared across the wide spectrum of disease? He methodically began to search for an answer—a search that resulted in our contemporary understanding of the biological stress response.

I've never read a book like this in my life.

It's not just that the book is speaking directly to things that I have experienced (all those sicknesses I've had, those generalized symptoms, the lack of clear answers). It *is* that, of course, but it's so much *more* than that. Nor is it simply that Selye was an outsider when he began his inquiry—no sense of how things are supposed to be done, no preconceived notions. (Sometimes, he seems to be saying, the most important questions are asked by outsiders.)

It is also that Selye somehow understands *how I want to think,* the way I want to define a big question, then begin zeroing in, systematically and logically, on clear and specific answers. Early in the book, Selye notes that nature "rarely replies to questions unless they are put to her in the form of experiments, to which she can say yes or no." I read this line again and again: *questions . . . in the form of experiments . . . she can say*

yes or no. One question at a time. From many such questions, from many yes-or-no answers, a mosaic grows.

And then comes this passage:

> Only those blessed with the understanding that comes from a sincere and profound love of Nature will ... succeed in constructing a blueprint of the many questions that need to be asked to get even an approximate answer. ...
>
> Only those cursed with a consuming, uncontrollable curiosity for Nature's secrets will be able to—because they have to—spend their lives working out patiently, one by one, the innumerable technical problems in performing each of the countless experiments required.

Blessed or cursed, I am certain that I am one of the individuals Selye is talking about. I'm sure that I can—that I must—spend a lifetime patiently working out technical problems, doing countless experiments.

Mind you, I have no expectation of doing anything grand like Selye did. But perhaps someday I could pose questions to the universe, which is to say design some experiments. Perhaps someday I might get a definitive yes or no. Perhaps, in that way, I might contribute my own small part to the grand mosaic that is human knowledge.

The Stress of Life is important to me for another reason: Reading Selye's words, I come to understand that stress isn't merely a *negative* physiologic experience; it has positive forms, too—such as excitement, anticipation, and motivation. While negative stress can be harmful—it can, in fact, kill you—

positive stress is necessary for a fulfilling life. And with the right attitude, we can transform negative stress into positive stress.

How? By *focusing on the things we can control, instead of the things we can't.*

For example, as Selye seems to suggest, we cannot control anyone's reactions but our own. Therefore, we shouldn't work to please others or to gain their approval; we must, instead, set our own goals and work to satisfy those. When faced with setbacks or failures, we mustn't blame others; assigning blame keeps us focused on things over which we have no power. Instead, we can respond to misfortune by learning more, working harder, and being more creative.

Stress might be unavoidable, but *The Stress of Life* guides me to understand that stress can help or hurt me. It all depends on how I perceive it and how I respond.

Three

Once a week, in my house, we watch *Columbo*. On this television show, imported from the United States, Peter Falk plays an unassuming L.A. homicide investigator with a trademark squint and ratty trench coat. *Columbo* is one of the few American shows allowed on the airwaves here. It's apolitical, harmless entertainment. Plus there are rumors—to my knowledge never confirmed—that Peter Falk is related to Miksa Falk, a nineteenth-century Hungarian politician and journalist.

Columbo is rumpled, a bit hunched, always searching his pockets for a pen. He chews on cigars, seems permanently overdue for a haircut. His suspects, by contrast, are wealthy,

well coiffed, endlessly cunning. Each executes a seemingly perfect murder—every detail thought out. The murderer is never a mystery. We see it happen at the start of each episode. The question, instead, is how this bumbling everyman can piece together the truth when every clue points away from the murderer.

The answer, every time: *brilliantly*.

Columbo plays cat and mouse with his suspects. Columbo is always on their turf: in their mansion, on their yacht, in their Rolls-Royce, in their library. He swills *their* liquor, poured into *their* crystal glasses, by the light of *their* roaring fire.

He asks a couple of questions, nods along with the suspects' lies. He blinks innocently. His bumbling manner puts them at ease. Columbo gives these suspects no reason to wonder whether their certainty—that they're better, smarter, cleverer than he—might be misplaced.

He thanks them, stands up to leave. That's when he turns around, as if something's just occurred to him. "Just one more thing . . ." he says.

Columbo, it turns out, is smarter than he looks.

I'm not the only one who loves Columbo; everyone in Hungary loves him (today, as I write, there's a life-size bronze statue of Peter Falk, in his signature Columbo attire, in the middle of Budapest). Nor is Columbo the last crime show I'll ever watch. I'll go on to watch the British thriller *The Saint* featuring Roger Moore, *The Persuaders!* with Moore and Tony Curtis, the French crime show *Maigret*, and plenty more after that. I have also watched a lot of real crime investigations. But *Columbo* is the first such show that I truly love.

And not just because Columbo is—as I will be soon—

a fish out of water amid powerful people. (They'll look right through me, those people. Again and again, they'll fail to notice that my mind, too, is taking everything in.) But rather because of that line: *Just one more thing*.

Here's the truth: Scientific investigation can be tedious. It generates a lot of data, and sometimes the bulk of that data appears to point in one direction. It can be tempting to look for the data that fit one's existing narrative, and when you find that data—which you will—to feel that you've done your job.

But you must do your experiments correctly.

You ask one question at a time. Then you change just one variable and ask again. And then you change the next variable. And then the next. *Just one more thing*. There's almost always just one more thing.

You must stay patient, examine everything, every tiny detail. You have to set aside the mountain of information that appears to confirm what you expect and deliberately seek out that one thing that doesn't. Because that thing—that tiny, nagging piece that, for whatever reason, does not fit—may, if you pay attention, point you toward truth.

I WAS SURROUNDED BY girls in high school. The school's classes were co-ed, but in my grade, girls outnumbered boys by two to one. The teachers and administrators believed it wouldn't be good for the boys to be so outnumbered, so they separated the classes by gender. At first, there were enough girls for two all-girl classes, while the boys had just one. But two years in, so many girls had dropped out of school that a single class could hold us all.

Most girls thought only about their clothing and hair. Back then, the clothes we could purchase in local stores were drab and uninteresting, so girls often hand-sewed stylish outfits for themselves. Not me. I didn't care about clothing—I still don't. (Back then, my mother knitted many of my most fashionable blouses and pullovers; I still have some of them, and I wear them from time to time, when I get nostalgic. These days, I let Zsóka pick out my outfits.) Whatever I happened to wear in high school, I was always glad to cover it up with a blue school coat.

Sometimes, girls in my class experimented with new haircuts or lightened their hair, earning gentle mockery from teachers. Once, my friend Ilona (who'd gone to the history competition around the time I went to the biology competition) showed up with hair two shades lighter than it had been the day before. "What happened to you?" the teacher asked. "Did you fall into a batch of peroxide?" I kept my hair as it had always been: brown, short, and a little shaggy.

I also had no interest in giggling about boys or going on dates. Sometimes when I went to the movies (Hungary had its own genre of Western frontier films, often filmed in the nearby Hortobágy), I'd see classmates on dates. Even if I'd wanted to date, I'm not sure I could have. I suspect boys thought I was too tall, too skinny, not particularly attractive. At any rate, no boys ever asked me, and that was fine by me.

In my class, there was only one student who could rival me in math. Mari was a gentle soul, one of those quietly brilliant students. Sometimes our math teacher would put a problem on the board and give us each a few minutes to solve it independently. I always managed to solve it, and Mari did, too. But

here is what was interesting: When the time came to explain our answers, Mari and I invariably discovered that we had gotten there using different methods. Often, we debated which method was the right one. Mari, though not usually competitive, could be adamant about her choice. So could I. The teacher always enjoyed this, so he'd allow us to argue. Five or ten minutes might pass as we went back and forth, each of us making the case for our own approach. Our classmates quickly learned the pattern: If Kati and Mari got the same answer in different ways, the rest of the class would get a break. They'd doodle, daydream, and pass notes, while at the front of the class Mari and I argued about methodology.

LIKE MANY OF MY friends, I had an F next to my name. In every high school record there it was, every time: *Katalin Karikó: F.*

The F didn't signify failure, as it would have on a U.S. transcript. It meant *fizikai,* the Hungarian word for "physical." The F told anyone who happened to see my form—university officials, for example—that I was the child of people who worked with their hands, physical laborers, versus those whose parents were doctors or professors. (My mother might have worked in an office or a pharmacy, but her eighth-grade education qualified her as a *fizikai* laborer.)

It meant, in communist Hungary, that educators paid a little bit of extra attention to me. The Party wanted to lift people from the working classes, to actively give them the sort of opportunities that might otherwise come more readily to children of the elite. These opportunities weren't handouts, mind

you. To take advantage of them, I had to be ambitious and willing to work. I was both of those things, and that little F next to my name ensured someone would take notice. Thanks to my *fizikai* status, I had the chance, as a high school student, to participate in summer classes at a university. I leaped at the chance.

Hungary's university system then was very different from the one that exists in America. In the United States, there are thousands of universities and colleges. Sure, the top-tier schools, like the Ivy League, are incredibly competitive. But if a U.S. high school student can't attend these top-tier schools, there are plenty of options. An American student who wants to attend college is sure to have a spot *somewhere*. In Hungary in the early 1970s, there were fewer spots to go around.

So attending the summer program was a way to help me prepare for the rigorous application process. But even without that edge, I'd have wanted to attend.

By now, my every desire was biology.

THE CITY OF SZEGED, about 145 kilometers from Kisújszállás and near Hungary's southern border, is bright and charming. It's filled with bustling cafés and restaurants, street music, and parks. It's pleasantly walkable and invariably sunny. In summer, people sprawl out on the sandy shores of the Tisza River, as crowded as any beach. One could pass a long, leisurely summer here. But that's not what I was there for.

During the summer of 1972, at age seventeen, I studied at the University of Szeged. I couldn't have been more elated with this honor. It was here, at the university, that Albert

Szent-Györgyi discovered vitamin C. It was here, too, that Szent-Györgyi identified key elements of respiration in muscle tissue, revolutionizing our understanding of the cell. Across the Tisza River, which bisects the city, was the new Biological Research Center of the Hungarian Academy of Sciences, which employed Hungary's most esteemed biologists.

My schedule during this summer program was grueling:

> Wake up at 5:00 A.M.
> Do homework.
> Attend classes from morning until evening.
> Do more homework.
> Sleep, but just a little.
> Wake up at 5:00 A.M. and start again.

I read until the words and formulas blurred. My neck and shoulders hurt from hovering over my books. I ate only what was necessary to keep me going. I rested just enough that I might be able to wake the next day and do it again. I devoured everything the professors taught me, every detail, every scientific term—things that I've been told make other people's eyes glaze over, but not mine. Never mine. I wanted to learn it all, every bit, and the more I learned, the more complex and fascinating our world became. And beneath all this was also some anxiety: Was I ready for university? Could I pass an entrance examination? And once at university, could I possibly succeed?

A FEW MONTHS LATER, on a warm, bright day, my high school class was enlisted to harvest corn outside Kisújszállás.

Groups of students were each given a row to complete: I worked next to a girl named Mária Friedl. Mária was one of a handful of kids who commuted from Kenderes, a small neighboring agricultural community with no high school of its own. (Every morning, in all weather, the Kenderes students walked to the train station, rode the train to Kisújszállás, then walked the twenty minutes or so to high school.) Mária had grit. She was a strong athlete, blunt and determined. She was a hard worker, too.

My family had cornfields, of course, as did my grandmother, and there wasn't a time I could remember when my hands didn't know how to do this work. Mária and I worked quickly, efficiently, finishing our row sooner than our classmates did. Some of these classmates, I suspect, worked more slowly than we did because they hadn't had as much experience picking corn. Others, like the girls working the rows closest to us, had long nails to protect. But perhaps more to the point, plenty of girls just wanted to enjoy the day. They listened to the radio and gossiped as they worked. It didn't matter. It wasn't a competition. We all had our rows, and we'd all finish eventually. I was just glad when Mária and I finished with time to spare.

Mária and I sat down at the edge of the field, drank some water, and lifted our faces to the sun. I closed my eyes, and felt the warmth of the day, listening to the sounds of my classmates chattering away. That's when I sensed a shadow looming—something large and dark that had placed itself between me and the sun.

I opened my eyes. Above me stood my Russian-language teacher. He was frowning.

"Katalin," he snapped. For some reason he spoke only to me, not to Mária. "Get up. Get back to work."

I'd known this teacher a long time. We used to live on the same street. His wife had been an elementary school teacher of mine, and I'd played with his son when we were young. I'd been to their house on many occasions. And yet for all that, as I looked up at him now, I understood something: I didn't actually like this man very much. He was an angry man, a chainsmoker who looked like he always had an upset stomach.

"I've finished my work," I explained.

"*Get up*," he repeated, stronger this time. No, I definitely didn't like him. He was a bitter man. Sore and hostile.

"The other students are still working," he said. Again, he spoke to me—to me only, as if Mária weren't also stretched out in the sun. Was this because Mária tended to be more straightforward with others, including teachers? Because she was one of those people who, to use an American phrase, took no shit? Or was it because she wasn't as academically minded as I, not bound for university, which meant she had less to lose? I don't know. But it was me to whom the man insisted: "Go back into the field and help them. Now."

I considered the situation. It's true that others were still working, but that was only because they hadn't worked as quickly, or as hard, as Mária and I. Those other kids had danced, sat down in the middle of the field, and gossiped, while we simply worked. So why should I now be punished with more work? It wasn't right. Some things just aren't right.

There has always been something stubborn in me, something that fights back when someone tries to force me into something. I have a way of digging in.

"No," I finally said. "I won't. I'm tired. I did my job. I'm staying right here." In front of me—above me—the man seemed to grow bigger. He stared at me, opened his mouth, closed it again. His jaw hardened.

Then he whipped around and strode away. But I knew that wouldn't be the end of it.

When we returned to the classroom, Mr. Bitter promptly wrote me up for a disciplinary infraction. The report said that I was a delinquent, that I'd violated the rules, that I'd gone against the values of the community. He handed the paper to me in the classroom, with everyone watching. As I looked it over, Mária stood up.

In Hungary, we have a saying: *What is in my heart is on my lips*. That was Mária. She said what she thought. "Well, then I want to be punished, too," Mária said.

Mr. Bitter turned to Mária, stunned. He seemed not to have considered Mária at all.

"I was with Kati," Mária continued. There was challenge in her eyes. "I also sat down after finishing the row. So I deserve the punishment, too." It was hard not to smile. How nice to have a friend like Mária: someone so bold and unafraid. How reassuring, as I was threatened by someone more powerful than me, to feel so seen and supported.

It turns out Mária wasn't the only one who had my back. Mr. Bitter spoke to other faculty about me, demanding the school take formal disciplinary action against me. This was the sort of thing that would go on my transcript, something universities would see. It was the type of thing that could derail a girl with ambition—really teach her a lesson about defying an angry man who feels entitled to her respect.

Thankfully, these teachers refused to take action against me. To this day, I'm not sure why. Perhaps they also didn't care for this unpleasant man. At any rate, they chose a student over their colleague, and I have been forever grateful.

Still, that didn't stop Mr. Bitter. Near the end of high school, he stopped me in the hallway. I'd just taken my final oral exams, for which I'd studied nonstop. I was exhausted, relieved, and apprehensive about the next step, which was to take the entry exams at the University of Szeged. Suddenly, here was Mr. Bitter in front of me, who clearly had something to say. "You know, Kati," he said. He spoke as if he were thinking aloud, as if the words coming out of his mouth had just occurred to him. But there was something cold in his voice, and cruel. "I know some people at the University of Szeged. I think I'm going to call them and I'm going to make sure you don't get accepted."

Call it youth. Call it overconfidence. Call it naivete, or stubbornness, or just plain foolishness. But I looked at Mr. Bitter standing before me—took note of his determination to hurt me—and I walked away. I left him standing there in the hallway.

Could he really keep me out of university? The truth was, I couldn't know for sure. But I didn't want to give him the satisfaction of upsetting me. About that I was certain.

I HAVE NO IDEA how many students applied to the University of Szeged. But I was one of them. From this pool, more than two hundred students were invited to take the written entry exams for the faculty of biology. I was one of them. Then,

thirty to forty were invited to take an oral exam. From there, only fifteen to twenty were selected to attend this program.

I was one of them.

When I received my acceptance, I thought about Mr. Bitter, who—because on a beautiful autumn day I'd sat down after completing my work—tried to block me from getting into university. Looking back, I now see that in attempting to derail me from university, he was attempting to keep me from everything that followed—my whole life. He was trying to rob me of all that I would accomplish later, and everyone who would be affected by my work. And all for the pettiest of reasons.

The man had failed. But still, I'd learned something from him, some important things: Not everyone is rooting for me. Not everyone wants good things for me. Not everyone wants my contributions. Some people may even choose to hate me.

Okay, then. Noted.

THE UNIVERSITY PROGRAM IN Hungary is five years long. From day one, biology students learn in both the classroom and the laboratory; over time, the lab work becomes increasingly important. After five years, in the Hungarian system, you are a biologist.

In five years, *I* would be a biologist.

But I knew already that I'd want to go further than that if I could, to a formal PhD program. The doctoral program would involve years of targeted research, capped off with a thesis and an exam.

In the summer of 1973, all this felt like a mountain I'd never finish climbing. But I couldn't wait to get started.

———

YOU SPEND YOUR CHILDHOOD in one place: It's what you know. It's all you know. Perhaps you even take it for granted: The embroidered throw pillows, all those bright bursts of flowers, scattered everywhere on the sofa. The particular angle of light that streams through eyelet curtains at a specific hour in the early morning. The solid, well-worn table around which you've had thousands of meals, done years of home-work. The sound of your father singing, deep and warm, as he does his chores each morning. The distinct fragrance of your mother's paprikash, onions and paprika and sour cream in proportions that are hers alone, the scent as unique as a finger-print.

It's just life, you think. This is what your life is.

Then one day you pack your bags. You've left home be-fore, but today is different. This departure is not for a week, nor even for a summer. This is the beginning of some new thing, some new life. You understand this, even if you cannot possibly yet understand what it means.

You look around, remembering the months you spent by your father's side, building this home, beam by beam. Think-ing of all the days and nights you spent here since, the tens of thousands of times your eyes have fallen on these walls, this table, this door, the one you reach for now as you step outside one last time before leaving for university.

And you see this long road that stretches before you, the start of a path that is yours alone.

PART
TWO

—

An Extremely
Brief Interlude
on Science

AROUND THE TIME I WAS STANDING IN LINE WITH MY kindergarten classmates waiting for my polio vaccine, scientists across the globe were making a discovery that, while still unknown to five-year-old me, would change my life.

By this point, biologists already understood a lot about genetics. They understood that genes are tiny snippets of DNA, packed into chromosomes inside a cell's nucleus. They knew that DNA is the genetic information of an organism—a blueprint not only for the making of the body but also for all the work that body does to keep that organism alive. They knew that DNA is "written" using four basic building blocks, or nucleosides: adenosine (A), thymine (T), guanosine (G), and cytidine (C). Just as the twenty-six letters of the Latin alphabet can be combined and recombined into an endless array of meanings, the specific order of these four nucleoside "bases" directs that gene's function.

They knew that each gene codes a specific protein, and that proteins, once made, do the work of the body. Gene *expression*—the process by which a cell uses the genetic information to actually *do something*—means manufacturing the corresponding protein. They also knew that proteins are manufactured in an organelle called the ribosome, which is in the cytoplasm of the cell.

They knew *what* happened. But they didn't understand *how*.

How, exactly, did the information in DNA, which is packed tightly inside the nucleus, trigger the making of a protein *outside* the nucleus? How can an inert blueprint that never, ever leaves the nucleus make something happen in a completely different part of the cell? The question, when I was born, was still a total mystery.

In the late 1950s, researchers at the Institut Pasteur in France began to hypothesize: Perhaps there was some physical intermediary, a short-lived "cytoplasmic messenger" (some scientists called it simply X) that copied sections of DNA's code—all those As, Ts, Gs, and Cs—then carried this information out of the nucleus and to the working parts of the cell? Some scientists actively laughed at this idea. François Jacob, one of the scientists who would be credited with the breakthrough, recalled that other scientists rolled their eyes, nearly jeering at this idea.

The history of science, it turns out, is filled with stories of very smart people laughing at good ideas.

But in 1960, after a series of failures, two independent experiments would confirm that the Pasteur researchers were correct: There is, in fact, a short-lived messenger that transports genetic information from the DNA to the ribosomes, where it gets translated to protein, then disappears.

Today, we call that little substance not X but rather messenger RNA, or *mRNA*.

Messenger RNA isn't the only type of RNA. But for my story, it's the one that matters most.

RNA, or ribonucleic acid, is a strip of genetic material whose

language is composed of nucleosides, just as DNA is (in the case of RNA, we call them *ribonucleosides;* DNA is made up of *deoxyribonucleosides*). But while DNA is meant to last forever, all RNA is temporary. It serves a specific purpose, then is broken down by the cell.

This ephemerality is reflected in its structure. While DNA is structured as a double helix (like a twisting ladder, with sugar-phosphate "rails" and two bases joining to form each "rung"), most RNA is just a single strand—like a ladder that's been chainsawed vertically down the center (with just a single base for each rung). Also, the sugar molecules in the rails of RNA have free hydroxyls, which can interact with the phosphate groups that link the nucleosides. These interactions break the long RNA chain.

Finally, there's a slight difference in the alphabet of their bases. RNA also has four types of bases. Three of these bases—A, C, and G—are identical to those in DNA. But while DNA contains thymine, RNA has a base called *uracil*. When uracil is linked to the sugar molecule, it is called uridine. So RNA's language is constructed from the letters A, C, G, and U.

DNA TO MRNA TO PROTEIN. This process unfolds in two parts, transcription and translation.

Transcription: The sequence of the gene—the order of the bases—is copied to RNA. Inside the nucleus, an enzyme (a type of protein that makes biochemical reactions happen) moves along the gene. A bit at a time, the DNA of that gene "unzips," exposing its unique arrangement of As, Cs, Gs, and Ts. The

enzyme makes a complementary strand of this information, which is mRNA. As the enzyme advances farther along the gene, the DNA strands reunite.

When transcription is complete, the mRNA leaves the nucleus, moving into the cytoplasm, to the ribosome, which will manufacture the corresponding protein according to the instructions encoded by all those bases.

Translation: The genetic code is translated into a protein.

The ribosome reads the mRNA, producing a protein. (In the same way that DNA is made from chains of bases, proteins are constructed from chains of smaller units, called amino acids. There are twenty different amino acids, and their order in the protein is determined by the order of the bases in the mRNA.) Once the chain of amino acids is complete, it folds like origami into a precise and complicated three-dimensional structure—exactly the shape that protein needs to do its job.

Once made, that protein gets to work, and in so doing, keeps you alive.

And what happens to that mRNA molecule that carried the instructions? More proteins are produced from it, then it disappears. Enzymes break mRNA down into its raw materials— bases, sugar, phosphate. Much of that material is recycled by your body; some of it is excreted. When the proteins finish their work, they, too, will be broken down.

This process is happening all the time, every minute of every day: Your cells make mRNA, that once-mysterious middleman between information and action. The mRNA travels from nucleus to cytoplasm, where it directs the making of proteins. *DNA to mRNA to protein,* with all the information coded in the DNA and RNA by the order of nucleoside bases, all

those tiny letters in the language of life. Again and again, this process unfolds—everywhere in your body, all the time, including at this very moment.

I'm simplifying all of this, of course. The truth is, this sort of simplification doesn't come naturally to me (or, I suspect, to most scientists). There is a wonderful precision to scientific terminology—a concise and exacting rigor that cannot be captured by ordinary vernacular. Also, I'm a logical, concrete thinker, not personally inclined toward metaphor or extraneous description. Still, I recognize that most people don't have four decades of deep immersion in molecular biology or biochemistry. Nomenclature that is obvious to scientists probably holds little meaning to many readers. Perhaps some readers have forgotten (or never learned in the first place) some of the key concepts that underlie my life's work. That's why I've done my best in these pages to describe complex ideas in a way that allows nonscientists to glimpse what I've been doing all these years, and why it mattered.

But we're already getting ahead of ourselves. For the moment, let's return to 1970s Hungary, where a curious, ambitious girl is just arriving at the University of Szeged.

PART
THREE

—

*A Sense
of Purpose*

WE WERE A COHORT OF EIGHTEEN. WE DID EVERYTHING together.

Those of us who started in the biology program at the University of Szeged in the fall of 1973 were together every day. Here our curriculum was predetermined. There were no classes to choose. This meant we sat together in every class, every semester. Between classes we dined together. In the evenings, we did homework as a group. Most of us lived in the same dormitory, too. We were—as much as any group of eighteen individuals could ever be—a single unit.

This is not to say we were the same. We came from all over, from every background. Some were the children of professors, others grew up on farms. Some were from tiny communities, others from the bustle of Budapest, and still others from the exclusive resort community of Lake Balaton. My friend Zsuzsa Kálmán was the child of a composer-musician who taught music classes in a teacher training school; she knew everything there was to know about music. Zsuzsa already had a serious boyfriend, Csaba, who was a year ahead of us in the biology program. They'd been dating since Zsuzsa was fifteen. Because she was years into a serious relationship—something I'd never considered—she seemed so incredibly worldly!

Our program also had a couple of international students. Hungary was an education destination for students not only from the Eastern Bloc but also from faraway nations that were communist-friendly, among them Cuba and Lebanon. In our program, there were two ethnic Hungarian students from Yugoslavia, and two girls came all the way from Vietnam.

Perhaps it is worth noting here: Half of the Hungarian students in my program had Fs next to their names. Were other countries as equitable in giving poor students or children of blue-collar workers access to a world-class education? And after decades of working in American universities, I wonder, too: What would it take for this to be the case?

I WAS NOT EVEN interested in genetics. Not when I arrived.

Early on, our head teacher, a professor, asked each of us what subjects we were interested in. He recorded our answers. "I like plants," I said. I'd spent my whole life studying plants. I loved their physiology, the way each plant had its own properties, uses, and place in a larger ecosystem. I loved that everything that mattered in our lives—air, food, water, beauty—came from plants. I loved knowing that plants, like animals, broke down into tiny units called cells, and that plant cells were bustling places—breathing, taking in nutrients, making proteins, and moving essential molecules from place to place.

But when I told my classmates that this was my interest, they sometimes looked baffled. Only two decades before, James Watson and Francis Crick had first described the double-helix structure of DNA (an achievement they made

based on work by Rosalind Franklin). Since then, scientists had made startling advances in understanding the fundamentals of genetic sequencing, replication, and function. They had even discovered that nifty little genetic messenger mRNA, which directed the making of proteins. The science of genetics was beautiful, elegant, and frankly mind-blowing. Genetics, many of my classmates insisted, were where the real action was.

Before long, I supposed, I'd be convinced, too.

OUR DORM WAS LOCATED next to a beautiful park, a short distance from the Tisza River, which we crossed daily via the Belvárosi Bridge to get to classes and the cafeteria. The Herman Ottó Dormitory had been open just a few months when we arrived in Szeged. It was brick and glass and ten stories high, and everything inside it was brand-new.

I swear: Everything, that year, felt brand-new.

Each first-year student was placed in a room with two older students, an approach that would allow us to integrate a little bit better in the community. The room had three beds, a sink, and some tables and chairs where we could study. An entire wall was made from windows. It was very bright, modern in feel, a great place to spend time. I loved to study there.

Some three hundred students lived in the dormitory, and with so many of us, there was always something going on—some burst of laughter coming from a nearby room, a bit of music, or a bubbly hallway conversation. Sometimes music by the Beatles or the Rolling Stones drifted through my window. Always someone was heading out somewhere—to hear music, or play basketball, or even just go to the library in a group.

Every one of us had a place to be, a path, a sense of purpose. Ahead of us lay endless opportunities.

We were still, of course, a country under the influence of the Soviet Union. I heard rumors sometimes that fellow students—dorm-mates or members of various social clubs— might be informants for the secret police. Likely, there was truth to this. The secret police were never far away in those days, especially in Szeged.

Szeged is ten miles from the nation's border with what was then Yugoslavia (today Serbia), and less than twenty miles from the Romanian border. Yugoslavia had fewer travel restrictions than Hungary in those days, which meant it had many Western goods. Sometimes university students traveled back and forth over the border to pick up blue jeans or other such goods. I had a friend pick me up a pair of jeans, which made me feel stylish and modern. But the lack of travel restrictions also made Yugoslavia a starting point for those who were trying to leave Hungary illegally. It wasn't uncommon to see the secret police on trains in the area or in the streets. They tended to be square-headed men with serious faces, eyes watching everything carefully.

Still, things had changed since my childhood. While the Party was still in charge, by now Hungary was experiencing what would come to be known as "goulash communism"— a little more liberal, a bit more relaxed than in the old days. Even if some of our peers might be informants for the secret police, their espionage wasn't likely to end with arrests or termination, like in the old days. These days, the Party was more likely to cancel a speaker or musician who was coming to campus than they were to give the students themselves a hard time.

Maybe they'd insist on shuttering a student organization. Perhaps, if you wanted to go abroad someday, they could keep you from getting a passport. It wasn't complete freedom, but nor was it living in fear. Hungary was, people used to joke in those days, "the happiest barrack in the communist camp." Judging by my classmates, this was true. While my Hungarian classmates joked together, often making veiled references to politics or ideologies, my Vietnamese classmates kept their mouths shut. As close as we all were, I never once saw them breathe a word that might get them in trouble.

I DIDN'T FEEL SMART. Not here. Back in Kisújszállás, I'd begun my education as a relatively ordinary student. I'd succeeded by outworking everyone else, eventually feeling as capable as anyone. Now, at university, it was the same story. The other students in my program seemed to learn things so much more easily than I did. Again, I had to work for everything I got.

We took classes in evolutionary biology, organic chemistry, analytical chemistry, physical chemistry, physics, and mathematics. Some of us—those of us who hadn't been exposed to English, which is to say most of us from small towns—took English classes, too. I'd had zero exposure to English, and I'll be honest: I suffered through those courses. After the third year of university courses, I spent a whole summer learning English; I passed my exams, but the language would never feel natural to me. For the rest of my life, even after decades in America, I would speak with a thick Hungarian accent. I'd use the past tense incorrectly ("he didn't

jumped" instead of "he didn't jump"). Sometimes when I talked, I would see native English speakers—even colleagues who had known me for a long time—squint at me, their tell-tale looks of confusion signs that they did not understand what I was saying.

I struggled with other things. I had no experience in a chemistry lab, for example. Other students, who had taken chemistry lab in high school, moved efficiently around the room, setting up test tubes and glassware (beakers, pipettes, and burettes) as if it were second nature. They pulled solutions into droppers effortlessly, knew without asking how to calibrate a scale. I was clumsy. I had no muscle memory for this work, no intuition at first. And the work we were doing was sometimes hard.

In analytical chemistry lab, for example, the professor would hand us mystery solutions—an ampulla of clear liquid, say, with no other information. It was up to us to figure out what the solution was made of, using a series of individual tests. We'd each work through the challenge logically, one step at a time. We'd drop the substance onto a flame; if colors flared orange, that meant it had sodium. (To this day, when I cook at a gas burner, I cannot resist dropping a bit of salt onto the flame to watch the color change.) If it turned blue, on the other hand, it meant the solution contained copper. These challenges were easy at first, but they grew increasingly complex. We might work for three hours before we could deduce the chemical composition of the solution in our hands. Sometimes I failed to figure it out entirely. In those moments, especially at first, I felt out of place. I'd try to remind myself then: Was this not precisely what Hans Selye had described, asking

yes-or-no questions of the universe? (Is the solution acidic? Litmus paper turns red, so yes. Did it turn blue? Then no.)

Was this not, in fact, the work of Columbo?

Just one more thing. That's how I got better: just one more question, one more test, one more thing I might think of, one more task to which I could apply myself. I could read, reread, then start over. I could memorize, test myself on what I had just learned, then study some more, just to be sure. Again and again and again: just one more thing.

If I have any superpower, it has always been this: a willingness to work hard and methodically, and refuse to stop.

We had a lot of homework, and I did every bit of it. It felt so difficult to retain all this information, as if filling my brain with new information might squeeze out things I had previously learned. I was often up until two in the morning. I'd sleep for just three or four hours before waking to do a bit more homework before classes. If I grew tired, I opened a window. The truth is, I was always tired, so the window was always open, even when it was snowing. (I still do this now, even in winter, to keep myself awake.)

Each morning, I'd cross the bridge toward my classes, traffic whizzing past me as I walked. Although I had a bicycle at first, it was soon stolen. I didn't get another. In the cafeteria, I ate whatever was served. The dorm had a kitchen where other students cooked meals, but I never did. I wasn't fussy. The food was fine. And, anyway, who had time to cook?

NOT EVERYONE APPROACHED SCHOOL as I did. Most, I think, managed to be a bit more relaxed about their work. A

small handful of my classmates packed the bulk of their study-
ing into the last few weeks of the semester. They'd cram for
final exams, absorbing like sponges hundreds of pages of ma-
terial at the last minute. Then they'd take their exam and head
to the bar for a celebratory beer. Whether they retained the
material or not beyond the exam, I cannot say. I know only
that this approach would not, could not, have worked for me.

Others, like my friend László Szabados, were more eclectic
in their approach to learning. These students wanted to dive
into everything—not merely science but also literature and
jazz music and folk traditions. László's father worked for the
railroad, so he could travel everywhere, which he did, often
sleeping in railway stations to keep his adventures affordable.
He'd come home with stories and his signature grin, his head
full of new ideas, then get back to work on his classes.

Me? All I could see was how much more there still was to
know. And if there was more to learn, I had to try. I couldn't
not try.

I WASN'T ENTIRELY SINGLE-MINDED, though. Discos were
becoming popular, and sometimes on weekends I went with
my friends to let off steam, dancing late into the night.

Sometimes I went to hear music. There was an interesting
trend in those days; young people were rediscovering folk
music from the countryside. Some artists were traveling
around Hungary, learning music and dance traditions from
villagers, then bringing these traditions to cities and university
towns. The university had a folk dancing group, and I can re-

member attending their events and watching my classmates whoop and dance in the old ways.

I also played basketball. Sometimes when I tell people this—*I played basketball in university*—it sounds impressive. It was not. The team was tiny and not especially competitive. At times we barely managed to field enough players for a game. Still, we played hard, running back and forth between baskets, passing the ball and getting sweaty, our shoes squeaking on the gym floor.

During these games, or walking home after, or even hours later, as I sat by the open window struggling to keep my eyes open, it would hit me: *I was so lucky*. I felt so fortunate just to be here.

Do not believe that hard work and happiness are in opposition. Do not believe that one must embrace leisure to know joy. These years in Szeged were among the happiest of my life.

HARVESTING HADN'T ENDED WHEN I went to university. This was still communist Hungary, after all, and there was work to be done. With all Szeged's sunshine, it's an ideal environment for growing grapes. And who better to harvest grapes in autumn than students who are just starting a new academic year and perhaps could use a break from their studies?

Every university group helped with the harvest. As in high school, some students worked with more enthusiasm than others. I remember one day, early in my university career. It was raining and cold. Being outside felt miserable. Everyone seemed to be grumbling, moving slowly. So the agricultural

cooperative for whom we were working issued a challenge: Whichever group harvested the most would get a small amount of money.

Some of my biology classmates shrugged at this. Not me. I'd recently been appointed youth leader for our group, and I had big plans for us. But these plans needed money, which this competition could give us. I called our group together. "Can we *please* take this more seriously?" I pleaded. I looked around. My friend Zsuzsa looked past me, squinting skeptically at the nickel-dark sky. "Look," I reasoned, "we have to be out here in the cold and the rain no matter what, right? So why not get something from it?" I explained that the money we earned could fund field trips, including visits to one another's homes. Wouldn't that be fun? To travel from home to home, getting to know where each of us came from?

I looked again at Zsuzsa. This time she met my eye, a smile forming on her lips.

We worked, and we won. And so began our field trips.

Perhaps you can picture us: a dozen or so university students, in blue jeans and with long hair, escaping the university for a weekend, moving as a massive, jabbering group. We'd step off the train together, laughing and joking and marching en masse toward someone's home.

It was so interesting to see people's different lives. Although Hungary in those days did not have wealth disparities nearly as wide as many places have today, there were differences. During the summer, we visited a classmate's home along pristine Lake Balaton. Her father was a financial officer for a local organization, and they had a two-story house. I'd literally never known anyone with a two-story home! It was so

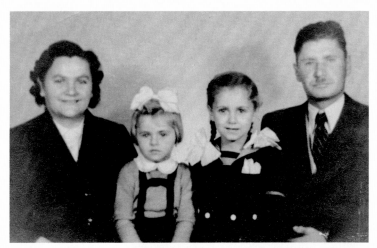

A family portrait (left to right): my mother, Jánosné Karikó, a book-keeper; me; my sister, Zsuzsanna Karikó; and my father, János Karikó, a butcher. Kisújszállás, Hungary, August 1957.

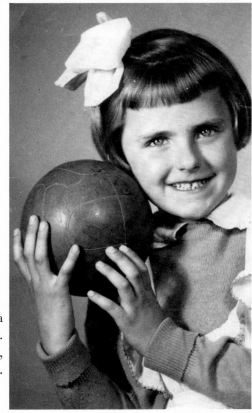

Me as a kindergartener. Kisújszállás, 1960.

Biology summer camp for seventh-graders, winners of the local biology competition (I am in the first row, third from right). Csillebérc, Hungary, 1968.

At age twenty, a biology student at the University of Szeged (then called JATE). Szeged, Hungary, 1975.

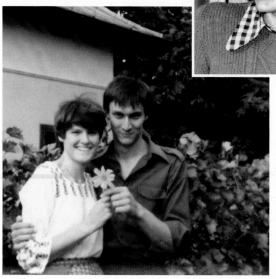

With my future husband, Béla Francia, when we were dating. Kisújszállás, 1979.

With my parents in the yard of our family home. Kisújszállás, 1979.

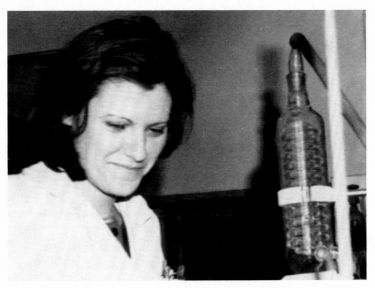

In the chemistry laboratory at the Biological Research Center of the Hungarian Academy of Sciences. Szeged, 1980.

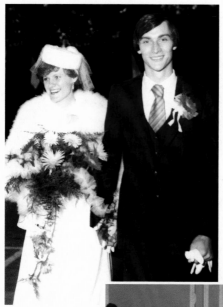

Béla Francia and me on our wedding day. Szeged, 1980.

Receiving my PhD diploma at the University of Szeged. Szeged, 1983.

My daughter, Zsuzsi, with the famous teddy bear she received from my mom for her first birthday. Szeged, 1984.

Celebration of
Zsuzsi's second
birthday.
Kisújszállás, 1984.

With our first car,
a Ford Pinto, a month
after arriving in
the United States.
Philadelphia,
Pennsylvania, 1985.

At my bench in the
Suhadolnik lab at the
biochemistry department
of Temple University.
Philadelphia, 1985.

At the tissue culture hood in the lab at the pathology department of Uniformed Services University of the Health Sciences. Bethesda, Maryland, 1989.

The lab bench in the neurosurgery department of the University of Pennsylvania School of Medicine, where I worked for seventeen years synthesizing mRNA. Philadelphia, 2005.

Working with Dr. Drew Weissman, with whom I established non-immunogenic, nucleoside-modified mRNA technology. Philadelphia, 2015.

My laboratory at the neurosurgery department of the University of Pennsylvania shortly before my eviction. Philadelphia, 2013.

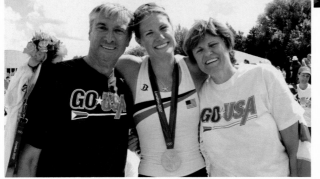

Béla Francia and I celebrating our daughter, Susan, winning a gold medal in rowing at the Olympics. London, UK, 2012.

With Dr. Uğur Şahin, co-founder and CEO of BioNTech, on the day we met. A few months later, I joined the company. Mainz, Germany, 2013.

With Penn vaccinologist Dr. Norber Pardi (left) and BioNTech cardiologist Dr. Gábor Tamás Szabó (right) at the International mRNA Health Conference. Berlin, Germany, 2019.

Standing next to a mural of me stating THE FUTURE IS WRITTEN BY HUNGARIANS. Budapest, Hungary, 2021.

At the reception of the Princess Asturias Award Ceremony: me; King Felipe of Spain; my daughter, Susan; her husband, Ryan; and my husband, Béla. Oviedo, Spain, 2021.

With neurosurgeon Dr. David Langer (left) and cardiologist Dr. Elliot Barnathan (right), early supporters of my work with mRNA, at the reception for my honorary doctorate degree from the Rockefeller University. New York, New York, 2022.

odd, though. Her parents, who had so much more than anyone
I'd ever met, didn't allow us to sleep inside their house; they
asked us to sleep in the garage instead. Nor did they cook for
us. Instead, we walked to the store and pooled our money to
buy our own food: bread and lard, mostly.

The next day, we traveled to a different classmate's home.
This family, by contrast, had very little—far less than my own
family. And yet this family was the picture of hospitality. They
prepared a massive stew in the yard, using pigs feet (the cheap-
est possible meat), laboring over it until it was rich with herbs
and spice. They served us generously. The food was delicious,
hearty and filling, warm in our bellies. This family had just
one room, which they gave over to us entirely, spending the
night in a relative's house, so that we students might sleep
comfortably.

I took note of this generosity, filing it away as something
new I'd learned about the world: that sometimes those with
the least share the most.

We couldn't visit everyone's home, of course. Huong, a
classmate from Vietnam, went instead to the home of a class-
mate who'd grown up in Szeged. There she cooked a huge
Vietnamese meal for all of us. I loved the food, and I espe-
cially enjoyed Huong's genuine excitement to share this cui-
sine with us.

I was thrilled when it was time to visit my home. We
chattered and cackled during the entire train ride to Kisújszál-
lás, then we walked from the train station to my parents' home.
It was autumn. My parents greeted us outside—my father
with his booming laugh, my mother shaking her head with an
amused, tolerant smile.

Inside, my classmates sprawled out on the floor, listening to music and laughing endlessly. My parents were so happy to get to know my classmates, to finally put faces to the names they'd heard so often. My father talked with everyone, asking question upon question. *And where are you from, and tell me about your family, and what do you want to do when you finish school?* Meanwhile, my mother bustled about the kitchen. For breakfast, she made a thirty-egg omelet using eggs collected from the hens that we chased around the yard. For dinner, my father made mutton stew, and my mom served us her goose-foot cake, and my friends ate every bite. (One of my classmates asked my mom for the cake recipe and she has baked it for Christmas, following my mother's instructions, every year since.) We walked into town, and I showed my friends my high school, including the little biology museum.

I was so glad to connect these two different worlds—the people I'd always known and the people I was certain now I'd always know.

Here are my friends, I kept saying to everyone we ran into. I could have said it forever: *Here are my fellow students who are also studying biology. The world is so big, and there is so much to learn, and we are the ones who get to learn it. We come from all over. We had nothing in common a short time ago, but now look at us. Now we are a team.*

ANOTHER HARVEST, IN ANOTHER vineyard. By now, it was fall of my fifth year at the university. September 1977. This time, the day was warm and bright. The fields glowed golden green.

The girls picked the grapes into buckets, and the guys carried large wooden containers, called *puttony,* on their backs like enormous backpacks. When our buckets were full, we called the guys and poured our grapes into the *puttony*. When those were also full, they emptied the grapes into a large trailer.

The sun warmed our skin as we worked. Professors picked by our sides, occasionally joining in the conversation. Nothing about the day felt like a distraction from what we'd come to study; it felt, yet again, like we were a team, working toward a common goal.

One man, noting that my bucket was almost full, approached me with the *puttony*. He introduced himself. His name was János Ludwig, he said, and he was a chemistry student. Then, with an almost startling intensity, he asked me what I thought about the Voyager missions, about the fact that *Voyager 2* would travel for four years before reaching Saturn.

I confessed that I had never heard about any of this.

He frowned, then explained: Two spacecraft, *Voyager 1* and *Voyager 2,* had recently left Earth on a tour through the solar system. They would fly past planets we'd never seen up close. *Voyager 2* would reach Jupiter in two years, Saturn in four, before heading to Uranus (nine years) and Neptune (twelve years)! Eventually—some forty years after launch—they would reach interstellar space and keep going.

All I could think about was those numbers: *Two years . . . four . . . twelve . . . forty.* What would my life be at each of those stages? I couldn't begin to imagine.

"You are going to be a scientist," János said, interrupting

my thoughts. "You should know about things fellow scientists are doing and have something to say."

János Ludwig would later become my colleague. And this first interaction with him summed him up well. János was blunt. Direct. He didn't care for small talk or for social graces. Here was a man who never once tried to be nice. He was placed on this earth, instead, to contribute knowledge. And this meant challenging fellow scientists—which included keeping me on my toes.

After that first encounter in the vineyard, I went to the library and looked up everything I could about the Voyager program. And this is why I loved János: Right from the start, he pushed me. He made me learn more than I would have otherwise. He made me better. I would know him for the rest of my life.

But first, I'd have to finish university.

ALL THAT HARD WORK paid off. I got the best marks in my first two years, and by my third year, I was recommended for the Study Award of the Hungarian People's Republic, the most prestigious merit award a student could get. The award carried tangible benefits, too. It allowed me to live for free in the dormitory and to receive a small stipend. My professors sent to the ministry the list of students they'd recommended for this award—fifteen names in total. And there, on the list, was my name: Katalin Karikó, biology student.

It was so strange, though: When the list came back from the ministry, there were only fourteen names. My name wasn't among them.

This was no error: Someone had actively removed it.

Well, that's odd, I thought.

Or maybe not so odd. I was, after all, the daughter of someone who in 1957 had been accused of crimes against the Communist Party. Apparently, my father's arrest reverberated still, a decade and a half later.

I'm not sure if the university held any discussions about the removal of my name. I don't know if someone stood up for me, or if so, who. All I know is that the removal of my name had no practical effect on my life. I received the award anyway. The only tangible impact of the ministry's omission would come more than four decades later, when my name had become known across the world. The university did some digging about my past, and they noticed a discrepancy in some of the paperwork. Everyone, including me, had claimed that I was a recipient of the Study Award of the Hungarian People's Republic. Yet no one could corroborate that. My name was nowhere on the official government paperwork.

"Did you really win that award?" reporters would ask. They'd ask it several times, just to be sure. Was I confused? Might I be lying?

Yes, I did win it. Even if the Party refused to acknowledge it at the time.

BEFORE MY FIFTH AND final year at university, I got a summer job at the Fisheries Research Institute, a research center in Szarvas.

Szarvas is a placid community on the banks of a lake that stems from the Körös River. My job was to analyze the lipid

content—the fat composition—of the farmed fish. We were trying to understand whether fish fed with corn would have unsaturated fatty acids.

The work had practical implications. We all know that some fats are healthier than others. With apologies to my father and butchers everywhere, the fats in a cut of pork or beef—saturated fats—aren't nearly as healthy as fats from most plants. A good rule of thumb for determining the relative healthfulness of a particular fat is this: *The lower the temperature at which a fat goes from liquid to solid, the healthier that fat is.* Bacon fat, for example, is completely solid at room temperature. Not so healthy. Olive oil, by contrast, is liquid at room temperature. It solidifies only when refrigerated, so therefore it is healthier than bacon fat.

But some oils, such as sesame and fish oils, remain liquid even when refrigerated. Not surprisingly, the healthiest fish oils of all, the ones that solidify at the lowest temperatures, are derived from fish native to the cold northern seas. Identifying exactly how different fatty acids formed, and how temperature might affect the healthfulness of fish, had big implications for aquaculture.

The day I arrived on the job, though, my supervisor left for vacation. I'd be alone in the lab for the next two weeks. So there I was, in a strange city, with a job that apparently couldn't be done. I decided I'd get started anyway.

I knew that one of my jobs was to isolate lipids from the fish and analyze them using a technique called thin-layer chromatography. But to do this, I needed solvents, one of them called ethyl acetate. I left the room where I was working and

found a colleague who looked like she knew what she was doing.

"Excuse me," I said. "Where do you keep the ethyl acetate?"

The woman shook her head. "Sorry, we don't actually have any ethyl acetate."

No ethyl acetate. Well, that would certainly make my job a challenge. I began paging through books, searching for instructions for making ethyl acetate from scratch. It took a while, but I eventually found a recipe. I'd need ethanol, sulfuric acid, and glacial acetic acid (this acid is like a superconcentrated vinegar, so acidic it can burn the skin).

I returned to the colleague. "Since you don't have any ethyl acetate, might you have some ethanol, sulfuric acid, and glacial acetic acid?" I asked.

She eyed me for a moment, then scratched her head. "Well," she said slowly, "we don't carry glacial acetic acid. But maybe the folks over in the Rice Research Institute have some?"

Great. I'd walk over there to ask. I just needed directions.

"It's a bit of a hike," she added skeptically. Finally, she sighed. "Perhaps you'd prefer to bike over there?" She gave me a bike, and off I went. I returned about a half hour later with a bag containing a single bottle of glacial acetic acid.

I found distillation glassware and got to work. It took a day, but I made that ethyl acetate. Which meant—at last— I could start to do my job.

I could have made an excuse. I could have made a whole series of excuses:

My supervisor is not here.

I don't have the solution I need to work on my own.

I don't know how to make that solution.

Even if I knew how to make that solution, I don't have the ingredients.

Actually, no one in the fishery has those ingredients.

But you find an excuse only if you don't want to accomplish something. If you genuinely want to do it, you find a way. You sit down, get to work, learn how to transform what you have into what you need. Me, I wanted to find a way.

I DID ANOTHER STUDY in Szarvas, analyzing how tiny insects generate unsaturated lipids in response to decreasing temperatures. This work would form the basis of my first-ever scientific publication. Although it would be years before the paper was officially published (in the June 1981 issue of *Lipids*), it meant something to me.

It's hard to explain to a nonscientist what it means to be published in a scientific journal. It's easy to talk about how important publishing is to one's career, of course; "publish or perish," the saying goes, and it's not inaccurate. Science, like so many things, is hierarchical. People who publish their findings in scientific journals tend to get more prestige in that hierarchy. If their publications get many citations from other scientists, all the better. The more publications and citations a scientist has, the more access she has to promotions, to grants, to awards, and to spots on the lecture circuit. That part is easy to explain and understand.

But it's more than that.

Science, at its core, is about contributing to human knowledge: to making discoveries that describe the world as it is. In biology, we are trying to understand life—what is happening in cells across the diversity of organisms. Every new finding contributes not only an answer . . . but also brand-new questions, ones that no one even thought to ask. Science is like a puzzle of infinite shape and scale, pieced together by many people across the globe. You, working on a tiny part of that puzzle, might spend years searching for a particular piece that you can snap into place. When at last you find it (*Aha, it fits!*), you don't merely complete a section of the puzzle, you also open new ways for the puzzle to grow.

Also, by definition, scientific journals include rigorous peer review: During the review process, other scientists scrutinize your work. They cross-check your findings. They actively look for flaws, things that you may have missed.

Imagine your own work being held up to the light, audited by multiple people, the best in your field, with the goal of finding every possible mistake. It's nerve-racking, but it's critically important. Peer review is the best way we have to distinguish fact from myth, to minimize the very human inclination toward motivated reasoning (to see what we *want* to see) and confirmation bias (to see what we *expect* to see).

Being published in a scientific journal is a way of confirming that you've done everything in your power to be intellectually honest. That you're doing science right.

So it mattered to me, that first publication. It matters to me still.

———

THAT SUMMER I SPENT in Szarvas was fun, and not merely because of the work I was doing.

During the academic year, Szarvas had two schools. First was the agricultural university. The student population there was mostly men. But there was also a college for kindergarten teachers, which comprised mostly women. During the summer, though, the kindergarten teachers—the women—went home.

I was housed in a dormitory with about two hundred men. One of them was a former classmate who'd left the biology program at Szeged. He welcomed me into the fold as if I were one of the guys. Everywhere I went that summer—everywhere!—I was surrounded by men, often many at a time. When I went to the movies, I might be the only woman among twenty men. When I went to the disco, I'd go with a different set of twenty men. When I went canoeing or for a walk, there I'd be, with yet another set of men.

These men were so *handsome,* too.

In my biological program, people had started pairing off. My friend Zsuzsa, by now, had already gotten married to her high school boyfriend. Me, I'd never had a boyfriend, never even been asked out on a date! I was a tall, skinny girl with a short haircut, blunt and practical. Now here I was, the belle of Szarvas. While I dated none of these men, I enjoyed being with all of them. The truth is, I'd never had so much attention from guys in my whole life!

And, as it turned out, my first date wasn't so far away.

———

EVERY YEAR IN DECEMBER, our biology program organized a holiday gathering. It was always a giant party. Alumni returned, students performed skits, and everyone poked gentle fun at professors. People toasted, cheered, ate, danced, and celebrated the completion of yet another semester of grinding work.

In December 1977, the party was held in the cafeteria of a textile factory on the far side of the city. It was a massive space, big enough to also hold a disco that came alive after our event. At this disco, I noticed a handsome guy. He was lean, with an angular face. He had a loose, physical energy about him. He was also tall—several inches taller than I was, which was a rarity. We glanced at each other, then both looked away. When I snuck another peek, his eyes met mine. That's when he approached me. "Want to dance?" he asked. His eyes flashed with something bright. Humor, maybe. I smiled, almost despite myself.

We walked together to the dance floor. The music was far too loud to talk beyond an exchange of names—his was Béla. But he was a good dancer, at once smooth and silly, and I was having fun out there. When the dance floor grew stuffy, we took a break, stepping out into the relative quiet of the hallway.

"How about a Coke?" Béla asked. I remember that: He offered Coke, not a beer. His forehead was damp from sweat. He grinned at me. He was one of those people who seemed to grin with their whole body. When I nodded, he said, "Don't go away."

The bar was in front of us, but that's not where Béla went. Instead, he returned to the room with the dancing. When he emerged, he carried a bunch of empty bottles. In Hungary, then, empty bottles could be exchanged for cash (there was still little waste, even then). I watched Béla carry the bottles to the bar and trade them for a Coke, which he brought back to me.

That's how I knew: This guy didn't have a penny.

Béla and I talked for a while. He told me he lived in Szeged. He'd come from Kistelek, but he was now in school here. "The university?" I asked.

"No." He named a school where some of my classmates tutored. It was a technical high school that prepared students for vocational careers.

A *high school*. By now, I was twenty-two years old, nearly a biologist. "How old are you?" I asked, incredulous.

He was seventeen. He and some friends had snuck out of their dorm, promising half a bottle of wine to the guard, who was supposed to report them for such infractions.

Still, I liked his smile, and I liked that he made me laugh, and anyway, wasn't this just a random guy I met at the end of the night who'd offered me a soda? I drank my Coke. We kept talking. We danced some more, and we laughed beneath the disco ball and swirling lights, and before we knew it, the disco was closing. When he offered to walk me back to my dormitory, I said sure. Why not? It was just a walk home, after all. It didn't have to mean anything.

It was about five kilometers back to the dorm, which means the walk took us close to an hour. It was winter, and cold, and even with my coat and gloves, I had to rub my hands together to keep my fingers from going numb. Béla, having snuck

out of his high school dorm, wasn't dressed nearly warmly enough, though it didn't seem to bother him.

He told me about his high school—it was a public boarding school, with about two hundred boys and only four girls. He shook his head. "You can see why we had to sneak out," he said. "That ratio is all wrong!" He talked about leaving home at age fourteen to attend this school and what he might do when he graduated. He was learning how to work on machinery to make metal tools. He could do metalwork, edging. He was good at the work, he said—great, in fact. He'd finish in the spring and would go straight to work.

There was something about this Béla. He was relaxed and a little self-deprecating, and he made me feel at ease. He was also curious; he asked me so many questions about myself— where I was from, what I was studying, what I liked about biology, and what I had learned—and he seemed genuinely interested in my responses. Beneath our feet, the river smelled rich and alive.

Near the end of the bridge, a poster advertised a film playing nearby. Béla gestured toward it. "You know," he said, "I hear that movie's really good." He looked again at the poster, then met my eye. One side of his mouth curled up. "Maybe you and I should go see it sometime."

I laughed, certain that this would never happen.

It was two in the morning before we finally reached my dorm. I turned to face Béla and thanked him for walking me home. I meant it, too: To get back to his dorm, he would have to walk back over the bridge, past and beyond the disco. It would be hours before he could sleep.

"So we'll see that movie?" he asked.

I said then what I believed to be true: "I'm never going to see you again."

In the morning, I was back at work.

The following week, I was studying in my room when a friend knocked on my door. "There's . . . uh . . . someone downstairs to see you." She paused. "A guy."

I went downstairs, and there he was: that seventeen-year-old kid who'd walked me home from the disco. "We should go see that movie soon," Béla said.

Maybe if I hadn't been so surprised to see him, I'd have said no. Instead, I had a date.

ON THE NIGHT OF our date, I waited for a long time in front of the movie theater. Béla was so late I was certain I'd been stood up. When he finally did show, he apologized and made a ridiculous excuse—"I had a nosebleed," he said.

I nodded, tolerated the lie, and went to the movies anyway. After the film, we stepped out into the street. Béla ran his long fingers through his short hair. "So . . . you want to get something to eat?" he asked. The restaurant next door wasn't fancy, but the food smelled terrific. And I was hungry by now—very hungry, actually.

The food was delicious: deep-fried crepes, stuffed with meat. The crepes were savory, juicy, and hearty, and Béla made me laugh as I ate. He told me more about his family. His father was a carpenter who loved to build furniture, but sometimes did other things: worked construction, cut beams for buildings. His father could make or repair anything at all: sewing machines, car engines, you name it.

"And you?" I asked. "Can you do these things, too?"

He leaned back in his chair. What a confident smile he had. "Of course."

His family had a bit of land in southern Hungary. He'd worked in the fields, as I had. They had beehives, and sometimes he traveled around the region, tending to the bees. As a young boy, he'd sold fruits and vegetables at the market.

We had a lot in common, in fact.

Then, abruptly, at the end of our meal, Béla stood. He announced that he had to go to the bathroom and disappeared. I finished my meal. He didn't return. I waited some more, but there was still no sign of him. After a while, I began to shift in my seat, wondering if this time I really *had* been stood up. I paid the bill and waited a little longer, then finally gave up.

I was on my way out the door when a stranger came over. "Are you Kati?" the man asked. "Your date is in the bathroom. His nose is bleeding. It's pretty bad; I actually thought someone had hurt the guy."

I burst out laughing. It was true, then, the excuse Béla had made when he showed up at the movie so late. He wasn't some flake, and he wasn't standing me up now. He was a well-intentioned guy who sometimes got nosebleeds.

We walked home again; this time, he tilted his head toward the sky, pressing a stranger's handkerchief to his nostrils.

BÉLA AND I SPENT New Year's together. Then in January, he came to my birthday party. He even brought a gift: a necklace with tiny beads. It was inexpensive, but colorful and cheerful, and it made me happy.

Before long, he joined our circle of biologists, fitting in better than you might expect a technical high school student would. He even began accompanying us on our home visits. I noticed that while he was very funny and got along well with people, he was quieter in groups, a little shy. I liked this.

My friends liked Béla, too, and they sometimes even helped him out with his homework.

Okay, I'll confess: Sometimes when he and I went out on a date, my friends completed his homework *for* him.

Again and again in the months that followed, Béla bribed the guard and walked over to meet me at my dormitory, carrying with him the key to get inside the gate of his dorm. The key unlocked a massive wooden door, a hundred years old; the key was huge and metal, like something from a medieval castle.

I liked him, and I liked these visits. Still, he was a distraction, and I needed to work. So I tried breaking up with him—several times. But Béla refused to be broken up with; he kept coming back.

In the spring, at Easter, he visited my family in Kisújszállás. My sister was there and both of my parents, and as we all waited for his arrival, my stomach knotted in anticipation. When Béla finally arrived, he carried a big bouquet of flowers, which he promptly handed to my mother. Suddenly, I couldn't bear another moment. I turned on my heel and left the house, catching only a glimpse of Béla's panicked confusion before I disappeared.

I sat outside, hearing the murmurs of awkward greetings— I could make out none of their words, but I could tell when the

conversation began to flow a little more freely. Only then did I return.

"What was that?" Béla whispered when we had a moment alone.

"I was too nervous," I said.

But it turns out I needn't have been. Béla was charming—friendly and open, and interested in everything about them. He and my father both loved to joke, and before long the two of them were laughing nonstop. One day into the visit, my mother pulled me aside. "You know," she said, "I would *love* to have a son like Béla."

A promising start, but there was more.

"But he is not a fit for you." She said Béla and I were too different. I was too academic for him, too old. It would never work. That's what she said: *It will never work.*

She was saying the very same thing I myself had told Béla on several occasions. *This will never work.* But there is something about me. When someone insists that something must be one way, I often feel compelled to do the opposite.

I did not argue with my mother. But I looked over at Béla and thought, *This might work.*

IT'S HARD TO DESCRIBE just how dramatically, and how rapidly, genetic science was advancing in those years. I still remember my final year at university, when a professor gave a series of lectures about the biochemistry of nucleic acids. One week, he explained to us that DNA and its corresponding mRNA had a direct, linear relationship—that for every base

in the gene, there would be a corresponding base in mRNA. This was the scientific consensus, as it had been for years.

The following week, he stood before us and told us that scientists had just learned something remarkable: This one-to-one relationship doesn't exist! Many human genes are interrupted with sequences of DNA, called introns, which aren't in the final mRNA. This discovery upended our entire understanding of the genome.

This was a revolutionary moment in the history of biology. Soon, I'd get to be part of it, too.

I GOT A FELLOWSHIP from the Hungarian Academy of Sciences. For two years, I could go anywhere the academy had a research institute. I knew exactly where I wanted to be: the Biological Research Center (BRC), right down the road in Szeged. I began working there before I even finished my university studies.

The BRC was the place to be—not only in Hungary but in all of Eastern Europe. The BRC had been founded just a few years before, with $1.2 million in UNESCO–United Nations Development Programme (UNDP) funding. This had allowed the BRC to launch with equipment and facilities that met the highest standards even of Western labs. Top scientists from across the globe served as scientific advisers. The UNESCO-UNDP funding also allowed Hungarian researchers to make visits abroad, bringing knowledge back home. The BRC was a melting pot of the best scientific ideas, from Hungary and beyond.

My first job there was in a lipid lab, where I worked under

the direction of Tibor Farkas, the biochemist who'd sent me to the Fisheries Research Institute. Our team had projects with other scientists, too. For me, the most important collaboration was with Éva Kondorosi and Ernő Duda. Tibor, Éva, and Ernő were wonderful scientists—brilliant, meticulous, humble, eager to teach, and unbelievably easy to work with. In this way, they were the embodiment of the BRC, which was known for being forward-thinking not only scientifically but culturally.

The Hungarian language, like Romance languages, has both a formal and an informal *you*. In nearly every setting, a Hungarian speaker adjusts the form she uses according to her interlocutor. We use the informal *you* (*te*) with close friends or with children. With older people, teachers, professors, and bosses, we use the formal *you* (*ön* or *maga*). At the BRC, though, everyone used the informal *you*. This wasn't a mere difference of language; it reflected a seismic shift in the nature of relationships.

At the BRC, we were scientists, every one of us. Whether or not we'd completed our PhDs, whether we had decades of experience or were just getting started, we were all contributing to the world's body of knowledge. Every one of us was to be taken seriously.

Soon after starting, I told Tibor that my father had been a butcher. He flashed a bright, friendly smile. "Oh! I wanted to be a butcher when I was young!"

I knew immediately that I liked it here.

In the project with Éva and Ernő, we were trying to develop *liposomes,* tiny sacs made from the same material as a cell membrane.

The cell membrane is the outer boundary of a cell, the structure that separates that cell from the rest of the world. It's not an impermeable barrier; if it were, then nutrients, energy, and signals from other cells could never enter. Nor would cellular waste, hormones, and signals ever exit. But getting past that membrane isn't easy.

The membrane is a bit like the wall surrounding a medieval fortress: You may be able to get in and out, but first you must get past a series of guards (in this case, proteins called receptors); even then, you might need an official (a transport protein) to escort you all the way inside.

In our lipid lab, we wanted to develop liposomes that could carry genetic material *from outside the cell* past the membrane. This would allow us to introduce foreign DNA into a cell, something that would be useful in genetic therapy and could potentially save lives. Not only would these liposomes deliver critical therapies into the cells, they would also protect those medicines from enzymes that would otherwise degrade them.

This was science on the cutting edge—liposomes had only been created in 1965.

But to make liposomes, we needed something called *phospholipids,* a naturally occurring class of lipids. These were commercially available in some parts of the world, but not behind the Iron Curtain.

Ernő came up with a solution: He visited a nearby slaughterhouse and asked them for a cow brain. Then he carried the brain back to the lab and set it on the counter. Its folds glistened beneath the bright lights. We spent a week extracting the phospholipids we needed, using organic solvents such as acetone, alcohol, chloroform, and ether.

This is just how things were done then. You couldn't purchase something? You made it yourself, even if that meant carrying brains from a slaughterhouse.

Once we finally were able to make our liposomes, we filled each with a tiny snippet of plasmid DNA—a small, circular, double-stranded DNA from the cytoplasm of a bacterium—and delivered those to mammalian cells. We did this work in vitro, in a cell culture, rather than in a living mammal.

Once the liposomes were inserted, we waited to see what happened. Would the DNA actually enter the cell? Would it make it all the way to the nucleus? If so, would it be transcribed and translated? Would that cell then begin producing the proteins for which that DNA coded?

To our surprise and delight, it worked. The liposomes bound to the surfaces of cultured cells, which allowed the DNA to enter. The DNA went all the way to the nuclei of those cells, where it was transcribed. After transcription, the mRNA *left* the nuclei to be translated into the encoded proteins. For a few days after, we could see that our mammalian cells were *actually expressing these foreign genes*.

This was absolutely remarkable.

EVEN THOUGH I HAD not yet graduated from university, I'd already reached the point where I could no longer effectively explain to my parents the work that I was doing. They had no sense of cellular biology or of biochemistry. They knew nothing of cell membranes or cytoplasm or plasmids or phospholipids. They had no frame of reference for genes that could be transcribed into RNA, then translated into proteins.

The truth is, these days, it is difficult for most people—even those with solid science educations—to truly understand the medicines upon which they increasingly depend. How many diabetics understand that the insulin that keeps them alive is likely made by inserting a human gene into that of a bacterium? How many leukemia patients know that a cornerstone of their therapy is based on nucleoside analogues, which stop the replication of rapidly dividing cancer cells?

Our world is so complex. There's more here than any one person will ever be able to understand. And it is always fascinating to see how people respond when the complexity moves beyond their understanding. Sometimes, people get angry. I have seen so many people get furious simply because they don't understand something. In these cases, they treat the complexity itself like some nefarious plot. (This anger, of course, is protective. It protects them from the fear that comes from uncertainty.)

My parents, though, chose a different response. My father, after following as much as he could, patted me on the arm. "Kati," he said, "you are a *kutató*." *You are a searcher*. He laughed. "Up until now, you have been searching my pockets for money. But now—now you search for other important things."

Kutató. He meant that I was searching for answers, for things that were not yet known. He meant I was searching for truth, or as much of it as one human can find in a lifetime. He was saying that for me, *the search itself was the point*. He wasn't wrong. In basic research, which is what I have spent most of my life doing, you are, by definition, doing something that's never been done before. There's no model to follow. This

means that most of the time you don't know what exactly you are searching for or how you're going to find it, or even *whether* you will find it, or how it may someday be applied. Still, you search.

You are a searcher. Even today, the phrase makes me smile. Sometimes, I guess, a person doesn't have to grasp every detail to understand the part that matters most.

When my father learned that my boss, Tibor—this outstanding researcher, a member of the Hungarian Academy of Sciences—had once wanted to be a butcher, he was ecstatic. So for my graduation from the university, he made smoked sausages, which our lipid research team cooked in the lab. We placed these sausages in hot water inside a four-liter beaker, then cooked them using Bunsen burners. The air filled with thick, fragrant swirls. When the sausages were ready, we carried them into our office, where we ate happily. When we bit into the sausages, juice squirted everywhere, just as it was supposed to. The juices stained our lab coats and dripped onto the floor. The meat was delicious—perfect, really. It tasted like home. Even decades later, the members of the lipid team would recall eating those juicy sausages cooked in the beaker.

AFTER I GRADUATED, I moved from the dormitory into an apartment with a classmate. My roommate, Anna, was quiet, and like me she worked constantly, which means we rarely saw each other. This suited us both fine.

Béla finished high school; I met his family for the first time at his graduation. If they had opinions about this older biologist who was dating their son, they kept those opinions to

themselves. He moved back home, to Kistelek, about thirty kilometers from Szeged. He took a job at a factory in Szeged, manufacturing telephone cables. He worked three shifts. Sometimes he came to visit me, and I always had a nice time with him.

But he was busy, and I was busy. That also suited me fine.

TO GET MY PHD, I'd need to continue working in a lab for a few more years. Tibor Farkas introduced me to an organic chemist who ran the Biological Research Center's nucleotide chemistry laboratory. Jenő Tomasz had come to the BRC from a pharmaceutical company. His lab had a graduate student whom I happened to know: János Ludwig, the intense, abrupt student who'd challenged me about Voyager flights that long-ago day in a vineyard. *You are going to be a scientist. You should know about things fellow scientists are doing and have something to say.*

Together, we would be researching something called the *interferon system.*

Your cells have some pretty ingenious ways of defending against viral infections. Some of these defenses make themselves obvious—a fever, for example. Other responses are more obscure. For example, when your cells detect double-stranded RNA, which is associated with viral infections, they release a class of proteins called interferons.

Interferons, discovered in 1957, have many functions. But they're named for their ability to "interfere" with viral replication. In 1978, as I entered this organic chemistry RNA lab, the molecular mechanism of interferons was just starting to

come together. One of the big discoveries had come from a London researcher named Ian Kerr. He'd figured out that a very short molecule called 2'-5' oligoadenylate (we'll call it by its nickname: 2-5A) was responsible for the antiviral effect of interferon.

It happens like this: When a cell recognizes that viral RNA has invaded, it "turns on" a system that converts ATP (a molecule that carries energy to your cell) into an extremely short molecule of RNA, just three or four bases long. This short molecule is 2-5A. Once made, 2-5A binds to an enzyme called RNase L, which degrades viral RNA, giving interferon its antiviral effect.

It's just one little system, invisible and obscure. But like everything that happens in the cell, it's remarkable—incredibly complex, dazzlingly precise, and somehow also totally ordinary. It happens every time your body fights off a cold or the flu or any other viral illness.

Now, imagine if someone could make 2-5A in a lab. Imagine if someone could deliver 2-5A to the cells—with a liposome, say. This could be a powerful antiviral.

An RNA that can be used as medicine. The idea was so exciting to me.

BY THIS POINT, SCIENTISTS were beginning to manufacture simple RNA molecules in the lab. And because 2-5A is shorter than most RNA molecules, it seemed that we had a real chance of making it. With the advances being made on liposomes, we might actually succeed in getting the molecule into cells.

Before now—before this very moment, in the late 1970s—

none of this work could have been done. Not anywhere. By anyone. People wouldn't have had the know-how or the materials. Now, for the first time, we did.

But we needed a couple of things first.

For one, we needed funding. Using his industry connections, Jenő reached out to a Hungarian pharmaceutical company, Reanal, to see if it could support our research. It was thrilled at the idea—a potential new antiviral! That was a medicine the world could use! They agreed to fund our work in the lab.

Of course, *that* was something else we needed: an actual lab, one that was well enough equipped to bring our vision to life. Because my colleagues were organic chemists, not biologists, it was up to me to figure out how to set up our antiviral screening lab from scratch. What a challenge this was!

Today, products can be ordered. These days, getting a pure, ready-to-use culture medium—one with the precise biochemical properties necessary to run your experiments—is as easy as picking up the phone or going online. A person can order it all: endless variations of RNA-modifying reagents, buffers, incubators, radioactive materials, a sterile hood, whatever you need.

There are also experts you can turn to. Today labs are set up in conjunction with lab planners, facilities managers, engineers, architects. There's an entire industry of consultants who specialize in turnkey lab setup solutions. There are checklists, equipment-to-staff ratios, formal training programs, and endless other resources.

None of that existed for me in 1978. I had to figure it out on my own.

I started by visiting different departments within the BRC, one at a time. I asked for guidance from anyone who might be willing to help me. I watched other biologists do their experiments. I took notes. I made lists. I asked question upon question and didn't stop, even when people made it clear they needed a break from the questions. I learned what it took to equip a tissue-culture room, how to make culture media, and the best way to establish sterile filtration systems. I learned about subtle differences in glassware and in cleaning techniques. I learned how to set up a sterile hood that would protect our experiments. I learned how to set up assays, procedures by which we could measure whether and how well the 2-5A might inhibit viral replication.

This was a remarkable opportunity for a graduate student. Learning from scratch also gave me a window into the entire field of biology—who was working on what, and how, and what big questions they were trying to answer. For example, I went to one laboratory in the genetics department to learn how they cultured cells. And it turned out that in this lab they were using something called a *Giemsa stain* to see the chromosomes inside the cell. This was something I had never seen! I also returned to the lipid lab, where I'd worked with Éva and Ernő. They were doing some experiments on how to freeze and thaw cells without forming ice crystals that would otherwise destroy their structural integrity.

Meanwhile, I was reading nonstop.

As I write these words, I've read nearly nine thousand scientific articles that seemed to me worth tracking (I've read plenty more that I didn't care to track). When I read a scientific paper, I usually read everything—not merely the abstract

or the conclusions but also the background, the experimental methods, every figure and table. I read the references, too, often using them as jumping-off points for new papers I want to read. My life has been journal after journal, day after day, week after week, year after year, decade after decade. All of this reading began for me at the BRC.

I also learned from others informally. There were about one hundred PhDs at the BRC, and many more who, like me, were working toward their doctoral degrees. Some of us took English classes together before each workday started. I often asked people in these classes about their research. Then at lunchtime, I'd sit with different researchers and try to get a sense of what they could teach me. I, in turn, answered their questions. No one was territorial; knowledge was communal. We were all eager to share what we knew. We batted ideas around together, we talked about papers we'd read. It was *science, science, science, science,* nothing but science.

Everything felt essential to me. Everything felt relevant. Even if it wasn't *yet* relevant, it might be someday. I didn't want to miss a thing.

Because this would be a viral laboratory, I also learned everything I could about viruses. That year, a Nobel Prize–winning biologist named David Baltimore and his colleagues published a landmark textbook about viruses. It was written in English, and I devoured it cover to cover.

VIRUSES ARE FASCINATING—UNIMAGINABLY SMALL and deceptively simple, capable of wreaking havoc on organisms millions of times their own size.

They're *tiny*. There's not much to them, either. A virus is a strip of genetic material (typically a single strand of RNA, though there are also DNA viruses and double-stranded RNA viruses) surrounded by a protective coating. Proteins on their surfaces have evolved to connect with receptors present on cells inside the host. This is generally how a virus begins to enter a host cell.

And enter a cell it must.

Outside a living cell, a virus is dormant. Inert. It can't do anything, including replicate. But once a virus enters a host cell, it's a different ball game. Once inside, the virus hijacks the cell's machinery, repurposing that cell into a virus factory. The cell stops doing what it's supposed to do; instead, it produces copy upon copy of the virus's genetic material, as well as new viral proteins. These, in turn, are assembled into entirely new viruses. Eventually, the host cell is so filled with new viruses that it bursts. This not only kills *that* cell but also releases all these new viruses into the environment; these, in turn, infect new cells.

It continues like that, exponentially, until something stops the cycle.

Reading David Baltimore's book, I was rapt. Viruses seemed so stealthy, so *industrious*. They demonstrated a genius that seemed far beyond what any human brain could ever figure out.

And yet we humans were fighting back. Just one year before Baltimore's book was published, humanity had successfully vanquished a virus for the first time in history. Smallpox was an ancient virus, contagious, brutal, and deadly. It killed 30 percent of those infected; in the twentieth century alone,

smallpox killed somewhere between 300 million and 500 million people. When I was just a toddler, the World Health Organization announced a major worldwide campaign to eradicate this virus. Throughout my childhood and adolescence, the whole world worked together on mass vaccination efforts.

The campaign had worked. For here I was, still a young woman just starting my career, and the last case of smallpox had already been recorded; within two years, the WHO would declare the planet a smallpox-free zone. This was an almost inconceivable feat, one that allowed humans everywhere, in all parts of the world, to breathe a collective sigh of relief.

I wasn't working on a viral vaccine, of course—that would come later. But if we could develop this antiviral therapy, it would be another important tool in humanity's fight against viruses.

We had a working lab that I'd helped establish from scratch. We had a problem to solve: Turn 2-5A, an RNA, into a medicine. We even had the funding we needed to do it.

I never, ever wanted to leave this place.

SOON AFTER BEGINNING WORK, I was home alone in the evening when I heard a knock on my door. When I opened it, two men I didn't recognize were standing there. They were on the young side, not much older than me. Serious faces. Sharp suits. It was their suits that gave them away. The only people who dressed like that were the secret police.

The secret police are at my door, I thought, a little stunned.

The agency they worked for wasn't officially the same one

that encouraged neighbors to spy on neighbors during my childhood, but it wasn't so different, either. Seeing them here, on my doorstep, was confusing and frankly surreal.

One of the men was of average build and totally silent. The second, heavier set and taller than me, did all the talking.

"Katalin," he began. *So he knows my name.* "We need your help." This guy seemed well educated. He was well-spoken and smooth, and he sounded like he was trying to be casual. Maybe even friendly. Still, I could hear something lurking beneath his forced nonchalance, something I did not trust. Everything in me went on high alert.

"As an employee of the BRC," he said, "you work with scientists from many different countries around the world. It's possible some of them could be . . . *foreign agents.* If they are, they might try to steal discoveries made by our own Hungarian researchers." He then named a few of my colleagues. *He knows where I work,* I thought. *He knows the names of the people I work with.*

"We need to watch out," the man continued. "We must prevent theft. Protect our values. If you help us, we'll help you." Although he didn't say it, I understood: He was talking about counterintelligence efforts. He was suggesting I spy on my colleagues. "On the other hand," he mused (again, so casually, as if he were saying the most ordinary thing in the world), "if you decide *not* to help, we can make your life *very* difficult."

There was a beat before he said the next thing, a dramatic pause that ensured I paid attention to every word that came next. "I traveled to Kisújszállás recently," he said. "I met your father in the pub." I pictured my father back home. Sitting in

the pub, innocently talking to this guy. Perhaps he assumed that this man was just a friendly visitor stopping by for a drink.

"Your father is very proud of you," the guy said. "Now, imagine if someone were to tell him that your success—your career—had ended. Especially if it ended because of *his* sin against our country. He'd be so sad, don't you think?"

My mind raced, putting together the pieces of all this man wasn't saying directly. He was suggesting that if I didn't help them, if I didn't agree to be one of their spies, I might be fired from my job. Worse, he was saying that if that were to happen, they would tell my father it was his fault.

The truth is, I wasn't convinced that they could keep me from working at the BRC. After all, it was 1978. Things were different than they'd been when I was young, I was almost sure of that.

But was I certain?

And even if all they did was tell my father that my job was in jeopardy because of him, my father would believe them. He would believe he'd ruined his daughter's opportunity to succeed. This would devastate him. My father was so proud of me. He'd always been so proud. Everything he had done, all these years, he'd done so his family could have a better life.

So I said to this tall, menacing man the only thing I could in this situation: "Okay."

I knew better than to argue with them. "Okay," I repeated. But even as I said it, I already knew that I would give them nothing. I would never write one note reporting anyone, never place a single call. And I never did. Not once.

Were there consequences of my inaction? The truth is I don't know. During my seven years of employment at the

BRC, even after I earned a PhD, I was never promoted from a research associate position. Eventually, I would be terminated due to lack of funds. But of course I can't say with any certainty that I would have been promoted if I'd actually become an active counterintelligence asset. It could easily have been that I wasn't productive enough, or that my research wasn't stellar.

Looking back, I wonder if that is the most insidious part of a society that asks its people to turn against one another, to report one another to the state—not so much what *does* happen, but rather the way we are left wondering about whether and how much the events of our own life were influenced by forces just out of sight.

WHEN I WAS WELL into my 2-5A/interferon research at the BRC, I got sick again. It all came back, all those symptoms from my youth: the fevers, the headaches, the loss of appetite. Everything hurt: my knees, my back, my wrists, my fingers. And I was weak. I was so very weak.

The doctors' best guess was that I had tuberculosis. A few years later, I would be told that this was a misdiagnosis, that I never, in fact, had TB. And certainly, my symptoms were inconsistent with that infection. I had no cough, no chest pain, no bloody sputum emerging from my lungs. My X-rays were clear. Still, for months I walked back and forth to an infectious disease clinic for TB treatments. Nearly everyone there did have TB, or some sort of sexually transmitted disease. Many coughed. Others had terrible sores. Still others were wasting away. At this clinic, the doctors gave me medicine that did not

work. When I didn't improve, they gave me even stronger medicine, which made me feel even sicker.

Months passed like this.

I was listless, and it was difficult to work. I took medical leave, but I did not improve.

One morning, I was walking home from the clinic. The sun was bright, and it hurt my eyes. Every step was painful. I wanted to sleep, or at least to lie down in bed and do nothing at all. I felt like a toy that had been drained of batteries. Something hit me then: a feeling, a *knowing*. I don't know how to describe it other than to say that it wasn't there, and then it was: this overwhelming sense of urgency flooding me.

I cannot let this happen, I thought. *I cannot stop working. I cannot settle for less.*

No one, I suddenly understood, was waiting for the work I hadn't yet done. Sure, if I stopped working altogether, my colleagues at the Biological Research Center would notice my absence. Then they'd hire someone else and go right on with their work. I could see, too, that there was a path even more insidious than my dropping out of the workforce. In this path, I simply lowered the bar for myself. It would happen gradually—a little at a time, and always for some reason. Those reasons would be real: illness, like the one I was suffering from now, or family obligations (supporting a spouse, caring for a child, looking after aging parents), or any of the other countless obstacles life might eventually throw into my path.

Each of those obstacles would always be more tangible than contributions I hadn't yet made. Obstacles have shape and structure; you can *see* them. One's future impact, by contrast, re-

mains invisible, hypothetical, at least until the future finally arrives.

Nobody would ever knock on my door and say, "Kati, this world needs the research you haven't done, the discoveries you haven't yet made." My contributions, at this point, didn't exist. That's the thing about potential: It always begins as nothing. And if that empty space was ever to be filled in, if it was ever to become *something,* it would be up to me.

I returned to work, and from that moment forward, I kept my pace up. No matter how sick I felt, I kept going. I never allowed myself to back off.

WHEN I FINALLY STARTED feeling better, Béla and I traveled to Poland and to Bulgaria. We traveled well together. We balanced each other. He still could make me laugh like no one else.

Sometimes we discussed the future. I'd told him many times that I would never stop working. Not to accommodate his schedule or anyone else's. Work would be my priority. And always, he said the same thing: *I understand.*

We returned to Szeged from our travels, and he said this again: "I understand." By now, it was August 1980. We'd been together for nearly three years. I was beginning to think perhaps he did understand.

"I mean it, Kati," Béla said. "Your work comes first. It's okay." I let this sink in. *My work comes first. It's okay.*

"Well," I finally said. I sat up a little taller and met his eye. "In that case, I think we should get married."

In Hungary, one receives a simple gold ring at engagement. But we couldn't get gold easily, and it would have been too expensive, anyway. So Béla, working at the cable factory, made copper rings for us, and we celebrated with an engagement ceremony at my parents' house.

My mother, though, still wasn't convinced. She took me aside and said, "Béla is a good man, but you, Kati, have your own mind. You are too strong. That's why I do not think this relationship will last."

Not to mention, she added, there was that whole age difference. "Right now, you and Béla look similar. But when you are forty-five years old, things will change. A forty-five-year-old woman is an old woman, while a forty-year-old man is a young man."

I thought for a moment about how to respond. Finally, I took a deep breath. "In that case, Mom, I guess Béla and I will have to divorce when I'm forty-five."

I couldn't rent a wedding dress; I was too tall. So I bought some white fabric, and a woman in the neighborhood in Szeged sewed my dress, the simplest pattern I could find. I rented a hat and a short white fur coat (it was October, and cold).

On our wedding day, Béla showed up in a three-piece suit with a bouquet of flowers. We walked together to the Szeged city hall. Our marriage ceremony was witnessed by his family, my family, and some of my colleagues. My mother's sister signed the marriage certificate, then we drove to a restaurant named Kék Csillag (Blue Star).

My father had insisted that he process the meat for the reception. While this had the advantage of reducing the cost of the wedding, it was also a chance for my father to express his

wishes for us in the truest way he knew how: with the fruits of his labor. He'd processed and prepared meat and delivered it to the restaurant that morning. They cooked and served it beautifully, and it was, as always, delicious.

I picture the scene now, almost like a snapshot: my father standing proudly, wearing a smile as wide as Lake Balaton, holding up a bowl in which the finest mutton was piled high. In this offering was everything he had to give: his expertise, his time, his history, his struggle, his care and attention and love.

What I wouldn't give today for just one whiff of my father's meat.

A traditional Hungarian Gypsy band played, and we danced and sang. People drank wine and beer, and we laughed, we talked, and we danced some more. The party may have been small and simple, but it went on late into the night, and I was happy.

In Hungary, the wife usually takes the full name of her husband, plus two letters (*né*) added to the first name, meaning "the wife of." And that is what people call you for the rest of your life. They don't even know your actual name.

I didn't want that. I liked my name, and I saw no reason to change it. So I told Béla that I'd take *his* name on one condition: He had to take *my* name. In the end, we both remained happily exactly who we'd been before the ceremony.

When the celebration ended, we walked home, just the two of us, at about two o'clock in the morning, just as we had the first night we'd met. We were still Katalin Karikó and Béla Francia, just as we had been then. But things had changed. Now we were husband and wife.

I was never a baby person. When my friends or classmates were around children, I observed the way they leaned in close and cooed, using a strange, high-pitched voice they'd never otherwise use. I also noticed that mothers began speaking about themselves in the third person—*Are you looking at Mommy? That's right, smile for Mommy!*—as if being a mother and an independent human, with a name and an identity distinct from the child, were somehow exclusive. I'd watch these women and then look at the tiny human who would require years of all-in caretaking, and I'd think, *Well, that's a big problem right there.*

Babies demanded so much. They took so much time. They could do exactly nothing for themselves. I didn't feel any pull toward these small, clinging creatures.

And yet on November 8, 1982—mere weeks after successfully defending my dissertation and earning my PhD—I found myself in a hospital, legs apart, pushing out a baby of my own. The day was a paid national holiday in Hungary. I was so happy to be giving birth on a paid holiday. It felt as if this new baby and I were off to a highly practical start.

The birth went along as many births do—painful but without any reason for alarm. (Béla was doing compulsory military service, so he missed most of this.) When the baby's head finally emerged, the doctor exclaimed, "It's a beautiful boy!" Then, a few minutes later, when the rest of the baby slipped out, the doctor corrected himself. "Not a boy! A beautiful girl! You have a beautiful, healthy girl!"

As the nurses washed her, I asked the doctor why he said it was a boy based on the head alone. "Why, the head was so

big," he said. "When I see a head that big, I just assume it belongs to a boy!"

The doctor placed the baby on a swaddling pillow I'd brought. I looked down at her then, really took her in: this wrinkled creature with her delicate eyelids, her tiny nose, those ten perfect fingers.

Susan. My Zsuzsi.

I lifted her hand, and I shook it. "Hello, Susan," I said. I did not use the high-pitched voice, wouldn't have known how to speak that way if I tried. It was, instead, as if I were meeting a colleague for the first time. "I am your mother. I am so very pleased to meet you." In response, Susan opened her mouth and howled.

THERE'S SO MUCH YOU can't predict on the day of your child's birth. I couldn't have predicted how smart Susan would be, how spirited and driven. I wouldn't have been able to guess how loudly and how passionately I'd cheer during her middle and high school sports games or the way these athletic events would give way to competitions in larger arenas, with far higher stakes. Nor did I know that Susan would, in turn, become one of my own biggest supporters, cheering me on when I won my own awards.

But I knew this: The child on the pillow in front of me, the one whose face turned red as a *pirospaprika* as I shook her hand and introduced myself, had in a few short moments transformed me completely.

Forget what I'd said about other people's babies. This new

creature wasn't any sort of problem—quite the opposite, in fact. She was love itself, the point of it all.

The swaddling pillow Susan lay on was the same one on which I had been placed at birth. My mother, too, had lain on this pillow on the day she was born, and my grandmother before her when she was a newborn. The pillow was hand-sewn with immaculate stitching, edged in eyelet and lace.

If ever Susan were to have a child, I was determined that she, too, would place *her* infant on this pillow. To ensure this happened, I'd carry this pillow with me for nearly three decades, from one home to the next, then all the way across an ocean. With each move, I'd pack it up carefully so that a fifth generation, and even beyond, might greet the world from this same pillow—a few moments of continuity and comfort, even in a world of unimaginable change.

Susan would, indeed, give birth someday. But on that day, this pillow would remain boxed in the attic, forgotten amid the chaos and confusion of a once-in-a-century worldwide pandemic—itself an event that none of us could have predicted or imagined.

I WAS AT HOME nursing Susan when I got a knock at the door. It had been a few weeks at this point. I was sleepless, and the world had become a blur.

Standing on the other side of the door was my colleague János Ludwig. "Katalin," he said, in his characteristically brusque manner. He didn't even glance at Susan. "What are you still doing at home? It's time to get back to the lab."

I started to tell him I was still nursing, that childbirth re-
quires time to recover. He held up his hand to stop me. "Your
experiments cannot wait, Katalin. You must come back now."

He moved to leave, then he turned around. The expression
on his face was the same one he'd worn that day I first met
him, standing in the sunshine at a vineyard on the outskirts of
Szeged: It was exasperation and impatience, and perhaps a
touch of something more—some expectation that maybe, as
long as I took myself seriously, if I paid attention and didn't
allow myself to get distracted, I could really be somebody.

"There is work to be done in the lab," János finally said.
"And here you are, feeding this baby."

Susan was born in November. By February, she was in a
day-care center.

In communist Hungary, you could enroll your child in
a nursery for a nominal fee. The day-care centers were big,
loving, and staffed by professionals. Many of the employees
were registered nurses. Every day, a pediatrician came by
to check on the children. Each child had a book—a record
of their health and development. If you had questions for
the pediatrician—*Is this normal? Does her rash require special
care?*—you could jot down these questions in this book.

The pediatrician read parents' questions daily, examined
the child, took time to respond carefully: *Yes, this is normal.
Yes, the rash is improving, but keep using the diaper cream for a
little while longer.*

As babies became toddlers, the attention continued. When
Susan first began climbing, for example, she stopped bending
one of her knees. The medical staff identified a muscle injury

in her thigh and recommended physical therapy, which she got (it helped, and the injury seemed not to hurt her long-term athletic prospects).

At these day-care centers, you never had to worry about whether your kid had a spare set of clothing or enough diapers. Cloth diapers were abundant and free, and the nursery provided tiny, soft uniforms, ensuring that the kids always had clean, comfortable clothes that fit well. You could drop off breast milk for your child as long as you were nursing. Then, as she grew, the nursery provided healthy food and age-appropriate meals. Every day after lunch, the staff bundled all the children in warm attire and blankets, took them outside, and let them sleep in the brisk air. This is a European thing: to let babies and children nap outdoors in all seasons, even during winter.

Picture the scene if you can: forty kids, all lined up in their little beds, slumbering peacefully as snow falls around them, like characters straight out of a fairy tale. I was always taught that these outdoor naps made children healthier and stronger. I don't know if any studies have ever been done on that, but I do know this: When Susan got to elementary school, she never missed one day due to sickness.

Sometimes today people ask me what it takes for a woman to be a mother and a successful scientist. The answer is simple, obvious: One needs high-quality and affordable childcare, as I had in Hungary.

Unfortunately, when great childcare isn't available or affordable, it is usually the mother who sacrifices herself. The truth is, I have rarely, in all my years in U.S. academia, found

families like ours—families in which the husband is the primary caretaker so that the woman can be a researcher.

Sure, you can find families where both parents work high-level jobs. But there's a catch: That family, the one with two working parents, must already have money. If they don't have some existing source of wealth? No. You won't find it. It doesn't work.

If we want more women in science, if we want more women in anything, this is something we must address. The sooner the better. An affordable system of quality childcare is an investment for a nation, and it is one, I think, that comes back a millionfold.

OUR RESEARCH AT THE Biological Research Center was exciting, and it advanced well. We could synthesize 2-5A, that short RNA molecule that held such promise as an antiviral, and we could deliver it into cultured cells using liposomes. But there were some challenges.

RNA is famously difficult to work with in the lab. To be useful in research, you must be able to keep your RNA samples intact. But that's not so simple. Most molecular biology methods start with a plasmid, the small, double-stranded, circular DNA isolated from a bacterium. During plasmid isolation you must first get rid of the bacterial RNA. To do this, you use special enzymes, called RNases, whose entire purpose is breaking down RNA. But, of course, you won't want those RNases to break down *your* RNA!

It gets trickier. RNases are everywhere. People naturally

have RNases on their skin, in their blood, and in their digestive systems. RNases are also present in sweat and mucus. So it takes almost nothing for surfaces and lab equipment to become contaminated with these enzymes.

Labs are contaminated. Lab *workers* are contaminated. Clothing and equipment and water are also contaminated. Laboratory samples and reagents (special fluids that are used in experiments) can be contaminated with RNases.

Even a tiny amount of RNase will destroy your entire RNA sample. The things that kill bacteria and viruses in a lab—hitting them with pressurized steam, or even boiling—don't work on RNases. Even if you manage to inactivate the RNases with heat, they often renature as they cool! There's an old joke among RNA researchers: If you want to decontaminate your laboratory of these enzymes, you'll have to demolish the building.

There are things you can do, of course—keep your samples on ice, use special filter tips on your pipettes, wear gloves, reserve a portion of your lab bench as a dedicated RNase-free zone. You can touch nothing while you work, and you can sterilize, sterilize, sterilize to keep away as many contaminants as possible.

Even then, it's tough going.

But let's say you do manage to keep your RNA sample free from RNases. That's when you face another problem: RNA, by its very nature, degrades easily. Remember that RNA, unlike DNA, is temporary. While DNA is meant to last forever, stable and unchanging, RNA is built to serve a purpose, then disappear. Its instability is *the whole point*.

While this is great for cellular efficiency, it sure creates a problem for RNA researchers.

Impossible, many of my fellow scientists said. For a long time, they told me this: RNA is a big problem. You cannot work with it. This was the conventional wisdom, the going assumption: At best, RNA just wasn't worth the trouble.

But I never bought that story. I can't say why, but I was never intimidated by RNA. On some level, I think I *understood* it. I was certain that if you could handle RNA in just the right way—if you broke your work down into minute steps and were fastidious about each one—you could work with RNA.

The problem, in other words, didn't lie with RNA. It lay with us, the researchers.

LAB WORK CAN BE so painstaking. Science is slow and repetitive, even when you aren't working with RNA. Sure, my work at the Biological Research Center was my dream job—We were pursuing a new antiviral compound. Our work might someday change the world!—but that doesn't mean that every moment was dreamy.

I measured. I poured. I stirred. I heated and cooled and waited and watched. I prepared samples and mixed reagents and organized the freezer and washed endless quantities of laboratory glassware. And when I say that cleaning was endless, I mean it just never, ever stopped. To be perfectly honest, some days the work of scientific breakthrough didn't feel that different from what my mother had done all those years in our family kitchen.

We lab workers did what we could to make it interesting. In those days we used glass test tubes, for example, and we marked each with a specific number before placing it into the

sample collector. Later, when the experiment was over, we washed those same tubes because we reused them (and, oh, we washed thousands and thousands of tubes!). Most of the time I washed the tubes with János. To pass the time, we played a guessing game: "Is the test tube I'm washing odd or even? Odd or even?"

A tedious and boring game, I suppose—a random guess that was either correct or incorrect, again and again. But it was less tedious than the alternative, which was to do all this scrubbing with no game at all. And, anyway, the game kept us laughing.

And for all the grunt work, I liked the lab. I felt in control there.

The work, for me, was happiness. I was happy.

But soon, Reanal Pharmaceuticals began to wonder where its miracle antiviral compound was.

Just one more thing, as Columbo would say. I tried one more thing, and when that thing didn't get us closer to a functional antiviral, I did even one more thing. My permanent position was shifted to a temporary one. I kept at it. One more thing turned into a thousand more things, and always the results were the same: We were able to create antiviral effects from our 2-5A, but not in a way that would be suitable for use in human medicine.

AND THEN, OUT OF the blue, came a phone call.

July 1984. The day of my mother's retirement from her job as a bookkeeper, the same job she'd had my whole life. A celebratory day. There was to be a big party. My father had done

what he always did when there was a celebration: He prepared freshly smoked sausages ready for boiling in water.

Maybe it was all the excitement or the stress of trying to get everything ready. But my father, after preparing all the food for the party, dropped to the ground in front of our house.

A heart attack, instantly fatal.

What do you say about the long night that is grief? About the empty space, that infinite void, that appears where just moments before had been laughter and so much love? About the way your heart searches, and searches still more, for the familiar and finds only absence? Absence now, absence forever.

What is there to say about the rupture this causes in your life?

No. There are no words. The months that followed were dark and difficult. I missed him. I miss him still. Through the worst of it, I did what I always did: I kept working.

Six months after my father died, I turned thirty. On my birthday, I made plans to meet Béla and friends at a local restaurant, called the New Hungária.

January 17, 1985. I woke early. Béla and Susan and I had just moved into a new apartment. We had a washing machine and a terrific tenth-floor view. That morning, I watched Béla rock Susan and give her a playful piggyback ride. I kissed Susan goodbye and left the house for what I expected would be an ordinary day of experiments. By then, we had a car, a Russian make called Lada. But I still took a bus to work each day, using my commute to think about my experiments, about what I might be missing and what I might try next.

It's funny what we remember and what we don't. I can remember, for example, the bus ride to the Biological Research

Center that morning. The day was cold—there was a deep freeze across Eastern Europe, subzero temperatures—and the air was crisp and clear. I remember crossing the frozen river. And of course I remember what happened when I arrived at the lab. But for the life of me, I can no longer remember who delivered the news. It was probably Jenő, but I have no memory of the moment it happened. All I remember is how I felt—as if the floor were dropping out from beneath me.

Reanal Pharmaceuticals had pulled its support. It was giving up on our work. The funding for my job—mine specifically—would run out by July 1.

Naturally I had a moment of wondering, *Why me?* My mind started cycling through arguments: I was good. I worked hard. I was the person who had set up this lab in the first place. I'd done it well, too. This was *unfair*.

But I allowed myself only a moment for such thoughts. As soon as I recognized that this was what I was thinking, I recalled the lessons I'd taken from Hans Selye, in *The Stress of Life*, the book I'd loved so much as a high school student: *Do not blame. Focus on what you can control. Transform bad stress into good stress*. That's when I turned my attention instead to what was in my power: I had to apply for a new job. All my energy and concentration needed to be on the next chapter. What was I going to do?

Okay. Think. You need a job, Kati. You need one fast. There were a few European labs where my experience working with 2-5A might be needed. One was in London, with Ian Kerr, who'd discovered 2-5A. Another was in Madrid, with Luis Carrasco, who studied how viruses interfere with cell func-

tioning. The third was in Montpellier, France, with Bernard Lebleu, who studied how interferons work.

Did I want to leave Hungary? Szeged? My sister? My mother, who'd been so recently widowed? No. I never wanted to leave. But I *did* want to work.

I frantically began writing to these researchers. They were interested, but there was one catch: I had to bring the money to support my position. "Just apply for a scholarship grant," they said. As if it were so simple. As if everything behind the Iron Curtain were like things were in the West. "Get yourself a stipend from a scientific foundation, and you'll be welcome here." Impossible. In Hungary, we weren't allowed to apply for such things.

There was another place I could apply, too. I wasn't so sure about it, to be honest, but what else could I do?

One night while putting Susan to bed, I told Béla we needed to talk. I took a deep breath and said, "I think we have to go to America."

PART

FOUR

—

An Outsider
Inside the System

Decades later, it would be the teddy bear that would resonate most. When, surreally, my face stared out from the pages of *The New York Times* and *The Washington Post* and *The Guardian* and *Glamour* and *Time* magazine, that one detail would appear in every story: the stuffed bear Susan carried with her on the day we left Hungary for the United States.

Sometimes in these articles there were even photos of the toy: an ordinary golden-brown bear with glass button eyes, its red fabric mouth caught in a forever smile. A simple thing, its worn velveteen fur revealing just one secret: A child has loved it beyond measure. There is no sign at all that this bear might once have harbored other secrets.

Susan's arm was curled around her teddy bear as she slept in the back seat of my sister Zsóka's car. We were in Budapest, still in Hungary, but not for much longer. We were heading to the airport. The hour was early. Béla, Zsóka, and I were quiet as we drove. The sun was behind us, not yet above the horizon. In front of us lay a life I couldn't yet imagine.

It was July, a year to the day since my father had died.

In the back seat, Susan, not yet three years old, stirred. She lifted her head, rubbed her eyes, then looked out the window. She gasped and asked, "Is this America?" Susan knew what was happening: Her mother had a new job. We were flying

across an ocean. Budapest to Brussels to New York, then finally to the city that would be our new home: Philadelphia. Not only would today be Susan's first flight, it would also be Béla's.

In the car, I turned around to look at her. Susan's eyes were so bright, so eager to believe she was glimpsing a new continent. She was, instead, looking at the bus depot on Hamzsabégi Street in Buda. From that day on, every time we passed by this bus depot during our visits to Hungary, we asked, "Is this America?"

Susan's arm was still curled around her bear when we finally did arrive in America, in New York, at John F. Kennedy International Airport. We were now just a short flight from our new city of Philadelphia. Unfortunately, a huge storm had been raging up and down the East Coast. Our plane was delayed, then delayed again. My body, now sitting in the third airport of the day, could no longer tell what time it was. In Hungary, people would soon be waking up.

Rain lashed the airport windows. I longed to close my eyes, just for a minute or two, but I didn't. I kept my eyes on Susan, her head in Béla's lap, her arm curled around her precious bear. Behind Susan and Béla, an endless stream of travelers passed. They glanced down at their boarding passes. They looked at their wristwatches. They double-checked the departures and arrivals boards. They weaved in and out of one another, then disappeared into the crowd.

NATURE IS A BRILLIANT biochemist. It is constantly reshuffling genetic material—moving, substituting, splicing, recom-

bining. It makes tweaks. It mixes things up. Each new life-form, every individual organism, is, in its own way, a tiny experiment.

Sometimes these experiments yield great benefits—such as the ability to fight viral infections naturally. For example, that work I'd been doing with 2-5A? I'd been working with something called *cordycepin*, a molecule derived from a genus of fungus called *Cordyceps*. This fungus, found in the mountains of Asia, infects the brains of insects, growing out of their heads like a rogue horn. For millennia, *Cordyceps* was an important part of traditional medicine. (Today, you can purchase *Cordyceps* supplements as an immune support and energy booster. Whether these supplements accomplish what their manufacturers claim, I cannot say, as dietary supplements are regulated as food and are evaluated only for safety, not efficacy.)

Cordycepin is a nucleoside with the same base (adenine) as adenosine. In fact, the only difference between cordycepin and adenosine is a slight alteration in the structure of their sugar.

By the mid-1980s, scientists had identified many such naturally occurring modifications—a missing hydroxyl here, an extra methyl group there—then isolated these molecules in the laboratory and tested them for potential medical therapies. This led to a class of drugs known as *nucleoside analogues*. These drugs made a profound difference to people's health. For example, AZT, the first drug that proved effective against HIV, was a nucleoside analogue. Deoxycoformycin (also known as pentostatin), a therapy for multiple leukemias, is a nucleoside analogue isolated from the *Streptomyces* bacteria.

You can't talk about nucleoside analogues very long without hearing the name Robert Suhadolnik. Dr. Suhadolnik was an American biochemist who wrote the book—literally—on nucleosides and nucleoside analogues. In 1985, the year I moved to America, he ran a lab in the biochemistry department of Temple University in Philadelphia. He wanted to generate 2-5A using cordycepin. I had published a paper that proved I could perform assays important to this work.

After I was let go from the Biological Research Center, I'd written to Dr. Suhadolnik. I sent him the paper that showed I could do the assay he needed to measure the effectiveness of 2-5A molecules. He promptly offered me a job: an annual salary of $17,000 to work as a postdoc in his lab for one year. With his help, and the sponsorship of Temple University, I got a J1 visa, which allows foreigners to come to America to learn specialty or practical training, especially in research and medicine.

I figured I would work for a year, learn, then return to Hungary permanently. Things turned out very differently.

WE SOLD OUR CAR for 900 British pounds, the equivalent of roughly $1,200. At that time, Hungarians were not allowed to take more than $50 in foreign currency out of the country, as this was a sign a person might be defecting. Yet in America we would need every dollar we could get. That's why I kept my eye on Susan's teddy bear. Back in Szeged, I'd carefully unstitched the seams at the back of the bear, placed all 900 British pounds in the center of the bear's stuffing, then sewed the whole thing up again.

It was everything we had, protected only by plush fabric and a few inches of stuffing.

Now, as we waited in New York for a flight that seemed never to arrive, Susan sighed, pulled the animal a little closer to her, then snuggled a little closer to Béla. I know she cherished that bear. But she had no idea how valuable it really was.

DR. SUHADOLNIK WOULD MEET us at the airport in Philadelphia. He'd arranged an apartment for us, and he'd drive us there when we landed. I asked in a letter how I'd recognize him, and he gave me a general description. "Oh, I've got blond hair and glasses. And I'm about six feet."

Because Hungary used the metric system, I had to convert *six feet* into centimeters. Otherwise I wouldn't have known if I was looking for someone short or tall.

As promised, Dr. Suhadolnik was waiting for us in the airport when, mercifully, we finally arrived. He was sixty years old, though he looked much younger. He was cheerful and welcoming and seemed very kind. (And six feet tall, it turned out, was just about exactly my own height.) He shook Béla's hand heartily and hugged us. He was especially sweet with Susan. He bent down and asked her about the flights, shook her bear's fuzzy hand. He made her smile—no small feat, given how exhausted we all were.

I liked him. I was pretty sure of that.

In his car, we moved north through the night. We snaked along the I-76 expressway. Red brake lights blinked on and off in the cars in front of us. We whizzed past highway signs—glow-in-the-dark lettering on bright green backgrounds,

which pointed us toward geographies and locales I'd never heard of. Crossing the still darkness of the Schuylkill River, I noted a row of small houses along the water. Their contours were illuminated by tiny lights that were reflected in the surface of the water. They looked like a fairy-tale village, out of place in this big American city.

Dr. Suhadolnik saw me looking at them. "Boathouse Row," he explained. "It's where crew teams—rowers—keep their boats. Lots of rowers in Philadelphia." Rowing. I'd heard of that; we had rowers in Hungary, though I'd never myself known anyone who'd done it. Who had a boat?

We exited the highway. We passed shopping centers and churches and banks. The storm that had kept us trapped in New York City had passed through Philadelphia, too: Fallen branches and felled trees lay everywhere. I watched it all, trying to remember every unfamiliar detail. I thought, *We live here. This is now our home.*

The streets grew quieter and darker.

Dr. Suhadolnik had rented for us an apartment in Lynnewood Gardens, a sprawling suburban apartment complex, a thousand units spread over a hundred acres. To be honest, it wasn't as nice as our apartment in Szeged; it didn't have a washing machine, for one thing. Also, we would discover the ceilings were thin, and when somebody in the apartment above moved about, we could hear every footstep. But it had everything we needed, and by the time we arrived, weary and overwhelmed, it felt like heaven.

"Thank you," Béla and I kept saying to Dr. Suhadolnik. "Yes, this is perfect. Thank you."

We set down our suitcases, said good night. Béla by now was dying for a cigarette, so I lay Susan down in her new bed, then wrapped the blankets around her. *Oh, my sweet Zsuzsi.* She closed her lids, then curled her body around her bear. This was fine; there'd be time enough tomorrow to remove the money and stitch the animal back up again.

When I returned to the living room, I found Béla standing by the rear window. Our apartment looked out on several acres of land, which at this time of night were almost entirely dark. Almost.

"Come look," Béla said, his voice hushed. "Something is blinking out there."

Blinking? I walked over, stood beside him, and looked into the darkness. Béla was right: Everywhere were tiny yellow lights, flashing on and off.

"Insects," I observed. Béla nodded.

We would learn that these lights were fireflies, a species that doesn't exist in Hungary. For a long while Béla and I stood like that: exhausted and relieved in the quiet of our new home, on this new continent, watching unfamiliar organisms light up the night.

IT'S AN INTERESTING THING, living in a new country. It can be difficult at first to distinguish the general from the particular. When you encounter behavior that seems odd—different, somehow, from what you're used to—it can be a challenge to know whether you're looking at a difference in culture or in personality.

Am I experiencing my new home? Or one specific individual who happens to live here?

The picture forms eventually. But it takes time.

I BEGAN MY NEW job just hours after arriving at Lynnewood Gardens. Suhadolnik's lab manager, Nancy, picked me up the first morning, another detail Suhadolnik had arranged. Nancy was just a little older than me, warm and cheerful, with the sweet efficiency of an elementary school teacher. In fact, she'd *been* an elementary school teacher. Then she took a summer job in a lab and never looked back.

Ours was a small lab. There were just a few of us: Suhadolnik, Nancy, a couple of grad students, and me. Everyone was welcoming, and they seemed genuinely glad I'd joined the team. There were many reasons to be hopeful. But some things were strange. A few of these oddities I noticed right away. For one, this new lab was very run-down. Our lab at the BRC had huge windows and bright light. It was well equipped and well organized, and it was spotlessly clean.

I'd assumed that labs in the United States would be like this. But when I walked into Suhadolnik's lab that first morning, I was taken aback. This place looked neglected. A bit filthy, even.

I'm talking *cockroaches*.

I'd lift a box, or an assay tray, or a stack of papers, and there they'd be: fat brown insects scurrying across the counter, fleeing from the light. There were also piles of old equipment, some of which hadn't been used for decades. Early on, I asked if I could make more room by discarding some of the equipment that wasn't being used. I was told no: The old

equipment might one day come in handy. Maybe. Someday. In the meantime, there it sat, covered with a layer of grime.

This wouldn't do. RNA, as I well knew, needed a pristine environment.

Cleaning a laboratory isn't nearly as much fun as building one from scratch, but what could I do? I started scrubbing.

Those early days were long and tiring. Everything was new. Speaking English all the time required so much energy. Sometimes Hungary felt so far away, it hurt.

When I was growing up, my favorite song had been by the Metro band, sung by Zorán Sztevanovity. I listened to it all the time: "Gyémánt és Arany" ("Diamonds and Gold"):

> *The luster of diamonds and gold is beautiful*
> *But this luster can only be yours*
> *If you mine for it yourself.*
> *I know you'll realize it was worth it . . .*

Now, an ocean away from everything I'd known, I still listened to this song all the time. I rocked Susan to it when I returned from work, singing it to her as if she were the one who needed that reminder, that familiarity, that sound of home.

BÉLA QUICKLY MADE HIMSELF useful. He really could fix anything, including cars that everyone else had given up on. Soon after we arrived, he began helping a Hungarian car mechanic. One day, in his eagerness, he lifted a transmission by himself. Well, his back muscles didn't appreciate that very much, and before long, he needed physical therapy. During

one of those sessions, Béla's physical therapist mentioned another client who had also immigrated to the United States from Hungary. This man was a bit older. "An artist," the therapist said, "or maybe a graphic designer. Nice guy."

This man and his wife lived maybe five miles from us. Perhaps, since we were new in America, would we like to meet?

Days later, we found ourselves standing on an unfamiliar doorstep in a suburban neighborhood. The door opened. There stood a couple about twenty years older than us, both with massive smiles. They were Laszlo and Betty Bagi.

Laszlo had an interesting history. He'd grown up outside Budapest. He'd just graduated from technical school when, in 1956, he'd joined the Hungarian Revolution. In the aftermath, he fled for his life to Austria, where he lived for years in a refugee camp. Eventually, he emigrated to America, where he joined the 101st Airborne Division of the U.S. Army and was stationed in Europe. That's where he met Betty. Now he was a graphic designer at a major consulting firm.

And the physical therapist was twice right: Laszlo was also a working artist.

Betty and Laszlo greeted us as if we were long-lost friends. "Szervusztok, gyertek beljebb!" they exclaimed. (Hello! Come in!) "Örülünk hogy szerencsésen ideértetek!" (We're so glad you got here safe and sound!)

What a comfort to hear my native tongue in this new land. What a relief just to talk to someone without first translating everything inside my head. Perhaps if you have ever spent time trying to make yourself understood in a language in which you aren't yet fluent, you can understand.

Betty and Laszlo ushered us inside. Their house was at once lovely and comfortable, filled with smiling photos of their two sons, who were already young adults. On every wall were framed silkscreen prints by Laszlo. He was a terrific artist; his prints were colorful, bold, and exact. I recognized Philadelphia in some of them, and Hungary in others. Many of his works were studies of trees and plants, each one crafted with such meticulous care that it was clear Laszlo appreciated botany as much as I always had.

Instantly, I felt grateful to the physical therapist who'd arranged this meeting. I remain grateful to this day. For him, introducing our families was such a tiny act of kindness, maybe even an afterthought. But he had given our family a great gift. For Laszlo and Betty would not only become our lifelong friends, they'd also be an important bridge between our old life and this still-unfamiliar one. They would help us find butcher shops that prepared meats in ways my father would have approved of. They'd invite us for holidays. They'd celebrate important moments with us. They'd help us feel at home.

ANOTHER STRANGE THING ABOUT my new lab: There were scientific journals everywhere, but we weren't permitted to read them. Not during the day, anyway. I still read everything I could, and when designing an experiment, I almost always went first to the scientific literature. *Had anyone tried this specific experiment before? Had anyone done research that might relate to what I was doing, or that could help me make my experiment*

even better? But the first time I tried to read on the job, Dr. Suhadolnik snapped at me. "Stop, Kati. No!"

I looked up from the pages. I couldn't imagine what I was doing wrong.

"Read at home," he barked. "On weekends or at night! This, right now, is *prime time*. During prime time, we *work*."

Was this not work, too? Searching for ways to make my experiments better?

SUSAN STARTED PRESCHOOL AT the Jenkintown Day Nursery, a cheery multilevel building and outdoor play space on a leafy street. When she arrived each morning, she leaped eagerly from Béla's arms. When he picked her up in the afternoons, she was exhausted and happy, bubbling over with new things that she had learned. She picked up English almost immediately, sometimes moving back and forth between languages when she spoke to us.

One day when I picked her up, a teacher told me Susan needed sneakers instead of the sandals I'd been sending her with. I stared at this teacher, unable to understand. Sneakers? What did this mean? I did not know this word.

There was so much I still didn't know.

LYNNEWOOD GARDENS HAD A community pool. It was behind a big chain-link fence, and you needed a full season membership to use it. Unfortunately, my $17,000 salary left nothing extra.

I remember standing with Béla and Susan on a brutally hot

day, our fingers wrapped around the chain link. We stared at the residents on the other side of the fence who splashed in the clear blue of the pool. They did cannonballs into the deep end, then rose, grinning, above the surface.

The air was so humid. Sweat trickled down the back of my neck.

"Maybe someday," Béla said. I nodded silently. Not long ago, America had seemed a single destination, bright and shining. Once we arrived, I'd thought, we'd have access to everything it offered. But now that we were here, I was beginning to understand: There were levels to America, destinations within destinations. We could be here, in this country, in this community, and still not be able to jump into a pool, even one that was right in front of us, even on a sweltering day.

We made do. We purchased many of our groceries from the clearance shelf. We were forever cutting out bruises from our fruits and vegetables. We pulled chicken from the bone, created meals from food just on the edge of expiration. Every banana I ate in the early years was mushy and brown.

My mother came to stay with us for a few months. She doted on Susan in a way I couldn't remember her doting on me or Zsóka, which means I got to discover a new side of her. This made me smile. While she was here, we spent thirty dollars a week to feed all four of us. We never had a penny left over.

I reminded myself that I hadn't come here for money, that I didn't need much. I'd never needed much. I reminded myself that I was grateful to be here, grateful to be able to perform my experiments. Sure, things might be tight, but I could live like this. Forever if I needed to.

———

ACADEMIC RESEARCH IS INHERENTLY hierarchical. It's almost like a little corporation. At the top, there is a principal investigator, or PI—the lab's equivalent of a CEO. The PI—Suhadolnik, in this case—oversees the research as well as the research team. The PI must figure out how to fund the work, too (typically, money comes from government grants). Beneath the PI is a postdoc, like me, plus any graduate students who work there (my bench was opposite that of a graduate student named Rob Sobol, a young, friendly guy, lovely and soft-spoken, who was soon to be married), and a lab manager (in this case, Nancy).

But organizational structure isn't culture, and within that basic arrangement are varying degrees of hierarchy. My lab at the BRC had been relatively easygoing. We worked hard, we did great research, and we knew who was in charge. But on a moment-to-moment basis, we didn't feel that hierarchy. We weren't *made* to feel it.

This new lab was different.

Suhadolnik was the boss. Literally. That's what he asked us to call him: *the Boss*. And certainly he could be a generous and encouraging boss. He also got things done. But Suhadolnik also reminded people, often, where they were in the pecking order.

Sometimes he'd storm into the office and point at a staff member—one of the graduate students, say. "Get in my office," he'd bellow. The rest of the lab would go absolutely still. The individual he'd targeted would move toward the office

with trepidation. Behind them, the door would slam so hard that floors trembled and lab glassware rattled. The rest of us kept our eyes down, stayed quiet. We were relieved that this time, at least, the Boss hadn't turned his anger on us.

Only Nancy, the lab manager, knew how to calm him down when he was upset. Everyone else just tried to stay out of his way.

The truth is, Suhadolnik rarely yelled at me. To the contrary, he often complimented me. When we met other scientists, he never failed to tell them what an asset I was to the lab, how hard I worked, what great research we were doing together. But it was strange and scary, all this shouting.

Was this how things were done in America?

BEFORE LONG, BÉLA WAS hired by Lynnewood Gardens. He was hired first as a janitor. Then they discovered that he could diagnose and fix anything mechanical. Boilers, trucks, heating systems, snowplows, funky wiring: Béla could do it all. Soon they promoted him to a more general maintenance engineer. He was a jack-of-all-trades at Lynnewood Gardens, in charge of everything from shoveling snow to fixing appliances.

Sometimes Susan accompanied him on his duties. In the winter, when school closed for snow days, she'd ride with him in the snowplow, moving through the parking lots while white flakes danced in the headlights. Sometimes she accompanied Béla to the boiler room and watched him take apart labyrinthine systems, part by part, then put them all back together again, better than before. Béla also did some side gigs for

Laszlo's consulting firm; the company was starting to install computers, and Béla helped them out by running cables through the office, including basic soldering.

I used Béla's expertise, too. I often brought broken lab equipment home. Béla could always get it working again. He even rebuilt a hybridization oven, a complicated sterile incubator that maintains lab samples with exact temperature and humidity control. Whatever equipment I brought him, Béla took it apart piece by piece, figured out exactly what was wrong, then found whatever part he needed to bring the broken thing back to life. Sometimes he'd rebuild it only to find some new thing that needed to be adjusted. No matter. He remained calm. Béla was as patient as he was precise.

Suhadolnik, by contrast, could be explosive. His temper kept revealing itself in new ways. One day, a graduate student from Thailand arrived to a meeting a few minutes late. Suhadolnik, furious, said the student wouldn't be allowed to join our meeting. Nor, though, would he be allowed to do anything else—not work, not read, not use the restroom. Nothing. The student was to stand outside the room, facing the door, just waiting in silence until our meeting was over.

Several times during the meeting, Suhadolnik stood up, walked to the door, and threw it open. Just to make sure. Just to make sure that this underling still knew his place.

Seriously. Was this how things were done in America?

MONTHS BECAME YEARS. SUSAN turned four and started kindergarten. She was a tall girl, and confident. She might have been the youngest in her class, but she flourished.

We didn't go out much. Sometimes we went to Laszlo's art openings, and once a year, we'd dine at a Chinese restaurant with cloth tablecloths. At home, I tried experimenting with different cuisines, but Béla finally confessed that he preferred traditional Hungarian food. So, I had to admit, did I.

By now, our family and the Bagis shared every holiday gathering: Thanksgiving dinners. Christmas. Fourth of July cookouts. On these occasions, Betty always gave Susan a special treat: a foil-wrapped chocolate molded into a symbol of that holiday—a turkey at Thanksgiving, a Santa at Christmas. They were lovely things, a treat for the eyes as well as the tongue, so simple and yet so filled with kindness.

We collected quarters for laundry. Every week we went down into the dark basement of a neighboring building and fed these coins into the washing machine. In our apartment, we listened to our neighbors move above us, and we learned their rhythms.

Susan took her first solo transatlantic flight at age five. She flew to Hungary, where my mother and sister were waiting for her. There, she passed a summer chasing chickens and gardening in the yard, just as I had done as a girl. We made this choice partly from necessity; the cost of the flight was far less than the cost of American childcare. But I was also happy to give this to her. I didn't want Susan to forget where she came from. I wanted her to know the Hungarian language and to understand what it meant to come from somewhere. I wanted her to have memories of the Hungary I knew, even as the country was changing fast.

While she was there, I phoned once a week—long distance was so expensive then—and I could hear the smile in her voice

as she described baking and eating lúdláb, my favorite dessert as a child. She talked about cuddling with my mother's chickens. My mother had given Susan a carriage for her baby dolls; sometimes she put a chicken into it instead, pushing the confused bird around the yard.

In our lab, we published a lot, and in some terrific places, too. In a single issue of *Biochemistry*, we had three papers, which is a major feat. I was the lead author on two of these.

In so many ways, my work was going well. Among other things, our lab was studying double-stranded RNA (dsRNA), which is present in many viruses. Because dsRNA can induce an immune response in cells, we examined whether dsRNA might boost the immune system in HIV patients by turning on interferon secretion. Unfortunately, we weren't able to help HIV patients, but the study, published in *The Lancet*, was meaningful. As Hans Selye, the author of the book that had so influenced me in high school, had observed, the universe reveals itself not only with yes answers but also with nos, as it did here. It was all valuable, all part of the larger mosaic.

I appreciated my colleagues, too. When Rob Sobol, the graduate student, got married, I was honored to be invited—the first such event I attended in America. I also loved the way Nancy kept the lab humming, as if she were a mother hen to all of us, determined to make sure we had everything we needed for our work.

But the Boss still slammed doors. Sometimes he yelled about things that none of us could control. Politics, for example. This topic wasn't entirely unrelated to our work—Ronald Reagan was president, and at the time funding for science

was at an all-time low. But I couldn't see how all that yelling *helped*.

Still, I reminded myself. Suhadolnik remained good to me. So far.

BECAUSE OUR LAB DIDN'T have windows, sometimes I didn't know what the weather was until I went to the bathroom down the hall. There I'd peek out a tiny window and note that it was snowing or that the sun was shining. Then I'd return to the lab, where I'd work for hours more without seeing the sky.

IT WAS 1987 AND America hurtled toward a new election. Perhaps this would resolve funding concerns. Maybe the Reagan-era dip in public support for science was just a temporary thing, a blip. The Democratic frontrunner, Gary Hart, spoke openly about rebuilding America's scientific research infrastructure. Things seemed hopeful, and Suhadolnik's mood seemed to lift. Then Gary Hart was photographed with a woman, not his wife, on his lap, while on a yacht famously called *Monkey Business*. By today's standards, the scandal seems almost quaint. Back then, though, it was enough to sink a presidential run.

When the *Monkey Business* news broke, Suhadolnik stormed into the lab. He did what he always did in these moments: slammed doors, cursed, and shouted. His rage, I was beginning to understand, was like an RNase, the enzyme that

degraded RNA. It was everywhere, free-floating, just search-
ing for a place to land. It contaminated everything.

By now, I'd met plenty of Americans. Nancy was Ameri-
can. Rob was American. Susan's teachers were Americans.
Betty and Laszlo and their kids were Americans. The physical
therapist who'd taken the time to introduce us to the Bagis was
American.

No, this wasn't the way things were done in America. This,
right here, was something else.

A RENOWNED VIROLOGIST, Paula Pitha-Rowe, delivered a
lecture at Temple. Paula was a full professor at Johns Hopkins
University in Baltimore, and she was brilliant. Her research
combined a deep knowledge of viruses with a strong under-
standing of the mechanisms of cancer. She'd grown up in what
is now the Czech Republic, another Eastern Bloc country. I
introduced myself, and we hit it off immediately.

Paula invited me and my family to Baltimore. We stayed in
her home, which was sunny and filled with art she'd collected.
She cooked delicious meals for us, and as we ate, we discussed
life in Eastern Europe. Paula took me to see her laboratory,
where I met members of her team. Soon thereafter, she invited
me to join her lab.

Paula was a strong supporter of women in the sciences. She
had a reputation as a fantastic mentor, particularly for women.
She was warm and kind and generous, and she was doing
groundbreaking work with the interferon system. The posi-
tion was an ideal next step for me. Just perfect.

I accepted the job in the summer of 1988, shortly before

returning to Hungary for a visit, our first trip back home. In retrospect, I suppose that I should have been more careful. Maybe I should have asked Suhadolnik before my trip for permission to transfer labs. But would that have changed anything? I'm not so sure. By the time I returned to America, Suhadolnik had gotten wind of my job offer. And that's when I came face-to-face with the full force of this man's rage.

It wasn't merely that he cursed, screamed, and slammed things. He certainly did those things, but he took it one step further. He presented me with a choice: I could stay in his lab and keep working or I could go home to Hungary. As my employer, he had the power to have me deported. That's what he said he'd do if I tried to take this new job. He would end my career. Did I not understand the situation here? He was the professor, the Boss; I was a nobody.

He repeated that part several times. I was a nobody. Then he told me to get out of the lab. Immediately. "Out! You're no longer welcome here!"

I was shaking as I picked up the telephone to call Béla. Before I finished dialing, Suhadolnik came at me again. "You are not using my phone!" His voice was cruel. "That's *my* phone, not yours. You go make your call from the street." He pointed to the door.

I did as he said. I left.

I called Béla from the street and asked him to come get me. Béla's car was at the repair shop that day, so he had to borrow a car from a co-worker. He rolled up, incongruously, in a giant white Cadillac. On another day, I might have chuckled to see him behind the wheel of that vehicle. Not today.

That night, Béla and I stood together in our kitchen while

I paced and tried to process the situation—not only what had happened but also what I might do next. My visa was tied to Temple. Without Suhadolnik's permission, I couldn't go anywhere. Not only had Suhadolnik made it clear that he'd never give that permission, he probably *would* have us deported.

I was scared, that's the truth. But I was angry, too.

"Why is he not saying, 'Thank you'?" I said, fuming. "Why is he not saying, 'Kati, you did a great job here for three years. You worked day and night.' All this time, he's been telling people how wonderful I am, and now I'm suddenly an asshole?" I sank down in my chair. "I mean, really. Would it be so hard to be grateful?"

But already I knew: Suhadolnik had valued my work only to the extent that it benefited him. My skill, my expertise, my dedication—these things were to be celebrated only if they belonged to him. Suhadolnik felt entitled to me. My decision to leave Temple was an affront—not only to his lab but also to his entire understanding of the world. Valuing myself more than I valued him was an unforgivable sin. I placed my head in my hands and moaned. "What am I going to do?"

Béla patted my arm. "The first thing you're going to do," he said, "is eat."

During dinner, the phone rang. It was the Boss. His voice was calmer now, almost sweet. It bore little relationship to the voice that had berated me just hours before. I kept my eyes on Béla as I listened to Suhadolnik say, "Kati, your chair is here. Your bench is here. Your job is here. I *want* you in my lab. I really do."

There was a long silence then. I waited, knowing there would be more. I listened to the people in the apartment above

us move across the floor. Finally, Suhadolnik finished, "But that is the *only* way you'll stay in this country. You work for me or you'll go home." Already, he said, he'd placed a call to Johns Hopkins. He'd told them I was a fugitive. My offer from Hopkins would be withdrawn. And his next move was to contact Immigration Services. So what did I want to do?

I think today about this whole sorry episode. I remember Suhadolnik's rage, his threats, the things he did later to carry out those threats. And the main thing I think is this: *That man overplayed his hand.* Even after three years, this man didn't understand me a bit, didn't get how I worked. He didn't understand that threatening me was the fastest, surest way to get me to do the opposite of what he wanted.

And that, I suspect, was because of a more fundamental misunderstanding. All this time, Suhadolnik believed I was working for *him.* But I wasn't. I was working to solve scientific problems. My North Star was the science itself.

IF I WAS GOING to get another job, if I was going to stay in America, I'd have to be scrappy. I'd have to do what I'd done at the fishery that long-ago summer, when doing my job (analyzing lipids from fish) required making ethyl acetate from scratch.

Back then, I'd had to break the process down into steps, to say, "If I don't have *this,* I'll have to go in search of *that.*" I could do that here, too.

What I didn't have was a recommendation letter. Suhadolnik had by now followed through with his threats. At his urging, my job offer had been withdrawn. I'd also received a letter

from the U.S. State Department asking me to visit the local office due to a potential visa violation. Suhadolnik had even taken one extra step: He'd removed my name from several scientific papers; one of them, for *PNAS* (*Proceedings of the National Academy of Sciences*), had already been at the galley stage, so this meant he'd paid money to have my name taken off.

So, a recommendation? Out of the question.

If I don't have a recommendation from Suhadolnik, I'll have to go in search of . . .

When I phrased it like that, I knew the answer: I'd have to go in search of someone who could understand *why* I didn't have a recommendation. I'd have to find someone who knew Suhadolnik well enough to know *why* someone might have problems with him. Fortunately for me, there were more than a few scientists out there who'd had problems with Robert Suhadolnik.

I started dialing, introducing myself. Explaining. Some of those scientists introduced me to others. Eventually, from one such connection, I landed an offer. The position was a post-doctoral fellowship, in the pathology department of the Uniformed Services University of the Health Sciences, a military medical school. The chairman was also studying interferons—specifically their role in fighting cancer. All four of his grandparents were Hungarian. Maybe our shared heritage helped.

At any rate, the job was a lifeline. It was an H1 visa, it was work, it was permission to stay in America. It was, in most ways, a good fit for me.

There was only one problem: It was in Bethesda, Maryland, outside Washington, DC. My family was in Philadel-

phia. I had zero connections to Bethesda. And, oh: I didn't have a U.S. driver's license, either.

Never mind those things. I'd make this work. I had to.

I got my Pennsylvania driver's license and quickly practiced at the parking lot at Lynnewood Gardens. The very first trip I took as a licensed driver was to Bethesda. Was I-95 a five-lane highway then? A six-lane? I no longer remember, but I sure remember hurtling forward, dodging speeding cars as if my life depended on it, which I suppose it did.

On my second trip to Bethesda, I was pulled over for going eighty-nine miles per hour.

I learned.

SOME LOCATIONS ARE IN-BETWEEN places. They aren't destinations. They represent instead the space between the points on the map that truly matter. They exist to be moved through. For me, the roughly 135-mile stretch of I-95 between exit 13 and exit 27 was exactly that sort of no-man's-land. Philadelphia on one side, Bethesda on the other. And in between, me. Going back and forth, back and forth, again and again and again.

Monday morning: I'd rise at three in Philadelphia. I'd get in my maroon Celebrity—then drive three hours through the dark. I'd carry a bag with me, inside of which was five days' worth of broccoli and sausage. I also had half a gallon of milk and a bag of bread. That was it. Every week, the same groceries, in the same quantities.

Sometimes as I drove, I hummed that old Zorán song, "Diamonds and Gold."

But this luster can only be yours
If you mine for it yourself.
I know you'll realize it was worth it . . .

By seven o'clock in the morning, I'd be in Bethesda, invariably the first one in the lab. I'd place my groceries in a fridge and get to work.

I worked day and night. I never went out. I kept a sleeping bag in my car and a key to the apartment of a Hungarian colleague who offered up a place to sleep, as immigrants so often do for one another. When I went there, I'd arrive very late. I'd roll out my sleeping bag in the living room, catch a few hours of rest, then rise again in the darkness. Many times, they knew I'd been there only because I brought the newspaper inside before heading to work in the early morning.

Often, though, I didn't even bother with the apartment. Instead, I'd roll out my sleeping bag right there in the lab office and fall asleep on the wall-to-wall carpet.

THIS WAS A TIME of quiet, intense learning. In the evenings, I visited the university library. I still read everything I could. I didn't just read current issues of scientific journals, either. I also went back to look at old papers, a hobby I still have today. I looked for every nugget of insight I might find, discoveries that perhaps seemed insignificant at the time but might be worth knowing about. I stored away facts. I wanted to learn everything I could about molecular biology, and then I wanted to go home.

At eleven P.M. the librarians kicked me out. Often, I went

back to the lab then, starting an experiment that would go into the wee hours of the morning. As I set up the experiment, I'd think about Susan and Béla, 150 miles away, sleeping in their beds in the home where I wasn't. I'd wonder then, *What am I doing here?*

And then I'd start my work, and I didn't have to think about it.

In the early mornings, I went running on the campus. There were nice paths and exercise stations between the trees. I'd listen to myself breathe, hear my feet hitting the ground, one at a time, and again I'd wonder, *What am I doing here?* Then I'd come inside and use a shower in the building and get back to work.

Friday afternoon, I'd sit in my car, in the endless traffic of I-95, inching north toward Béla and Susan. That was the only time I didn't have to ask myself, *What am I doing here?* The answer was clear: I was heading home.

THROUGH IT ALL, I kept applying for jobs, introducing myself to potential employers with handwritten letters. One of the jobs I'd applied for was at the medical school at the University of Pennsylvania (Penn). A new cardiology lab. This was a research assistant professor position—not especially glamorous, but it was right in the heart of Philadelphia, and the lab was specifically looking for a molecular biologist.

I always kept careful track of my applications. When I mailed them, I wrote down where I'd applied, what the position was, and who the contact was. Two weeks after applying, I'd call the potential employer to check in. I did this with the Penn job, too.

The secretary who answered my call told me that they were planning to readvertise the position. They hadn't found the right applicant yet. "Can you take another look?" I told her my name. "Just take another look, please."

Thirty minutes later, I got a call from a cardiologist named Elliot Barnathan. He was my age, thirty-four, just getting a new lab set up. He'd looked at my résumé. He'd seen what I could do. He was interested and wanted a personal meeting.

LIFE ISN'T LIKE GEOGRAPHY. In life, there are no in-between places, only bridges. *This time of my life got me from here to there.* From each bridge you pick things up, you take them with you. You carry them forward, into the next chapter.

One day, a former fellow in the pathology lab returned to visit his former colleagues. He offered us Lipofectin, a new lipid formulation that could be mixed easily with DNA and would allow it to be delivered to the cell. Lipofectin was supposed to be simpler and more reproducible than the liposomes I'd worked with previously. Because it had an added positive electric charge, and cell membranes have negative charges, Lipofectin was more effective, too.

And here it was, prepackaged and ready to go.

I thought about what we'd gone through in Hungary— Ernő visiting the slaughterhouse and returning with that cow brain. All the painstaking work we'd done to extract the phospholipids we needed. Now here was this new thing. Lipofectin.

Well, this is going to change everything, I thought.

———

WE'VE REACHED THE PART of my story that journalists, later, all tend to present the same way: as *a series of unfortunate events*.

My time at Penn would span decades. These decades split into three distinct episodes, involving two different departments and three very different physician partners. Years later, after the world had turned upside down and strangers suddenly knew my name, a young doctor with whom I'd worked in the third of these episodes (the Weissman years) would write an essay about me. He'd describe me—neither inaccurately nor unkindly—as someone whose career was discussed "only in hushed tones as a cautionary tale for young scientists."

You are, in other words, about to watch someone become, by many standards, a cautionary tale. That's because my three Penn episodes, for all their differences, followed a similar pattern: a series of setbacks punctuated by moments of extraordinary breakthrough. The breakthroughs, for the most part, remained almost entirely invisible. The setbacks, though? Those were on full display.

As for whether I truly was a cautionary tale, well, I suppose that depends on what you value.

SOME PEOPLE HAVE A way of putting you at ease the instant you meet them. Perhaps it's something about their face—the easy smile they flash upon seeing you, as if they're greeting

not a stranger but rather an old friend. Maybe it's their body language, some sort of unguarded openness as they extend their arm to shake your hand. Or maybe it's their eyes—both softness and sparkle, suggesting at once kindness and curiosity.

Whatever it is, I felt instantly comfortable when I met Elliot Barnathan. Never mind that this was an interview; Elliot was cheerful and welcoming, as if there were nothing he'd rather be doing than sitting down with me. He struck me as the kind of person who would be a good neighbor, a good citizen. A good colleague.

At that first meeting, Elliot asked to see my "lab book"— a handwritten record of the experiments I'd done, with evidence of the results. He flipped through the pages carefully. I noticed him pause a couple of times, really taking in what he saw. Elliot had a thick Burt Reynolds moustache in those days, so it was hard to tell, but I'm pretty sure I saw him smile.

I waited quietly as he moved through the pages, experiment after experiment. Finally, he held up an X-ray film, the results of a Northern blot—a technique that separates different types of RNA into bands according to size, allowing one to understand exactly what types of RNA are present in a sample. I don't recall which experiment it was, but I do remember the delighted surprise in his voice as he asked, "You did this?"

As I've explained, RNA was exceedingly difficult to work with. But there, in the Northern blot he held, was proof that it could be done: The page was filled with evidence of a vast array of RNAs that I'd made and managed to keep from degrading.

You did this? I nodded. Yes. I'd done that. And I could do it again.

The job offer came swiftly after that first meeting.

ELLIOT WAS RELATIVELY NEW to the cardiology faculty at Penn, though he'd been part of the institution for at least a decade. He was a Penn man to his core. He'd attended Penn as an undergraduate, then gone to medical school there. He'd done his medical residency at Penn and his fellowship, too. Penn was also woven into Elliot's personal life; he'd met his wife there, and most of his closest friends were affiliated with the university. I sometimes joked that Elliot attended kindergarten at Penn, too. Surely, if he could have, he would have. Now he was on the faculty, just setting up his own lab.

One day a week, Elliot worked in the medical school's cardiology clinic, caring for patients. But he was primarily an investigator doing basic research. (Basic research is more general inquiry, designed to expand human understanding, as opposed to applied research, which solves extremely specific problems with practical applications.)

Because I'd be a molecular biologist in a clinical department of the medical school—a PhD in a sea of MDs—I might be a bit of a fish out of water. But that was fine with me; I had research skills that a clinician couldn't have. Also, working among MDs would almost certainly give me the same benefits that working among biochemists had offered. It was the thing I valued most: a chance to learn.

Besides, let's face it: When *hadn't* I been a fish out of water?

The position didn't pay much, and it wasn't tenure-track, which meant I'd never have complete job security. But it had other advantages: I'd be able to live full-time with my family again. I also hoped that Penn would help me get my green card. My position as research assistant professor would last five years; at that point, the university would decide whether to promote me to research associate professor. While this promotion still wouldn't put me on the tenure track, at least it would give me an opportunity to establish my own lab and work with students.

By now, Béla and I had our sights set on a new home on a peaceful street in a suburban neighborhood. It had two stories and a wide, sloping lawn where Susan could play. It was in a great school district. We could afford it for one reason only: The interior was a disaster.

But I was married to Mr. Fix-It. Nobody would be able to fix up a house like Béla could. Sure, it might take a while, but both Béla and I had grown up without running water. Even a work-in-progress house felt like luxury to us.

The day I started the job at Penn, Béla and I signed the papers on our new home.

ELLIOT WAS INTERESTED IN a class of molecules called *plasminogen activators*, which help dissolve blood clots.

Clots are one of the body's critical responses to wounds. If our blood didn't clot, we'd bleed to death every time we got a cut. However, in the wrong context, clots can be dangerous. If they form inside blood vessels, clots can restrict blood flow. Blood clots in coronary arteries cause heart attacks. Clots can

also break loose and travel to other parts of the body, such as the lungs or the brain, causing potentially fatal strokes. Clots can form at any time, but we're especially at risk for them after surgery.

Plasminogen activators are part of the body's natural defense system against dangerous clots. These molecules circulate through the body like tiny roaming security guards; when they come upon a clot that might be forming in the wrong place, they get to work, dissolving that clot and restoring healthy blood flow. This is yet another way your body looks out for you, doing crucial, invisible work twenty-four hours a day, without your ever having to think about it.

Elliot was especially interested in a specific type of plasminogen activator called *urokinase*. His idea was that if we could identify and isolate the genetic sequence (the order of the nucleoside bases) for a *urokinase receptor*, a protein that binds to urokinase, we could deliver these receptors postoperatively to tissue in surgical locations. The presence of urokinase receptors would boost urokinase in that area and minimize the risk of clots forming.

It was a good idea. A very good idea. But Elliot wasn't a molecular biologist, which is why he needed my help. Elliot's plan had been to do this work using DNA. I listened to him explain his vision, then I presented a different idea: Why not use messenger RNA instead?

By this point in my career, I'd been working with lots of RNAs, but I hadn't yet synthesized mRNA. I'd been fascinated by mRNA—the messenger that instructs our cells to make specific proteins—ever since I learned about the molecule as an undergraduate. I'd been struck then by the idea that

we might someday use mRNA to coax our cells into making the specific proteins our bodies need to fight disease. The more I learned, the more convinced I was that mRNA held great therapeutic potential. And by the time I got to Penn, the science of mRNA was advancing fast.

RECALL THAT MRNA WAS discovered only in 1960. Even before that decade was out, scientists at the University of Cincinnati had isolated mRNA to create mouse globin (part of the oxygen-carrying proteins in red blood cells) in the lab; they'd done this in vitro, in a test tube, using a cell-free medium, in 1969. But to get the mRNA into actual *cells*, scientists needed other things. First, they needed a lipid package—like the liposomes I'd been working with at the BRC lipid lab back in Hungary. By 1978, scientists working independently in London and at the University of Illinois had successfully delivered liposome-packaged mRNA into mouse and human cells. The cells then began making the encoded protein (in this case, it was rabbit beta globin).

Those experiments were still early, with limited clinical utility. However, the concept had always intrigued me: We could instruct the body to make specific proteins on demand. These proteins could do the essential work of keeping the body healthy. The process would involve only temporary molecules that would then be easily degraded by ordinary cellular processes.

What a marvelous way this would be to help the body heal itself!

By the time I started working with Elliot, in 1989, we scien-

tists had even better lipid delivery vehicles, such as Lipofectin. We also had an array of other new tools. Thanks to the scientists Paul Krieg, Tom Maniatis, Michael Green, and Douglas Melton, we could now make mRNA that coded for any desired biologically active protein. And because we had learned to harness the power of an enzyme called Taq DNA polymerase (named the "molecule of the year" in 1989 by *Science* magazine), which amplified genetic material, we also had a new technique for making unlimited copies of genetic material: polymerase chain reaction, or PCR.

What all of this meant practically was that the pieces were in place to begin working with mRNA in earnest. Suddenly my mind was overflowing with possibilities.

ANOTHER GREAT THING ABOUT Elliot: His mind was wide open. When I presented my idea about using mRNA to make urokinase receptors he listened carefully. He asked a slew of smart questions—mostly related to the notorious instability of mRNA. I presented, in turn, hypotheses for how we might minimize these challenges.

To my mind, getting mRNA into a cell, then having it translated into protein (urokinase receptors or any other), was a bit like manned spaceflight. Sure, there were myriad challenges to safely exploring space: lack of oxygen, altered gravity fields, the very real possibility of an entire spacecraft burning up when it hits the earth's atmosphere upon return. But every challenge in spaceflight had an individual solution. So, surely, did the challenges with mRNA. These challenges might be daunting, but they weren't *infinite*. We could identify

each, then set about finding a solution, one at a time. Collectively, these solutions would transform the seemingly impossible into the possible.

Elliot listened to me describe the details of liposomes, membranes, and ionic bonds, as well as the specific nuances of buffers and reagents and sequencing techniques. Finally, he leaned back in his chair. He rubbed his chin thoughtfully. Then he asked the big question. This was the first time I was asked this question in earnest, though it would not be the last.

"So, this mRNA approach . . . you really think it will work?"

I did. That was all he needed to hear.

ELLIOT'S PHILOSOPHY AS A principal investigator and mentor was simple: Hire smart people who have good chemistry with one another. Listen to them. Give them mentoring and support where they need it, then get out of their way. Encourage them to outgrow you, to move beyond you . . . and celebrate them when they do.

I was one of Elliot's first hires—before me, he'd hired a lab technician named Alice Kuo, who was thoughtful, patient, optimistic, and wonderfully precise. He'd also hired a Penn medical student named David Langer, who would spend one year in the lab as part of a coveted fellowship. Already, David was well known around these halls. Not only had David gone to Penn himself but he'd also grown up in and around the Penn cardiology department; his father, Terry, had been a renowned and much-loved Penn cardiologist. A few years before, Terry had suffered a debilitating stroke, which left him

paralyzed on his left side. This was a genuine tragedy. In response, the entire cardiology department had rallied around David with the attention and care of an extended family.

David seemed like a nice enough kid. He was charismatic and assured, buzzing with the intensity of a varsity rower competing at the World University Games (in fact, he'd done exactly that just two years before while rowing for Penn's varsity crew team). He was young, though, still in his early twenties, and if I'm being honest, there was an air of cockiness about him.

Before long, Elliot would round out this team with postdocs and fellows, as well as a steady rotation of medical students. It was my job to instruct the medical students—to teach them how to make RNA and to work with it, so that we could do our experiments.

I didn't mind teaching—I'd loved teaching Rob Sobol, back in Suhadolnik's lab—but these Penn medical students quickly got on my nerves. They were very inexperienced and yet could be so full of themselves! Also, their minds seemed permanently fixed on the future, on what their lives *would be*, rather than on the task right in front of them. This meant their work was never the quality that it needed to be. They could be careless in the lab, scattershot.

But being careless with RNA was a ruinous mistake; it meant your RNA samples degraded. Then you had nothing. You had wasted your own time, and everybody else's, too.

I could, I'll admit, be curt.

I remember, early on, an experiment with David and another medical student. I'd tried to teach the two of them everything I knew about making mRNA—the first necessary step

to any experiment involving RNA. Making mRNA is a pains-taking process. First you must isolate a gene. In this case, we were working with a luciferase gene, which directs the protein that makes fireflies light up. Next, you insert that gene into a plasmid (the small, circular, double-stranded DNA in the cytoplasm of a bacterium). Add a protein that allows transcription to take place. Once transcription happens, you've made mRNA . . . but for it to be useful in an experiment, you have to eliminate the plasmid DNA. Add an enzyme that destroys DNA. Then collect the mRNA that remains into an Eppendorf Tube and centrifuge it.

This all takes time, and like everything related to RNA, it requires being absolutely meticulous. I'd explained everything to these students, every step of the way. But either they hadn't listened closely enough or they just didn't care. By the time they finished, no mRNA could be seen on their gel.

I assumed their RNA must have degraded.

I reviewed the steps with them, trying to figure out where they'd gone wrong. It turns out they'd added the DNA-destroying enzyme *before* they'd transcribed the DNA into mRNA. This was such an obvious, boneheaded mistake, it blew my mind. "What were you thinking?" I scolded them. "If you destroy your DNA before it's transcribed, there's nothing left to transcribe from!"

The two of them looked down, muttered some apologies. It was infuriating. I had important work to do, and here I was, being held back by a couple of kids who had zero long-term investment in the work. I tried to remain calm—I've never been someone who yells—but I also told them the truth. "This

is shit," I said. I couldn't pretend otherwise. We were going to have to start over. "It's useless, *garbage*."

I did what people do with garbage: I threw their gel into the trash. The two of them just stood there, slack-jawed. It was as if no one in their whole lives had ever told them the truth.

The next day, Elliot called me into a private meeting in his office. "You know, Kati," he began. He rubbed his temple for a moment before continuing. "You don't need to be so *blunt* with people."

Ah. So those medical students complained about me to my boss.

David, I thought. It *had* to have been David. Who else would be so comfortable complaining about me to the lab director? Around these halls, David was a golden boy, adored by all. He'd known Elliot since he was a boy. *Of course* he'd go to Elliot. Something inside my chest hardened. Already, David had so many advantages. He'd grown up in a wealthy suburb. He'd attended an Ivy League university. When he finished medical school, he'd be a third-generation physician. He was the kind of person for whom opportunities would rise like wildflowers, forever offering themselves to be picked.

I reminded myself that I'd had to work for everything I had, that I'd done so without complaining. I reminded myself that by the time I was David's age, I'd already set up an entire biochemistry lab from scratch, without any help from anyone. I'd worked with János Ludwig, the king of bluntness, and did I ever complain to our boss? No.

I'd had none of David's advantages, and if I could work

with RNA, surely he could, too. He could if he tried. Was it too much to demand that he try?

But Elliot had such a gentle, reassuring way of talking. Even now, as he was reprimanding me, I got the feeling he was genuinely on my side. "Kati," Elliot said, "it hurts people when you tell people their work is shit. I'm not saying don't correct people. I'm just asking you to do it in a way that's still encouraging."

Elliot gave me some suggestions for what to say next time I grew frustrated with one of the students. *I know you worked hard, but it seems that your RNA degraded,* or *Next time, you'll need to complete the steps in a different order,* or *These things can happen, you'll have to be a little more careful next time.*

"Okay," I said. I sighed. Sometimes working with other people could be so exhausting. "Okay, I'll try."

ALTHOUGH ELLIOT'S LAB WAS on the fifth floor of the Johnson Pavilion, I was also given my own research space on the first floor. I shared this space with another scientist, also a woman, named Jean Bennett. Jean was an MD-PhD, an ophthalmologist by training, deeply interested in the genetics of retinal disease. Jean was wonderful: whip-smart, warm, enthusiastic, and absolutely brimming with energy. I liked her immediately. While Jean, unlike me, was on a tenure track, we had plenty in common in other ways. We were both outsiders in this cardiology lab. We were also both mothers—Jean had three young children at home, and her husband worked long hours, too.

In those days, being both a mother and an academic re-

searcher was a bit of a rarity. Places like Penn just weren't set up for working mothers. Early on, Jean observed that talented women scientists often became lab managers—running things from behind the scenes, while never being given credit for their work. She and I agreed that we wanted something different: We wanted to be the ones *making* discoveries, not merely assisting while others, usually men, made breakthroughs.

While our shared lab space didn't have much, we were determined to make do. Whatever one of us had, we shared with the other. Neither of us had an independent budget or funding, so we sometimes got creative with our supplies. For example, I often purchased Hungarian pickles in bulk, in oversize jars. I began saving these jars; in the lab, we'd sterilize them, then use them to store Eppendorf Tubes or other materials. Everything we had was patched together from spare parts, and that was fine with us. We were both just thrilled to be doing our respective research.

I STILL READ SCIENCE journals all the time—hundreds of studies every month. I couldn't get enough. I read at work, and I also had my own subscriptions to *Nature* and *Science*, which I read at home. Sometimes I'd burst into the lab in the morning waving around the latest issue, exclaiming, "Did you read this article?" And then I'd read aloud something about sensory detection in crayfish or bacterial DNA replication.

Sometimes I noticed the students glancing at one another as I talked—*here she goes again*—but Elliot always listened carefully, sometimes with a quizzical look on his face. When I finished, he might grin. "So, Kati, does this have something to

do with our work?" Sometimes it did, often it didn't. But either way it was fascinating, part of a wondrous biological system that never ceased to amaze me with its complexity and precision.

Once we all agreed how incredible biology really was, we got to work. We'd look at the results of the previous day's experiments, try to assess what we'd learned, and then, in response, begin designing new experiments. Every day, some new experiment. Every day something new to learn.

PLENTY OF STUDENTS AT Penn did roll their eyes about me—about the articles I waved around that didn't seem directly relevant to their career aspirations or about my demands for precision in the lab or about the fact that I was a non-tenure-track faculty member who did her own experiments because she didn't even have any postdocs working with her.

One student, though, began following my every direction. This student read every article I brought to the lab, invariably asking detailed follow-up questions about the article's contents—about its design or methodology, or about the lab techniques involved, or about an obscure reference it might have made. The more I answered, the faster the questions came. I noticed this student began working harder, and more carefully, than the others. And the more corrections I gave, the harder this individual worked.

This student, to my surprise, was David, the darling of the cardiology department, the very same kid who had ratted me out to Elliot. This was something I certainly hadn't expected!

Some of David's passion for learning, it became clear, was motivated by his father's illness. Seeing his beloved, brilliant father so debilitated by a stroke had instilled in David a profound sense of purpose. He wanted to do something extraordinary. He wanted to do something *good*. This personal mission was so steady and unwavering, it sometimes seemed like an arrow shot from a bow.

But still. That doesn't explain why David chose to respect *me*. I had no prestige in that department, no grants, no committee appointments, no budget of my own. I had nothing to offer him but that which I'd learned. I was basically a nobody at Penn—a nobody who could at times be sharp with people.

But maybe that was the point. Maybe in that early, untactful moment when I told him his work was "shit," he'd glimpsed something important: I would tell him the truth. If I complimented him, it had nothing to do with who his father had been. If I respected him, it was because he'd earned my respect.

He did earn it, too. What can I say? Sometimes people surprise you.

PENN DID HEART TRANSPLANTS, and sometimes Elliot got calls in the middle of the night: *When this heart transplant is finished, do you want the diseased heart for your lab?* He always did.

So, there he'd be, heading into work at three A.M. to collect from the surgeons an intact human heart packed in ice. He'd carry the heart back to the lab and begin flushing it with warm fluids so the cells could be harvested for our experiments.

Once, when he was alone in the lab at around four A.M., the heart in his hands began reflexively beating, like something out of a horror story.

Sometimes science is a brain carried to the lab from a Hungarian cattle slaughterhouse. Sometimes it's a human heart beating in your hands in the lonely night. More commonly, it's experiment after experiment, one at a time.

I would do thousands of experiments in Elliot's lab. Maybe that sounds like a lot. But you have to understand how science works.

While an individual experiment is the smallest possible unit of the research process, it is not in itself *research*. In science, your overarching goal is to develop and test hypotheses; to do this, you need results not from one single experiment but rather from a mountain of them. You need to do each experiment many different times, each time changing only one variable. For each experiment, you also need control studies, in which no variables are changed, so you have a point of comparison.

Sometimes when an experiment didn't provide the results I'd anticipated, I glanced at a quote hanging on the wall, from Leonardo da Vinci: *Experiments never err, only your expectations do.* It might seem that an experiment fails, but that's only because your hypothesis was wrong or because you made an experimental error. Unless you do many different experiments, each time adjusting a little something, you can't possibly know.

Now imagine that you're working with brand-new tools, brand-new reagents. You don't yet know how these elements perform in different experimental conditions. That means

even more experiments. You're essentially proving new technology while simultaneously running your own inquiries. Every time I mixed a new reagent, I tested it to eliminate any potential error.

I'll say this: My experiments were always extremely well-thought-out. I considered potential outcomes and designed each experiment to yield the most valuable information. I had many controls. I made adjustments, then ran the experiment again. I always insisted on doubting my results until there could be no doubt whatsoever. If I ran into a technical error, I created new protocols to avoid that error in the future.

This level of care, though, meant resisting some of the pressures and incentives of academic research.

Academic research is fiercely competitive, and it's filled with almost indescribable pressure. Certainly, there's pressure to stand out, to make a name for oneself—to publish, and to have your publications cited by others. But the pressure goes well beyond that. For one thing, there's the issue of funding. While universities typically cover the salaries for professors in the humanities, arts, and social sciences, scientists in medical research are expected to pay their own way. Sometimes they accomplish this by doing clinical work; others get their salaries (as well as those of everyone who works for them) funded externally, through private funders but mostly by government grants, which is taxpayers' money.

And even when you get grants, not all the money goes to your research. The university gets a percentage for university operations. I'm talking 50 to 65 percent of your grant. Sometimes more.

The financial stress is immense; this leads in turn to a dif-

ferent kind of urgency: to *produce*—more, faster, and not always better quality. To be *first* to publish, rather than the most careful.

Funding pressures can also shape the nature of research. There's tremendous pressure to do the kind of studies that will get you the funding you need—to go, in other words, where the attention and money *already are*. That's not necessarily where the breakthroughs lie, nor is it where the greatest need is. Funding, in other words, can leave very good ideas totally unseen.

I was always so stubborn, though. When I saw the pressure to produce *more, faster,* it only reinforced my determination to design my studies meticulously. I was determined that my work would have integrity.

I published more slowly than others. I didn't want my scientific papers to be rushed. I didn't want to be so eager to publish that I risked contaminating the scientific literature with dubious results. It was important that the results of my experiments not only were crystal clear and wholly convincing, but also could be reproduced.

Elliot recognized this. He seemed to appreciate how conscientious I was, and he never rushed me to go faster than I thought I should. He trusted me. That's because he had integrity, too.

And as for going where the money was? Well, that I absolutely did not do.

I'D ARRIVED AT PENN just as the medical school was undergoing a change in leadership. The dean had recently retired.

The new dean of the medical school and CEO of the hospital system was a physician named Bill Kelley. Kelley had been trained at Duke and was widely seen in clinical circles as something of a wunderkind; prior to arriving at Penn, he had been, at thirty-six, the youngest chair of medicine in the entire country, at the University of Michigan Medical School.

I'd known of Bill Kelley since my graduate school days. One of my first experiments in Hungary had investigated a rare inherited disorder called Lesch-Nyhan syndrome. Among the symptoms of Lesch-Nyhan are compulsive self-mutilating behaviors (biting fingers, banging heads). Kelley had proved that the problem was genetic, a deficiency in a particular enzyme. Since our RNA lab at the BRC had all the reference molecules, I had been asked to analyze blood samples collected from children with this behavior and to determine if their enzyme level was low. So all these years later, when I learned that Bill Kelley—*the Bill Kelley!*—would be joining Penn, I was over the moon.

He had big plans for the place, too.

Kelley brought with him a team who had also trained at Duke. This team, like Kelley himself, were evangelists for *gene therapy*—preventing or curing diseases by modifying DNA. Under Kelley's leadership, Penn built a cutting-edge center for genetic diseases, the brand-new Institute for Human Gene Therapy, as well as a new department within the medical school: the department of molecular and cellular engineering. Kelley hired one of his ex-colleagues from the University of Michigan, Jim Wilson, as institute head.

The message was clear: Penn's future lay with gene therapy.

Certainly, that's where the money was. The Human Ge-

nome Project, which would identify every human gene and its sequence, had just been launched. *Forbes* was writing glowingly about the biotech industry, noting "blockbuster" products and "sky's-the-limit growth potential." In the early 1990s, before the dawn of the internet bubble, gene therapy was the Next Big Thing.

Yes, gene therapy did have potential. Already by this point, we'd seen early, small-scale success stories. And the truth is, DNA had some technical advantages over mRNA. DNA's stability made it much easier to work with than mRNA. But as I saw it, there were downsides, too. Gene therapy involves changing a person's genome; changes are long-lasting. When that manipulated cell divides, the changed genetic material will be a part of the new cell, too.

By contrast, mRNA therapy wouldn't make lasting changes to the cell—wouldn't, in fact, get near a person's genes. And since mRNA is broken down quickly by the body (as would be any protein produced from the instructions carried by the mRNA), mRNA therapy could create a significant effect (drawing urokinase to a surgical site to prevent blood clots, for example) that was also *temporary*. It was so efficient, too! With mRNA, we could theoretically deliver the right proteins to the right places without needing to move DNA into the nucleus at all.

It's not that I didn't believe in gene therapy. I simply believed there was a role for both gene therapy *and* mRNA therapeutics. I wanted the institution to be open to both approaches.

But Wilson never seemed interested in mRNA or my research. He barely glanced my way; on the rare occasions he did, it always felt as if he were looking right through me.

Early on, Elliot and I were called into a project grant meeting with Jim Wilson and others. The goal was to shape the agenda for a proposal our chief would submit to the National Institutes of Health (NIH). The grant, if we could get it, would be worth millions of dollars. Jim Wilson presented some data about adenoviruses, a potential vector for genes (a way of carrying genes into the cell). I asked a lot of technical questions. His responses grew increasingly brief—eventually becoming so curt that I began to wonder if instead of asking questions, I was just making irritating noise. In the same meeting, I tried to advocate for mRNA research to be included in the grant. Well, Wilson moved on before the words were out of my mouth. It felt as if he were saying, *Everyone knows you can't work with RNA.* Meanwhile, there I was, right in front of him: a scientist who could work with RNA and had proved it.

THERE WERE OTHER CHALLENGES with this new leadership. One of Bill Kelley's early actions was to replace the chief of medicine with another Duke buddy, Ed Holmes. In turn, Holmes promptly fired the chief of cardiology—Elliot's boss—and launched a nationwide search for a replacement.

Holmes's wife, Judy Swain, happened to be a cardiologist. Funny thing. She's the one who got the job.

I won't say that Judy and I were completely different. In fact, she seemed as headstrong and ambitious as I was. My ambition, as I've said, was one of curiosity. I was a scientist through and through; I wanted more than anything else to understand how the world works. In my quest for knowledge, I'd set exacting standards for myself and for my study design. By

living up to these standards day after day, I'd become a very good scientist. But I was learning that succeeding at a research institution like Penn required skills that had little to do with science. You needed the ability to sell yourself and your work. You needed to attract funding. You needed the kind of interpersonal savvy that got you invited to speak at conferences or made people eager to mentor and support you. You needed to know how to do things in which I have never had any interest (flattering people, schmoozing, being agreeable when you disagree, even when you are 100 percent certain that you are correct). You needed to know how to climb a political ladder, to value a hierarchy that had always seemed, at best, wholly uninteresting (and, at worst, antithetical to good science). I wasn't interested in those skills. I didn't want to play political games. Nor did I think I should have to. Nobody had ever taught me those skills, and frankly I wasn't interested in them anyway.

Sometimes people appreciated this about me. Jean Bennett, for example, often told me how grateful she was for my directness. Jean was a terrific scientist, sharp as a tack. But she told me that she had been raised to be docile and agreeable, even if it meant not standing up for herself. "Your candor is *refreshing*, Kati," she insisted. "Some of us need to do more of that."

But I got the feeling Judy Swain felt a different way entirely.

The New York Times would run a profile of Judy while she was at Penn. The article began by saying that she was "determinedly, decisively" at the top of her male-dominated field, noting, "She planned it that way and would never accept any-

thing less." That phrasing, to me, captured Judy well. She had in abundance those skills that I didn't value.

She'd made those skills work for her, too. Judy was, in those days, the sole woman directing the cardiology section of a department of medicine in a medical school of this size and caliber. She would also be the first woman to lead the American Society of Clinical Investigation, after eight and a half decades of male leadership. These achievements are breakthroughs in their own ways.

But aren't there many different ways of succeeding? Shouldn't there be?

The truth is, I never felt supported by Judy. I certainly didn't feel respected. In meetings, it always seemed as if she spoke to Elliot instead of me, barely glancing my way even when we were discussing my work. She rarely asked questions about my research, and I got the feeling she didn't think it was worth much.

Meanwhile, strange things kept happening. For example, Judy had been in that early grant meeting with Jim Wilson— the one at which I asked many questions and proposed making mRNA a part of the NIH grant. I recall that after this meeting, she requested I no longer attend such meetings.

Things got worse from there. Although I worked on Elliot's team, physically I worked in Judy's lab space on the first floor of the Johnson Pavilion (Elliot's lab was on the fifth floor). Once I tried to get some deionized water—tap water that's been run through a cartridge to remove ions. Deionized water is a standard lab ingredient, and relatively inexpensive. But a student stopped me, suggesting I go to the fifth floor for

my deionized water. *This* water had been purchased with funding from *this* lab. When I asked some questions, the student confessed that he and other students had been instructed to stop me from using the water, since I wasn't part of their team.

It was a small thing but it felt jarring.

Another time, Judy suggested I stop talking to my Hungarian colleague in our native language, implying I'd never learn to speak English well otherwise. I remember she said this in a friendly voice, as if she were just trying to help me. But there was something about her tone that nagged at me, something I couldn't quite put my finger on at that moment. It was only later that I'd recall the false friendliness of the secret policeman who'd once stood on my doorstep in Hungary.

Yes, *that's* what I'd heard beneath her apparently cheerful tone: a warning.

In another incident, Judy called me to her office. There she told me "people" were complaining about me, saying that I was too difficult. *Destructive* was the word I remember her using.

"Hold on a second," I said. "Who are these people? What, specifically, is their complaint?" There wasn't much I could do with vague accusations. I suggested she call these individuals into the office so that we could discuss specific behaviors, actual relationships. When Judy refused to give me any more information, I walked out. I had no time for this.

I'm not saying I was easy. I was, after all, the same person I'd been in high school, back when I'd debate, sometimes fiercely, why my way to the correct math answer was better than my classmate's. I was still the same girl who'd defied the orders of Mr. Bitter, my angry Russian-language teacher. But

I also wasn't a kid anymore. I was a scientist—an experienced one, a *good* one.

Besides, how many men have been permitted to be "difficult"? Back at Temple University, nobody batted an eye when Dr. Suhadolnik screamed and banged things in the lab or when he threw things in his office. This sort of behavior was just what great men *did*, wasn't it?

Surely Judy Swain had also been around difficult men. Had she treated them as she now treated me? Or did she instead do what people throughout history have done with difficult men: Take their stubbornness and impolitic behavior as de facto proof of their genius?

For me, the bottom line was this: I was doing good work and I didn't want to pretend to be someone I wasn't. Why should I have to pretend?

Well, I suppose there might have been one very good reason to pretend: As I said, I had five years to prove my worth to the institution. If I did that, I'd be promoted from research assistant professor to research *associate* professor. And if I didn't? Well, that probably would be it for me. At Penn, nobody can work more than five years as research assistant professor. It would be promotion or nothing, up or out.

And the authority for this promotion-or-out decision? It belonged not to my immediate boss, Elliot, but rather to the chief. It belonged to Judy. The person immediately above Judy in rank, the one to whom I might appeal a decision? Well, that was Judy's husband, Ed Holmes.

My fate was in Judy's hands, and if I wanted to stick around, I probably should put up and shut up.

For better or for worse, that has never been in my nature.

———

WHEN PEOPLE LOOK BACK on my career, they tend to point to only a few contributions, the ones directly related to the breakthroughs that came later. But scientific inquiry is rarely, if ever, linear—especially in basic research. In those days, Elliot and I were making all kinds of discoveries. For example, we learned that endothelial cells lining the blood vessels could express high levels of urokinase receptors—in other words, that these cells might be a good place to study the very kind of thing we wanted to understand.

In another study, we compared urokinase receptors in different types of bladder cancer cells—one set more benign, the other more malignant. We learned that the malignant cancer cells expressed about three times the amount of urokinase receptors as the benign ones.

We also compared the amount of urokinase receptors in healthy coronary artery tissue to that of people with heart disease; while we didn't see a difference in overall quantities, we did note differences in where the urokinase receptors could be found (in diseased arteries, they were closer to the insides of the vessels). We noted what we'd learned and thought about how these discoveries might be part of a bigger picture.

We were publishing in all kinds of journals, too—cancer journals, hematology journals, biochemistry journals. Sometimes I published without Elliot. For example, Jean and I co-authored a publication that identified repeat sequences in a gene that coded for a protein in the rod cells of the retina. I also published an article by myself that presented a technique for optimizing PCR technology.

The things I learned went on and on. That's the thing about basic research: When you're learning everything you can, you can't predict where it goes.

SOMETIMES IN THE LAB, we'd have potluck lunches, and I'd bring in huge trays of Hungarian food, the way my mother always made it. As we ate, I'd tell my colleagues about my childhood or about my early years of research behind the Iron Curtain. Jean and I still got along wonderfully in our shared lab space. We buoyed each other when work didn't go well, cheered for each other's victories, talked often about our families. She helped me navigate my struggles with Judy Swain, and I did what I could to help her, too. For example, when Jean ran into a sudden childcare issue, I arranged for someone Hungarian to look after her children in the afternoons.

I liked it there, that's the thing. I didn't have everything, but I had the things that mattered to me most.

At home, too, we didn't have much, but lacked for nothing. As Susan moved through elementary school, she continued to thrive. She had many friends and so many interests. Sometimes she read for hours at a time; other times, she explored the woods behind our home, doing who knows what, always returning with flushed cheeks and a bright smile. In third grade, she started playing the saxophone, and she practiced all the time. At first, it was the same three notes again and again. Then it was the same *scales* over and over. I almost always worked through the evening when I was home, and while I admired Susan's dedication, I will admit that sometimes I turned around and shouted, "Okay, can we *please* take a break

from practicing now?" The more she practiced, though, the less painful it became to hear her.

She also began to play sports—in fifth grade she took up softball, in sixth grade she ran track. Eventually, she picked one sport for every season. There was a practical reason for this; it extended her days at school, removing some of the pressure on me and Béla. Susan's "childcare" was whatever coach she had at the time.

She didn't complain. Susan almost never complained. Throughout her childhood and adolescence, she happily wore hand-me-down sweaters from the sons of Laszlo and Betty (fortunately, it was the nineties; the oversize look was in). She didn't mind that we went out to dinner only once a year or that during school breaks, I'd bring her to the lab, where she'd sit and read all day. She still went to Hungary, alone, all summer, and every time she called home, she sounded so happy. She'd update me about my mother's chickens and tell me about whatever new food she'd learned to make. After the Iron Curtain fell, she'd tell me eagerly about the American candy one could now find in Hungarian stores. "Mom!" she'd exclaim. "You can get peanut M&M's here now!" (These were her favorite; I was more partial to Goobers.)

Béla and I were different with her. If Susan ever came home complaining about a teacher, my instinct was to start asking questions about what Susan could do differently. Béla used an alternative approach. He'd look aghast, just *absolutely shocked*, then he'd say something completely absurd: "Why, who is this teacher? What kind of car does he drive? I'm going to slash his tires! I'll beat him with a two-by-four!"

He was always kidding, of course, and Susan knew it. The

very idea—that her loving, jokester dad, who prided himself on his humor and honesty and ability to build and fix things, might do something destructive or violent—was ridiculous. "Oh, will you, Daddy?" she'd exclaim, clasping her hands together like a princess who's just learned there would be a ball in her honor. "Do you promise?"

By the time he responded—"Of course I will! Anything for my girl!"—Susan's mood had already lifted.

But even as he joked, Béla remained protective of his little girl, far more protective than I ever was. I wanted Susan to be independent. Actually, if I'm being honest, it was more than that: I *needed* her to be independent. My career depended on Susan's independence.

ANOTHER THING I LIKED about Penn: The university brought the world's greatest scientific minds to campus to deliver lectures. These were the winners of the most significant awards in the sciences: the Louisa Gross Horwitz Prize, the Lasker Award . . . even the Nobel Prize. I attended many lectures, listening intently on two levels simultaneously. First, I wanted to know everything about the lecturers' research, about what they knew, about how they'd made their discoveries. But all the while, I was listening for potential applications for mRNA therapy.

Sometimes I asked many questions of the speaker, which I noticed caused my fellow audience members to shift uncomfortably in their seats. I sensed I was violating some kind of politesse, but I didn't care. Were we building socialites or scientists here?

I remember one lecture when a Very Big Name in science—I'm talking a scientific legend, a real luminary—came to campus. I was so excited. I was ready to drink in everything this researcher had to say. But soon after he began speaking, my heart sank. It was so clear to me from what he said, and what he neglected to say: This science giant, who had once been at the forefront of the field, hadn't kept up with his reading. Listening to his talk felt like opening a time capsule from decades past. In the years since he'd made his breakthroughs, new molecules had been discovered, new mechanisms of action described and articulated, new lab techniques developed that expanded the possibilities of what we could know. But there he was, clearly stuck in time. It wouldn't be the last time this happened, and every time it did, I made a note to myself: *Whatever happens, I must never stop reading. I must never. If I no longer can keep up with my reading, I will not give a talk.*

I sometimes delivered lectures of my own. These were always small, just for our research team, but I always worked hard on them. Then, a few years after I started at Penn, a colleague who had moved to Temple University invited me back there, to deliver a lecture. The talk was about an RNA molecule called ribozyme. Elliot and I, along with a couple of other scientists, had shown that ribozyme could be effectively delivered to the cell with Lipofectin.

I hadn't returned to Temple since that terrible moment when I'd been thrown out and threatened with deportation. As I began speaking, I looked out at the small crowd that had gathered to hear me speak, and there he was: Robert Suhadolnik, the man who'd caused me such distress. *The Boss.* He watched me and listened carefully, and as I spoke, I had flashes

of the night he called me on the telephone and declared that I
could either work with him or go home to Hungary.

That night, after hanging up the phone, I'd said to Béla,
Would it be so hard to be grateful?

It is an important question.

Near the very end of *The Stress of Life,* the book that had
so moved me as a high school student, Selye thinks carefully
about two mutually exclusive responses to stress in human re-
lations: revenge and gratitude. Revenge, he notes, is an at-
tempt to relieve stress. It is a very human response to a threat
to one's security. But revenge, he observes, "has no virtue
whatever, and can only hurt both the giver and the receiver of
its fruits." Revenge brings only more revenge, in an endless
cycle. If the goal is to relieve stress in a way that *enhances* one's
life, rather than detracts from it, there is a better way: One can
be grateful.

Gratitude, Selye explains, is also cumulative. Like revenge,
it brings ever more of itself. But the place where it leads is en-
tirely different. Gratitude amplifies those things on which a
successful life depends: peace of mind, security, fulfillment.

Would it be so hard to be grateful? The truth is, no. It is
rarely so hard. One can find the good even in situations that
end badly. One can always find a way to say thank you.

Standing there at Temple University, with Suhadolnik's
eyes on me, I took a deep breath. Then I told the audience that
it had been a Temple professor, Robert Suhadolnik, who had
brought me to America. I said that he'd given me my start and
that I'd learned a tremendous amount working in his lab. It
was because of Suhadolnik that I'd learned to really harness
the power and possibility of RNA. It was because of him that

I'd learned about nucleoside analogues and the ingenious way that nature can make tweaks to nucleobases. I said that the work I was now doing, and whatever work I'd do in the future, couldn't have been done without Professor Suhadolnik.

The words I spoke were true. Admittedly, there were other true words I could have shared that day. But what happened as I spoke is so interesting. The mind is always so interesting. As I chose *this* story—Katalin Karikó is, above all, grateful—it became more than true, it became *truth*.

I *was* grateful.

After I finished, Suhadolnik approached me, all smiles. He hugged me and said he was proud of me, that it was good to see me. I thanked him politely, now understanding something new: *People forget*. They forget the specifics of how things were, the whole messy story of what they did, or how those things might have affected someone else. And if I demanded that Suhadolnik remember things as I did? If I insisted that he apologize for how he behaved, or feel remorse? I'm certain the only result would be this: I'd wait forever. Some part of me would remain eternally stuck in 1988, threatened by someone who wasn't *even there anymore*. I'd end up like Mr. Bitter, with his grievances and his sour stomach.

No. I didn't want that. I was ready to move forward. Not for his sake, but for mine.

WHEN I WAS FIRST hired, Elliot assured me we'd pursue grants for my work. He was good at writing grants; he'd gotten great funding for his lab, including from the American Heart Association, from the National Institutes of Health, and

from private investors. He was optimistic that my mRNA research would attract funders, and so was I.

I wrote grants all the time in those days. I'd bring them home and work on them all evening, while Susan did homework and Béla installed new kitchen plumbing or constructed new bookshelves. When they both went to bed, I'd keep working. One by one, every light in our neighborhood would go out, except for mine.

I was still working on my English, so these proposals took so much time. Elliot always helped; he would review my applications, tweaking my grammar or helping me reframe the work to make it seem just a bit more compelling. Grantors, he'd explain, need you to *sell* a project. You must show them enough data to make them want to fund it, but not so much data that it looks like you've already done the research. They want ambition, tempered by realism. It's a delicate balance; Elliot understood that balance. He helped me understand it, too.

And yet.

I wrote at least one grant application a month. For two years I did this. I submitted research proposals to private and government agencies and the University Research Foundation. Not one came through. The rejections were always some variation of the same thing:

We have completed our review of proposals, and I regret that we could not fund yours. . . .

Limited likely utility . . .

There is a question about whether the experimental approach is likely to be as useful as the investigators' project. . . .

There is the issue of the stability of mRNA. . . .

I regret that we cannot . . .

I regret that we will not . . .
I hope that you will be able to find other funds. . . .

I read the rejections carefully. I tried to learn and to improve. But the rejections just kept coming. With no luck on the grant side, we approached private investors. In 1994, after I'd been at the University of Pennsylvania for nearly five years, Elliot and I traveled to Princeton, New Jersey, where we made a pitch to an investment firm for support. The meeting went well—great, in fact. A team of men in expensive suits and silk ties listened carefully, asked good questions, then shook our hands enthusiastically. They told us they'd give us money—I believe they promised $70,000. Elliot and I returned to Philadelphia confident that we finally had support for my work.

And then . . . nothing. We never heard from these investors again. They ignored our follow-up calls and emails. To my knowledge, the word *ghosting* didn't yet exist, but that's exactly what they did. They ghosted us. (Sometimes, today, I think about those investors, and I wonder if they are kicking themselves; surely, that would have been the best $70,000 they had ever spent.)

Anyway, I never got a dime for my mRNA projects. As you might imagine, this didn't go over so well at Penn.

THINGS WERE DIFFICULT IN those years—for everyone, it seemed. There was extraordinary turnover—some might call it a mass exodus—among cardiology faculty. In fact, before long, it felt as if the department had been almost completely overhauled.

Fortunately, Elliot was one of the few who had stuck around. In his lab, I was learning every day. I was contributing to a body of knowledge. I was pursuing something that I was certain would be useful . . . someday, to someone, even if it was only in a small way, even if it didn't happen in my lifetime. I was content to stay here for as long as I could.

In January 1995, doctors discovered two lumps in my breast, which they suspected were tumors. The doctors tried to take a biopsy, but the lumps were too calcified. This was bad news, and it meant I had to go straight to a lumpectomy operation (luckily, the lumps were benign). I drove to the surgery with Béla, and when it was over, we returned home, where I went to work on a grant that I did not get.

Almost immediately after my diagnosis, Béla received a letter in the mail. It was time to renew his papers; he could pick up his green card in the U.S. embassy in Hungary. He returned to Hungary, staying with my sister, who lived in Budapest. It would be a short trip, we thought. But when Béla returned to Zsóka's apartment after visiting the embassy, he shook his head sadly. "You've been my sister-in-law for a long time now," he said. "So, I have a question: Do you love me?"

Zsóka gave him a funny look. "Sure . . . ," she said, a little cautiously.

"Good," Béla said. "That's good that you love me. Because it seems like I'm going to be staying here for several months." The process of getting his green card, apparently, would take considerably longer than expected.

Soon after Béla found himself stuck in Budapest, Elliot called me to his office. Elliot was quieter than usual. His face

looked pained. After a few long moments, Elliot shook his head, told me he was sorry, but he had a message from Judy.

My time was up. Five years had passed since I'd been hired. My up-or-out moment had arrived. And apparently, the calculation was simple: I hadn't brought in money. No grants, no private funding. This was apparently what anyone needed to assess my value to the institution: I had none. The message from Judy, the chair, was this: I would not be promoted to research associate professor.

My mind raced with all the other ways I *might* have been evaluated. I'd done terrific experiments. I'd published papers, and more were on the way. My colleagues had turned to me again and again for help designing experiments. Meanwhile, I was working steadily toward a very big idea, that mRNA could someday be used therapeutically. Okay, this research hadn't gotten much attention in the halls of Penn, not yet, but it was a *really great idea*.

But those weren't the criteria that mattered.

"I'm sorry," Elliot said. I could tell this was true. He was sorry. But an Ivy League research institution is so much bigger than any one clinical researcher. There simply wasn't a path for someone like me. I wasn't moving up, so it was time for me to move out.

But . . . what if I didn't? What if I just . . . stayed on? That's what I asked Elliot next. Did I have to leave?

As I said, no one had ever stayed past this moment without getting a promotion. There wasn't even a title for a former research assistant professor who had been denied promotion but stayed on anyway. There had never been a need for one. We were in uncharted territory here.

It would be a demotion, that's for sure. But still: What if I stayed?

BY FEBRUARY, I HAD a new title, senior research investigator. Béla was still in Hungary, still sorting out his visa. We talked on the phone sometimes, and when I told him my new title, he thought for a moment. "You're saying no one at Penn has ever had this title?"

"I don't think so, no."

Béla chuckled then, in that way that always made me feel like all was still okay with the world. "Then you've made history! Congratulations!"

I would have liked to talk to Béla for longer. I missed him terribly. But in those days, long-distance calls were so expensive. We could never talk for long. All around me were reminders of his absence: stalled home renovation projects, tools that lay untouched for months. Béla had been rebuilding a salvaged car when he left, and the sight of all those engine parts scattered on the garage floor filled me with an almost physical ache.

With Béla gone, I tried to really be there for Susan, to balance the demands of being a working scientist and a sole caregiver. I did what I could. I listened to her practicing her saxophone—she'd joined a jazz band at school and was playing real songs now, a relief after all those scales. I picked her up from basketball practices, cheered at her games (sometimes so loudly she shot me looks from midcourt). I helped with her homework.

But with Béla so far away, I was more aware than usual of my lack of options.

———

IN FEBRUARY, SUSAN NEEDED to do a project for social stud-
ies. The theme was South America. She was to write a report
in the style of a travelogue—as if she herself had traveled the
continent and was reporting on what she'd seen. She asked for
my help.

In 1995, there were still travel agencies that operated out of
storefronts. You could walk in and pick up brochures about
different destinations. Then, once you knew where you wanted
to go, a travel agent would plan the whole thing for you. They
created the itinerary, booked hotels, made plane reservations.
Well, I couldn't afford to go anywhere, but I drove to a travel
agency and picked up brochures for South American destina-
tions: Chile, Brazil, Peru, anything from the continent they
had.

That night, I sat with Susan as she cut out pictures and
started to write her report. We looked at maps together, fig-
ured out what routes she might take through this imagined
journey, discussed how she might lay out the project. I was
delivering a lot of poster sessions in those days, so I had adhe-
sive spray and markers. I brought these out, and with me sit-
ting by her side, Susan began to lay out one page at a time.

We both assumed the project might take a couple of hours
at most. But by the time she put on pajamas and brushed her
teeth, she still had plenty of work to do.

"Mom, what if I were to put this nice big picture of Machu
Picchu on this left-hand side, then set Lake Titicaca and Lima
on the right?"

"Hmm . . ." I frowned, eyeing the map. "See, Machu Pic-

chu is between those other two destinations. Could you fit Lima and Machu Picchu on a single page?"

Hours passed. Susan kept writing and writing, as I worked with the pictures and proofread her report. We kept checking the clock; if she finished soon, she could still get seven hours of sleep. Then more minutes ticked by, and we'd adjust our expectations; maybe she could still get five hours. Four and a half hours. Three and a half.

I'd long gotten accustomed to how still the neighborhood became in the quiet hours between night and morning. Susan was experiencing this now for the very first time. She must have inherited my ability to go without sleep; she didn't seem tired at all. To the contrary, the longer Susan worked, the more resolved she seemed to make this project something really special. I noted her determination, her focus, the way her jaw was set in absolute concentration.

Before we knew it, the first crack of light was appearing in the east. Susan was still in her pajamas, putting the finishing touches on her project, when it was time to leave for school. We grabbed the report and some school clothes, and she dressed in the car.

I dropped her off and watched her walk toward the entrance of the building. It was like seeing Susan in a new light, catching a glimpse not of the child she'd been but of the person she would become. *She's so determined,* I marveled.

BY THE FOLLOWING MONTH, Béla still wasn't back. I missed him so much, I didn't know what to do with myself. I wrote letters to then president Bill Clinton. I wrote letters to the

First Lady, Hillary Rodham Clinton. I wrote letters to the American embassy in Hungary, to lawyers, and to immigration offices. I told them that my husband was stuck overseas and that we needed him. Wasn't there anything they could do?

If I heard back, it was always the same. *Be patient, there is a process.* But I have never had much patience for other people's processes.

Béla's thirty-fifth birthday, March 18, fell on a Saturday that year. On that day, Susan and I packed up the car and drove to Washington, DC. There, we staged a two-person protest in front of the White House.

It wasn't much of a protest, to be honest. Just me and Susan holding signs (Susan's read, LET MY FATHER COME HOME!) that nobody in power—let alone Bill Clinton—would ever see. But it was an *official* protest; we'd gotten a permit. I wanted my daughter to see that in America a person could do this—could stand in front of the place where the president lives and say, "I don't like something. I am calling on you to do something different." It's something that would have been unimaginable to me as a child in communist Hungary.

In front of the White House, Susan brought out her saxophone. She played music she had learned in jazz band, songs like "Turn the Beat Around" by Gloria Estefan, "Colors of the Wind" from Disney's *Pocahontas*, the theme song from *Forrest Gump*. A few kids who were on a class trip approached Susan, curious about what she was protesting. "My father is stuck in Hungary," she told them, "and I want him to come home."

By the time Béla finally got his green card, many months had passed. It was summer when he returned. (Had he brought

the sun or was it the sun that returned him to us? Either way, warmth had come again.) Laszlo Bagi made a huge banner reading WELCOME HOME, BÉLA, which we hung between the trees in front of our house. When Béla finally walked up that path, as handsome and loose-limbed as on the night I met him, we cheered.

There was a funny moment soon after Béla returned when we happened to have two saxophones in the house—we rented Susan's instrument, and there was a slight overlap between rental contracts. While Susan practiced on her new saxophone, Béla picked up the old one and tried to blow a few notes. I'd forgotten how terrible a first-time saxophonist sounded. Susan tried to intervene, teaching him how to hold his lips, his cheeks, his fingers. Her lessons only made things worse. "No more noise!" I complained. The next thing I knew, Béla and Susan began chasing me all around the house, blowing into their saxophones as loudly as they could. I covered my ears, running from room to room trying to get away from this awful cacophony, and all the while I was thinking, *I am so happy. I am so happy to have my family together again.*

SOME MOMENTS IN THE lab you don't ever forget. These are the occasions when you walk right up to the outer edge of human understanding. Then you take another step, crossing the threshold—breaking through—into new discovery.

In December 1996, Elliot, I, and Alice, the lab technician, were standing around a dot-matrix printer. It was almost Christmas. Holiday lights were everywhere. The weather was strangely warm in Philadelphia that year; by the time I showed

up at Betty and Laszlo's for Christmas Eve dinner, it would feel like springtime.

But I wasn't thinking about any of that.

In front of me, the printer had come alive, laying down its lines of dots. Again and again, we listened to the printer's insectlike *zzzzzzck*, three seconds at a time, followed by the *cla-clunk* of the printer returning to the start of the next line.

We had done an important experiment, the culmination of years of work. This experiment was the thing toward which we'd been working since I first joined Elliot's lab seven years prior.

We were testing whether we could coax cells to make the urokinase receptor by delivering the encoding mRNA.

We'd begun with a group of cells that did not, on their own, make the urokinase receptor protein. We divided these cells into two groups: our experimental group and our control group. To the experimental group, we delivered lipid-packaged mRNA that coded for the urokinase receptor protein. To the control group, we delivered a different kind of lipid-coated mRNA, which did *not* code for the urokinase receptor.

We'd been fastidious, just as we had been with all the research that led to this moment.

We gave the cells time to begin translating the mRNA. Then, because urokinase receptors cannot be seen with a microscope, we added to both groups of cells trace amounts of radioactive molecules known to bind specifically to urokinase receptors. Alice was the master of making such molecules. The binding, if it occurred, would operate almost like a lock and key: The urokinase receptors were the lock, and these labeled

molecules were the key. If the cells had made urokinase recep-tors, they would hold these radioactive molecules in place.

We gave this time, too.

Then Alice began to "wash" cells—rinsing away any of the radioactive molecules that hadn't bound to any potential urokinase receptors. She washed the cells repeatedly, many times, so that we could be absolutely sure of our results.

If any radioactive molecules remained, it could be for one reason only: They had bound to urokinase receptors. And if urokinase receptors were present? Well, that meant the mRNA had worked.

Zzzzzzzck, cla-clunk. The radioactive molecules were being measured by something called a gamma counter, which was attached to the printer. We leaned in toward this printer, watching as a single line of dots appeared at a time.

Zzzzzzzck, cla-clunk. Whatever the results were, everything that mattered had already happened. It had worked or it hadn't. Whatever the results were, we'd learn from them. I reminded myself of this: One always learns.

Zzzzzzzck, cla-clunk. I met Elliot's eye, then Alice's. Christ-mas lights blinked. On and off, on and off. Was that a number forming on the page? It was.

Zzzzzzzck, cla-clunk. Gradually, the data began to form on the page. The experimental group had tons of radioactive ma-terial. But the control group? None.

Oh my God (we said this so many times: *Oh my God, oh my God, oh my God*): The results were beyond doubt. Our experi-mental cells were *actually making urokinase receptors on their surfaces*. We had successfully used mRNA to make a specific

protein inside a cell. And we'd done it using technologies that were simple and inexpensive.

There was tremendous clinical potential here.

THERE'S A FAMOUS STORY, possibly apocryphal, about Archimedes lowering himself into a bath and figuring out, in a flash, the principle of the buoyant force. In his excitement about his breakthrough, he ran naked through the streets of Syracuse, shouting, literally, "Eureka!"

Some scientists store champagne in a nearby refrigerator—keeping that bottle cooled for years or even decades—just waiting for a moment of breakthrough.

By any measure, this was a breakthrough. A major one.

But Elliot, Alice, and I did not sip champagne, nor did we run (clothed or otherwise) through the streets of Philadelphia, or even through the Johnson Pavilion, where our lab was located.

The truth is, I did at that moment the thing I always did: returned to work. Already, I wanted to try this same experiment with different cell lines, using different quantities of mRNA. My mind was racing with a million ways to tweak this experiment, to retest, to reproduce the results again and again. As always, I wanted to make sure that this result was beyond doubt, that anyone else, taking the same steps, would be able to reproduce our results. I also wanted to see if we could get a better result, even more proteins.

But still, there is nothing like being the first to know something that no one else has ever understood (Here is how to make a urokinase receptor from mRNA you made in a lab,

look what you can make cells do!). In that moment, as an unseasonal warm front passed through the City of Brotherly Love, creating a surreally balmy winter holiday, I felt powerful, wholly triumphant.

ELLIOT WAS A GOOD man, and a good scientist. But there was another thing about him: He had a great head for business.

He'd filed patents on some of his research related to preventing cardiac blockages; those patents had been licensed by a biotech company, which then had a successful public offering. An IPO is an arduous process, and Elliot had proved himself to be a sound, wise member of the team. He'd helped lead many external meetings with venture capitalists and pharmaceutical executives, doing everything from scientific planning to investor pitches.

Within Penn, he'd also proved his business savvy, coordinating efforts between our lab, a chemistry lab, a vascular surgeon, and the corporate technology department.

Elliot was terrific with people. He could think on his feet. He could explain big ideas. He could move seamlessly among widely different people: lawyers and chemists, biologists and executives, investors and doctors. A lot of employers could use a guy like Elliot.

I suppose I should have seen what was coming.

A FEW MONTHS AFTER our dot-matrix moment, Elliot received an offer to head up a cardiology group at Centocor, a biotech company largely known for monoclonal antibodies.

Monoclonal antibodies are like the antibodies made by the body—they neutralize pathogens or harmful molecules—but they can be produced in a standardized way in a lab. They're a highly targeted way to fight illness and they're extremely effective.

The job was a natural fit for him; Centocor had a particular monoclonal antibody therapy in development called ReoPro, which helped prevent blood clots. By 1997, ReoPro would have FDA approval; on the day that news was announced, Centocor's share price would jump from $2.56 to $52.

This was obviously a tremendous opportunity for Elliot.

What I'm saying is that I understood *why* Elliot would accept Centocor's offer.

I simply didn't understand what would happen to me now that he was leaving.

I LOVED ATTENDING SUSAN's athletic events. I loved the sounds of the games—all those sneakers squeaking on gym floors, the chaotic shouting in the bleachers during an especially exciting moment. The crack of a bat when it hit the softball just right or the kind encouragements offered after a third strike. *It's okay, it's okay, nice try.*

I loved how thoroughly a bunch of adults could lose themselves completely in a game that had zero stakes beyond the hopes and heartbreak of children who might never even remember that day. And I adored all those can-she-or-can't-she moments when an opportunity would arrive for a young athlete, and you just didn't know if she had what it took to rise to the challenge. Often, she didn't. But occasionally, a player

would surprise you. That's when every parent and coach would erupt in roars.

Sitting on the sidelines, I was one of "those" moms: I cheered too loudly. I leaped to my feet and shouted directions from the sidelines, waving my arms like some sort of air-traffic controller gone mad. I invariably embarrassed Susan, who either ignored me completely or shot me such fierce looks that other parents would turn to me with eyebrows raised. "Uh-oh, you made her mad!" they'd say, laughing. Since I always shouted in Hungarian, they'd have to ask me what I'd said.

As an athlete, Susan was . . . okay. She played with great spirit, she had some athletic intuition, and she loved being a part of the team. I could also tell that some part of her desperately wanted to win. But she didn't seem to believe in herself. I could see her hesitating out there, holding herself back, as if afraid to make a mistake. This, of course, only made me shout louder.

I remember during one of Susan's basketball games, early in high school, I spent the entire first half yelling at her in Hungarian. By this point, she'd actually made a rule: no yelling in Hungarian ("It's embarrassing, Mom!"). But I just couldn't help it. When I got excited, as I always did during her games, I slipped into the language that came most naturally. In this game, Susan had been on offense, but you'd never know it. She was even taller than I was by now, six feet two, but she still spent the first half hiding behind the defender. It was perfectly clear she didn't want anyone to throw her the ball. I knew she wasn't confident in her ball-handling skills, and that if she took a shot, she'd very likely miss. I knew that missing the shot

would be devastating. But I also knew something else: She'd never improve if she continued to hide like that.

"Gyere előre, ne bujjál el!" I shouted. (Get out in front, don't hide!) "Be aggressive! You can *do* this!"

I yelled and yelled, and did not stop until halftime. That's when Susan's coach turned around and pointed at me in the stands. "Whatever your mom is saying," the coach instructed, "do *that*."

Susan had a teammate, Holly, whose mother, Janet, was as loud as me. We used to sit next to each other in the stands; together, we created twice the spectacle. Janet sometimes brought cheerleading pom-poms to the games. These pom-poms were apparently to Holly what my Hungarian was to Susan: *completely mortifying*.

At around the time Susan announced her no-Hungarian edict, Holly banned Janet from waving the pom-poms. Thereafter, Janet gave *me* the pom-poms, which I shook high above my head. Eventually, the girls banned both Janet and me from attending the games at all.

Still, I'd do it all again if I could: the cheering, the pom-poms, every loud, embarrassing moment. I think it matters, having your own personal cheerleader. I think everyone deserves to know, *Here is someone who believes in me. Here is someone who believes I can do great things, and who will never, ever quit rooting for me.*

WHEN ELLIOT LEFT PENN for Centocor, help came in the form of an old friend.

David, the medical student whose work I'd once tossed in

the trash, declaring it "shit," had long ago finished his fellow-ship in Elliot's lab. He'd returned to medical school, gotten his MD, and finished his internship. Now he was a neurosurgery resident at Penn.

We'd stayed in touch through the years and even continued publishing some papers together. David still read everything I handed to him and asked me a million questions, too. I swear, sometimes it felt as if David were trying to download the contents of my brain to his own. I suspect he would have done that, too, if only he could figure out how.

"Someday, Kate"—he always called me Kate, as if I'd grown up down the road from him in Cherry Hill, New Jersey—"I'm going to know everything you know." Then he'd flash that mile-wide grin.

I'd shake my head in response. "Ah, but I'm still learning," I'd tease. "By the time you know what I know now, I'll know even more!"

David had stayed at Penn for his residency, and he was intent on joining the clinical faculty when he finished in two years. This would require at least one sacrifice. He'd hoped to be a vascular neurosurgeon—an incredibly specialized type of physician who operates on the blood vessels of the brain and spine, providing potentially lifesaving care for patients affected by strokes and brain aneurysms. Obviously, he had a deep connection to this work because of his father's stroke. Vascular neurosurgery would have been a great fit for him in other ways: These surgeries are intense and require a very specific type of personality. A vascular neurosurgeon needs to be able to make smart decisions quickly in the most intense, highest-stakes situations. They need to be nimble, to think on

their feet. Perhaps most important, they need to be relentless about learning and improving.

David, by now, had proved that he was all these things.

Unfortunately, Penn wouldn't need another vascular surgeon—they needed a spine surgeon instead. David seemed happy enough to commit to this work. His future was laid out: He would split his time between clinical work and basic research . . . and he wanted to work with me.

Even though we weren't in the same lab or department, David remained all in on mRNA therapy. In fact, he'd had a new idea: Maybe mRNA could be used to prevent cerebral vasospasm, a dangerous narrowing of the blood vessels of the brain, which can occur after an aneurysm or stroke. He explained that cerebral vasospasms are potentially fatal and entirely too common, and that there was no good way to prevent them from happening.

But nitric oxide causes blood vessels to dilate (expand). If you could deliver nitric oxide to these narrowed blood vessels, you'd counter the effects of the vasospasm. Unfortunately, because nitric oxide is a gas, with a half-life of mere milliseconds, it can't be injected. David hypothesized that we could create an mRNA therapy that would code for a protein that made nitric oxide—a potential therapy with a clear, lifesaving effect.

By the time Elliot announced his departure, David and I had been working across departments for a long time. Our cross-department connection wasn't so unusual; for years, I'd been seen as "that crazy mRNA lady" around Penn. Every time I met a physician or researcher, I'd tell them that I could make mRNA, that I could work with any kind of RNA, did they need any?

What *was* unusual, though, was how deeply David believed in the work. Not only had he managed to secure a small grant—about $25,000, if I recall correctly—for our work, he'd also delivered a paper at a conference in Arizona: "Bypassing the Nucleus: mRNA as Gene Therapy." I guess it's fair to say that David wasn't merely a believer in mRNA—he'd become an mRNA evangelist.

David knew that when Elliot announced his departure, there wasn't much hope for me at Penn. I had no grants, no funding, no respect from anyone with any formal power. Penn's Institute for Human Gene Therapy was almost fully operational now, with a $25 million budget; links to numerous biotech companies; and plans for early-phase clinical trials related to cystic fibrosis, breast cancer, muscular dystrophy, brain cancer, and a rare genetic condition called ornithine transcarbamylase (OTC) deficiency. All the attention was on these efforts.

Elliot's lab had been a bit like a protective force field—a lipid envelope, really, protecting me from forces that surely would have otherwise degraded me by now. Without Elliot, my days at Penn were numbered.

David took this threat to my career as seriously as he took literal brain surgery. "But this place can't lose you, Kate," he fumed. "*I* can't lose you. And, anyway, what will you do about your green card status?"

I assured him I'd be okay, I'd figure something out. Maybe there was another lab, in another university. I'd done that stint in Bethesda, after all. I could find another bench somewhere. I didn't say the other thing I was thinking: Susan was in high school now, and she wanted to attend Penn. I had no idea if she

could get in, but I was certain that without the discount that the university gave to faculty and staff, we'd never be able to afford it.

David remained furious. His rage extended beyond my situation. His dad had been close with many of the Penn cardiologists who'd left under the new leadership. In fact, his dad's best friend and David's godfather, Mark Josephson, had been the cardiology head who'd been fired, only to be replaced by Judy Swain. As far as David was concerned, what was happening to me was an extension of what he'd seen happen too many times already.

"Kate," David pressed, "you're an amazing scientist. You work your ass off. You have all the right intentions. And you have a great fricking idea. So, fuck politics. Fuck Bill Kelley. Fuck Judy Swain. If cardiology doesn't want you anymore, I'll make sure someone does."

David approached the chair of the neurosurgery department, Eugene Flamm. He insisted that their department really, *really* needed a molecular biologist. They needed *me*. Mind you, David was just a resident then. This thing he was doing— telling a department chair how to staff the department, suggesting changes to structure and hiring and by implication workflow and priorities and funding—was so far out of the usual protocol, he might as well have been telling the head coach of the Philadelphia 76ers who their first-choice draft pick should be.

But David was nothing if not confident. He adored Penn and he wanted the place to be great. Hiring me, he insisted to Eugene Flamm, was exactly what the place needed to be great. David planned to partner with me on research. Shoulder to

shoulder. Indefinitely. And we could do that only if I became a member of the neurosurgery department.

David was always so passionate, and his energy was infectious. He knew how to make a persuasive argument, too. Apparently, Eugene Flamm wasn't immune to any of this. Before long, I became a full-time member of the neurosurgery department.

I was so grateful, but David just waved away my thanks. "Stop, Kate!" he'd insist. "I'm being totally fucking selfish. For the rest of my life, I get a great person to work with. Neurosurgery gets your expertise. Penn gets the research we'll do together. This isn't just win-win, it's, like, *win, win, win, win, win.*"

Later, too, when he was asked by other physicians, why are you working with her (That's always how they asked it, too; why are you working with *her?* Again and again, he got this question), David—a superstar in those halls, a guy who frankly could have worked with anyone—never once failed to sing my praises: "Because she's brilliant," he'd say. Or, "Because she's not merely chasing grant money, she's trying to do something." Or even simply: "Because this idea of hers is going to work. I'm telling you, we're going to make it work."

As I say, it matters to have your own personal cheerleader. It helps to have someone who believes in you, someone who, when the going gets tough, will never quit rooting for you.

DAVID AND I WERE like characters from a buddy-cop movie—as different as could be. I was so compulsive, exacting; David was all wild motion and big energy. I was practical,

matter-of-fact. David wore his passions exuberantly on his outside, as if he were wrapping himself in a cloak of everything he felt. My eye was fixed on the long-term horizon. David was so eager, he rushed headlong toward every opportunity.

Once, David was invited to present a poster about mRNA at a big medical conference in Washington, DC; he'd taken the day off and hopped on an Amtrak, his poster tucked firmly under his arm. He'd arrived eagerly at the conference center only to find . . . nothing. No one was there. This massive conference center was completely empty. The only person he found was an older guy vacuuming the hallway. Bewildered, David approached the man. "Is there a science meeting here?"

The guy shrugged. "Not today."

It turns out David had shown up a week early. I was so hypervigilant, so obsessive, I could never imagine doing such a thing!

But David's exuberance came with advantages. He was fearless. When we struggled with the right lipid formulation to deliver mRNA to the cells, David didn't hesitate to pick up the phone to call any researcher who might be able to help. I'd hear him on the phone, inviting himself to their lab or home without an ounce of hesitation, and I'd marvel that someone could be so comfortable doing that.

And for all our differences, David and I shared some important traits. For one thing, we both had zero patience for complacency.

There were so many researchers who worked beautifully within the system of academic medical research. They got along with their colleagues, they joined committees, earned

every gold star. By nearly every measure, they were success-ful. But they were so *incurious*! They had grants that funded their work and seemed happy enough to live off those. They wanted a nice life, and had one, and that was enough. I sup-pose there was nothing wrong with that.

But David and I were hungry. We wanted to learn every-thing, examine closely, leave no stone unturned, make a differ-ence. For better or for worse, we were both cursed with what Hans Selye had described as "a consuming, uncontrollable cu-riosity." Together, we chased one more thing, and one more thing, and then still one more thing after that. Sometimes I complained to David about the strange lack of curiosity I saw among people who were, in theory, at the top of the scientific hierarchy, and he would try to place it in context. "Doctors are trained to have tunnel vision," he'd tell me. "That's just how they are."

"Yes, but—"

"I'm telling you, Kate, it'll make you crazy if you try to change it."

I'd sigh, and then we'd both get back to whatever puzzle we were trying to solve that day.

We arrived early, we worked late. When David left the lab, he headed to the Schuylkill River, where he'd row with the same intensity he brought to our lab. Then he'd return to work, and I'd still be there, my eyes focused on a ream of data.

We cloned the gene that directed the making of the induc-ible nitric oxide synthase (iNOS), the protein that makes nitric oxide, and we used it to make mRNA day after day after day. (David, by now, could make mRNA beautifully; for the rest of my career, I'd compare everyone's work to his.) We treated

cultured cells with iNOS mRNA in vitro to see if they would make nitric oxide. When they did, it meant that we had made the mRNA correctly. Then it was time to test it in animals. We put iNOS mRNA into pig brains and peered through a cranial window to see if the blood vessels would dilate, recording on tapes to document it. David knew of some preeminent researchers at the University of Chicago who studied cerebral vasospasm in monkeys. We visited their lab together, carrying iNOS mRNA in an ice bucket. (Their system didn't work while we were there, so we couldn't determine if the mRNA worked in animals.) David also made a connection with a guy named John German at the Toshiba Stroke Research Center in Buffalo, New York; I traveled to Buffalo in a swirling snowstorm to test our mRNA on rabbits. There I was given specific instructions for how to scrub in. The directions were extremely detailed, and the whole process reminded me of my father washing up before starting his work back in Kisújszállás. When I mentioned to Dr. German that this operation on the rabbit reminded me of my father's profession, he brightened. "No kidding!" he exclaimed. "My father is also a neurosurgeon. And my grandfather, too!" He told me that in fact that grandfather, William German, had helped establish the first neurosurgery department in the United States, at Yale University.

I laughed at the misunderstanding. No, I explained. My father had done a very different kind of work. At any rate, this particular test couldn't prove that the iNOS mRNA had the effect we wanted.

David and I did have some successes; before testing the

iNOS mRNA in animals, we proved that in cultured cells it translates into functional protein. But the effect in animals was curiously limited. We got a couple of publications out of our work—David and I published a study in which we showed that mRNA could get the rat brain to express luciferase. We also published together a study showing that a phosphate buffer yielded high levels of protein expression from mRNA. But we agreed we needed stronger, more consistent, more *reproducible* results. We wanted to see it working not only in vitro (in cells isolated from the body) but also in vivo (in a living animal).

Fortunately, we were both still young . . . or at least young-*ish*. We had years to figure this out.

AS I SAID, DAVID hoped to be a vascular neurosurgeon, but he hadn't been able to do that work at Penn. He had made his peace with being a spine surgeon. He seemed happy. But when Eugene Flamm accepted a job offer at a new neurological institute in New York, he invited David to come along. David said yes.

At this point, I'd been in the neurosurgery department for only two years.

It was a difficult goodbye. "I'll put in a good word for you with the new chair," David told me. The new neurosurgery chair, Sean Grady, was joining Penn from the University of Washington. Grady had a great pedigree—med school at Georgetown, residency at the University of Virginia, training under the superstar neurosurgeon who'd worked on Christo-

pher Reeve—as well as the square jaw, blue eyes, and facial symmetry of a television news anchor.

I shook my head. "Nobody's going to make RNA like you," I told David. "Everyone else will disappoint me. I know this already."

David smiled, though his eyes were rimmed red. "I did manage to learn a few things through the years, didn't I?"

He really did.

When he spoke again his voice shook. "I always thought I'd stay at Penn for the rest of my life. I figured you and I were going to save the world together with our mRNA therapies, I really did." David raked his fingers through his hair a few times. "But maybe I'm supposed to save the world in a different way."

I thought about David's father, the way a stroke had stolen everything. This event, which had so ruptured their family, was part of David's origin story, just as my own father's career as a butcher and his sudden death from a heart attack had been part of mine.

David needed to do this. Of course he did. Still, the decision was clearly a painful one for him.

When I'd first met David, I'd understood that he would be given abundant opportunities. Now I wondered if having lots of options might be its own sort of burden. If many doors are open to you, but you can walk through only a handful in one lifetime, do you live forever haunted by what-ifs?

Finally, David smiled, with that wide, infectious grin I'd come to know so well over the last decade. "You know you're never actually getting rid of me, Kate," he said. "I'm going to call you all the time."

"I know you will, David." Then I added, "I'll be okay. And I'm happy for you." What else could I say? David had been my cheerleader when I needed one most. Now it was my turn to cheer for him in this new life.

For the record, I was right: No one I've worked with since has ever made mRNA as well as he did.

PART
FIVE

—

Susan's Mom

THE WORLD WAS CHANGING FAST. WHEN I ARRIVED AT Penn, the science library still used card catalogs, and science journals had to be read in print. By 2002, a little more than a decade after I arrived, all that would change. Science publications, including back issues, would be digitized; I could read them and save them to my laptop from anywhere in the world. But in 1997, the year I moved to neurosurgery, I still wandered through remote stacks of the library, picking up hard copies of *Cell*, as well as dozens of other journals, flipping through physical pages one at a time.

When I found an article that interested me, whether at home or at Penn, I always made a copy. This meant I was never far away from a photocopier. I even began to consider one of Penn's copiers "mine." Most of the time, I had it all to myself.

One day, I noticed a newcomer using "my" copier: a serious-looking guy of indeterminate age. He was balding a bit but had no wrinkles or jowls. *Younger than me,* I thought. *But maybe not by much.* He wore a button-down shirt, tucked neatly into unwrinkled khakis. Comfortable, well-made shoes. The outfit of a pragmatic, unflashy man. He acknowledged my presence with a tiny, solemn nod, then returned to his copying.

I waited my turn but I didn't like it.

He copied page after page, then moved on to a new article. Who was this interloper, anyway? Was he planning to stick around? Was I going to have to wait for my copier more than once?

I did the only thing I could under the circumstances. I introduced myself.

This was Drew Weissman, the man whose name would someday be forever linked with my own. Drew had just come to Penn from the National Institutes of Health, where he'd been a fellow in the renowned lab of Dr. Tony Fauci. I hadn't heard of Dr. Fauci at this point, but when Drew offered no further explanation, I understood that "Tony" was a big deal. I asked more questions. Drew answered each politely and succinctly. Drew was an MD-PhD, an immunologist and microbiologist. He had just started his own lab at Penn; it was small, but he had big plans for it. He wanted to find new vaccines for infectious diseases: influenza, herpes, HIV, malaria. He told me he was currently working on an HIV vaccine.

In those days, I talked about mRNA with all who would listen, regardless of their department or field of study. I'll admit, I was a bit like a street vendor, hawking my big idea to anyone who might want it. *mRNA! Get your mRNA right here! I've got mRNA for heart surgery! mRNA for brain surgery! I'll give you mRNA for whatever therapy you might need! Trust me, you won't find better mRNA anywhere!*

Until this moment, my mind had been so occupied by the therapeutic potential of mRNA, I hadn't been interested in vaccines. Now, standing by the photocopier that I resented

having to share, I began to see a whole new prospect for mRNA.

You need mRNA for a vaccine? Sure, I can do that, too!

When I described my work to Drew, his quiet deadpan transformed into something new. The reaction was subtle, the tiniest widening of the eyes. In another person it might have meant nothing. But for a guy as understated as Drew, this little flicker of muscle might as well have been an audible gasp: I could see that I'd gotten his attention.

It turns out Drew had recently done an assessment of all the different ways he might deliver an *antigen*—a molecule that triggers an immune response (such as a virus, bacterium, or parasite)—to cells for vaccine development. He'd determined that he and his lab staff had access to every possible method except one: *He didn't have access to mRNA.*

Drew himself had no experience with synthesizing RNA. Now by sheer coincidence he was standing next to an mRNA researcher! As I look back, the serendipity of this feels almost unbelievable. Sometimes even science, with all its rigor and discipline, depends on plain old luck.

All of which is to say, by the time David, my second Penn physician collaborator, departed for his new life in New York, I'd already met and begun doing some studies with my third: this studious, photocopier-hogging immunologist.

NATURE IS FILLED WITH lock-and-key partnerships, in which two very different molecules—an enzyme and the substrate it acts upon, for example—fit together exactly right. When the

two find each other, their complementary parts snap securely into place, and a remarkable chain of events unfolds.

Again and again in biology, lock meets key and big things happen.

I didn't know it yet, but standing there at the copy machine, I'd just clicked into my own lock-and-key system. Drew and I were very different, but each of us had exactly the knowledge and skills that the other needed. I was an RNA scientist who didn't know much about immunology. He was an immunologist without RNA experience. Our connection would set into motion a cascade of events that would change... well, everything.

SUSAN WAS CHANGING, TOO. She was starting to think about colleges.

I still wanted Susan to attend Penn. For nearly a decade, I'd been surrounded by people who'd insisted there was no better place to learn. Penn, after all, was the Ivy League, one of the best universities in the country. It was the Szeged of America. The tuition discount was significant, too. The path, to me, seemed clear.

Susan, by now, wasn't convinced. She wanted to attend college in California instead. When UCLA sent her some brochures, complete with a parking pass, she waved the pass around the kitchen. "But look, Mom!" she exclaimed. "I already have a parking pass! I'm practically a student already!"

No, I said. California required cross-country flights. Airfare was too expensive. Barring any surprises, her path would

be Penn or Penn State. Both great options, but I knew which I wanted for her.

For the first time, Susan and I began to fight over academics—about homework, how well she'd prepared for quizzes, whether her grades were as high as they needed to be. And, oh, those SATs! I purchased every SAT prep book, and in the little free time we had together, I drilled her on vocabulary words. *Accede, berate, dearth, hackneyed, perfidious, restive, vindicate.*

The vocabulary words, like our arguments about the SATs themselves, went on and on.

Susan would rather have done anything than study for that test. More than anything in our lives before or since, the SATs, and my expectations about them, caused friction between us. At the end of each day, I'd ask her, "How many hours did you study for the SATs?"

"I read a book," she'd respond. Which was fine, but she didn't answer my question. And would that book get her into Penn? I remembered how obsessively I'd studied in high school—how high the stakes had been. I couldn't understand why she wouldn't want to work just as hard.

Béla, though, always told me to leave her alone. "She's doing well," he assured me. "Everything's fine."

"It's not fine!" I'd insist. "Penn is one of the hardest schools to get into in the whole country!"

These fights, of course, were about more than just one test. I wanted everything for Susan—not just Penn, not just an outstanding education, but also the fire and tenacity she would need in a world that might be wholly indifferent to her. I wanted

her to go after whatever she wanted with everything she had. I worried that holding herself back on the SATs meant she would hold herself back in other ways, too. So I pushed, and she resisted, and we each declared the other to be stubborn.

Sometimes, though, we'd take a break from all this fighting about grades and standardized tests and college applications. After dinner, we'd head outside to play a bit of basketball, all three of us. Even then, I didn't let up. I know that some parents, when playing games, go easy on their children. They pretend to play just a little worse than they otherwise would. They give less than their all, intentionally lose, so that their kid might rack up a few wins. I could never do that with Susan (neither, to my relief, could Béla).

What good would it have done to let her win? Maybe it would make Susan feel better in the short term, but how would it help her in the long run? As I say, I wanted everything for her. In my experience, "everything" was a long-term game.

PENN, THESE DAYS, SEEMED to be playing a far shorter-term game. By 1999, the university health system and medical school were in crisis. Over the last decade, Bill Kelley, as the head of both institutions, had made some bold gambles. During his decade of leadership, he'd not only founded the Institute for Human Gene Therapy, he'd also purchased three hospitals and hundreds of physician practices, overseen the construction of new buildings, renovated more than a million square feet of research and clinical space, launched a dozen new institutes, and recruited many new faculty, including a new head for every department.

These bets hadn't exactly paid off.

The health system (and by extension the medical school) had, in the last three years, lost hundreds of millions of dollars. The crisis bled into the university as a whole; a new campus master plan, including new dorms, had to be put on hold. Moody's Investors Service downgraded the university's credit rating.

Sean Grady, the new chair of neurosurgery, told us all he would be paying scrupulous attention to budget concerns and resource allocation.

Resource allocation. That meant who got lab space.

Not long after arriving, Sean sat me down. He was polite enough. He listened to me describe my research. He asked a few questions, then told me without much excitement in his voice that it sounded exciting. He observed that I'd had some publications in reputable, if small, journals. But, he said, he was under tremendous budgetary pressure and was concerned about my lack of funding. Was I aware, he wondered, that there was a precise formula, a "dollars per net square footage" ratio, that determined down to the last inch how much lab space researchers were entitled to, based on their funding? "Going forward, the university will be strictly enforcing this fiscal guideline," he cautioned. "So I'll need you to start prioritizing outside funding."

Sure, I said. Fine, whatever. But could I tell him more about my work with mRNA?

IN MAKING VACCINES, DREW wanted to target *dendritic cells*. When we first began talking, I didn't even know what these

were. I assumed he was talking about some type of neurons, cells of the nervous system whose morphology included extensions called axons and dendrites. In fact, dendritic cells are immune cells—a type of "professional antigen presenting cells"—that had just been discovered.

The immune system is wondrously complex. The immune response unfolds over the whole body, involving multiple organ systems and many layers of protection. Since I'd attended university, there had been staggering advances in our understanding of immunity—so many that, just two decades later, much of what I'd learned was already obsolete. Fortunately, working with Drew was like taking a crash course in immunology. While Drew rarely spoke without a reason (his wife once joked that he had a daily word limit that he couldn't exceed), what he did choose to say always brought to life complicated ideas with a wonderful clarity.

Drew explained that dendritic cells are a great target for vaccines, because they link the *innate immune response*—a series of generalized, immediate responses to infection—to the *adaptive immune response*.

Your immune system exists to protect you from dangerous *pathogens*, the billions of invading bacteria, viruses, fungi, and parasites that bombard you and would otherwise hurt you. It also helps you respond to injuries. Your immune system's first layer of defense against pathogens is physical. Your skin forms a barricade through which potential invaders cannot pass. Mucous membranes in your nose and respiratory tract trap intruders like flies on flypaper. Enzymes in your saliva, eyes, and sweat dissolve microbes on contact. The acid in your stomach does the same. Tiny hairs in your lungs called cilia actively

sweep pathogens out of your system before they can gain a foothold.

But sometimes an unwanted pathogen breaches these barriers. That's when the cells of the *innate immune system* kick in. Within minutes of infection, scavenger cells surround and begin devouring the pathogen. "Natural killer cells" (yes, they're actually called that) seek and destroy those cells in your body that show signs of having been invaded. A torrent of proteins called cytokines jump into action; some of these (like the interferons I'd studied in Hungary and in Suhadolnik's lab) prevent a virus from replicating. Other cytokines recruit new cells into the immune response. (Similar responses happen during sterile tissue injury, when no pathogens are present.)

The cells and proteins of the innate immune system are like frontline guards who have each learned a single task. Each does the exact same thing, *regardless of the specific pathogen that has invaded*. This lack of specificity has the advantage of speed; your innate immune system switches on almost immediately upon infection.

But you have yet another layer of protection, as well: the *adaptive immune response*. While the innate system is generalized, the adaptive system is more like a highly trained, precision special-ops force that targets *a specific pathogen*. One type of adaptive immune cells called B cells generates *antibodies*, each of which has the precise physical characteristics required to neutralize that very invader. T cells jump into the fight, too. Some T cells are highly specialized killer cells that recognize and destroy the cells infected by that pathogen. Other cells make new cytokines, which help activate yet more immune cells.

Because the adaptive immune system tailors its response to a particular pathogen, it takes a few days to ramp up. Once it does, it's wondrously precise, extraordinarily powerful, and long-lasting. Not only does the adaptive immune system help you *clear* this infection, it also *remembers* it. Some adaptive immune cells, called memory cells, might hang around for the remainder of your life, just waiting to leap into action if needed. Should you ever encounter that pathogen again, memory cells will recognize it, enabling your adaptive immune system to respond much more quickly.

Dendritic cells, as Drew explained, make an ideal vaccine target, because they are responsible for starting *all* these immune responses.

Your body contains about fifty million dendritic cells. Each is covered in branching extensions, like tree limbs, which extend and retract (hence the name: These branches resemble dendrites). As they make their way through the skin, the lungs, the stomach, and the intestines, dendritic cells patrol for signs of invasion. If a dendritic cell detects a pathogen, it breaks it down into parts. It then "presents" these pieces on its surface, like a warrior adorning itself with jewelry made from pieces of its enemy. Meanwhile, it travels to the lymph nodes, where it "shows" the parts to the cells of the adaptive immune system. It's as if the dendritic cell is declaring, *Here are the bad guys. Take a good look. This is whom you need to fight. Here is how you do it. Now go get 'em!*

ALL VACCINES WORK THE same way: by safely introducing a specific antigen to a body, along with an immune activator,

called an adjuvant. There are many ways to do this. Some vaccines contain a weakened version of a live virus, others use a dead or inactivated virus, while still others use a recombinant protein, composed of a recognizable but noninfectious part of the pathogen.

But it is very challenging to make a vaccine against many pathogens.

For example, HIV (human immunodeficiency virus), the virus that causes AIDS (acquired immunodeficiency syndrome), is unusually wily. For one thing, HIV hijacks the body's immune system, invading and replicating inside T cells—the very cells that should be fighting viruses. Also, because the virus changes its genome (its nucleosides) every time it replicates, there are near-endless variants of HIV. The virus also camouflages itself with sugar molecules, making it difficult to detect. Finally, HIV inserts *its own genetic material into the host's chromosomes,* ensuring that, once present, it will never leave.

That's why, after forty years of research, no one had yet succeeded in creating an effective vaccine against HIV.

Drew had an idea. He thought we might be able to use mRNA to coax dendritic cells into producing the major structural protein of HIV—something called the "gag" protein—as a means of activating the body's defenses against the virus. (A quick note: "Gag" here has nothing to do with gagging, it's shorthand for "group-specific antigen.")

The process would unfold like this:

1. In a laboratory, create mRNA that codes for the HIV gag protein.

2. Deliver this mRNA to the body, along with an adjuvant to stimulate an immune response.

3. Once this mRNA enters a cell, it will travel to the "protein factory," the ribosome.

4. The ribosome will begin making gag proteins according to the instructions encoded in the mRNA. *Because these proteins are isolated from the rest of the HIV virus, they will not be infectious.*

5. As the cell makes these gag proteins, the adjuvant will alert the immune system to recognize this protein and launch an immune response.

6. The immune system will clear the gag proteins using ordinary cellular processes.

7. Thanks to the adaptive immune response, the body will remember these gag proteins forever. Should the body someday encounter a gag protein in the form of *an actual HIV virus,* it will be able to neutralize the virus before it enters the cells, and/or quickly eliminate any infected cells.

In a way, this mRNA vaccine would work like other vaccines: It would expose the body to an antigen (in this case, the gag protein) and stimulate the immune system, then let the body do its work. But instead of delivering the antigen itself, the mRNA vaccine would provide instructions for *making that antigen inside the cell.*

The body, in other words, would be *both* the antigen factory *and* the immune response to that antigen.

A vaccine like this would be a breakthrough. There would be some practical benefits, as well. Most HIV cases are in low-

and middle-income countries, with the highest incidence in sub-Saharan countries, which have the least access to affordable vaccines. While conventional vaccines require huge manufacturing investments, mRNA can be made inexpensively and quickly.

Now, as we stood by the infamous copier, Drew asked: Could I make mRNA that coded for the gag protein?

I smiled. *I can make any kind of mRNA*, I told him. *No problem at all.*

WE BEGAN QUICKLY. DREW gave me a plasmid that coded for the gag protein; I subcloned it and made this mRNA in my lab at neurosurgery. We "complexed" this mRNA with Lipofectin, then delivered it to dendritic cells in a cell culture.

In many ways, the results were promising. Hours after we introduced our mRNA to the dendritic cells, we could see that the mRNA had been translated; our cells were making gag proteins! These cells were also showing signs of having stimulated an immune response. This was an important marker, signaling that the mRNA was a good vaccine candidate.

But something curious was happening. Drew told me that the dendritic cells were *also* producing a huge amount of inflammatory cytokine—far beyond anything we might have expected. "The cells are activated," he said. "They're *incredibly* activated." For a guy who uses zero hyperbole, this phrase—*incredibly activated*—was really saying something.

It seemed that something about the mRNA itself was causing an inflammatory response.

My mRNA was causing inflammation?

I thought about this. For a decade I'd been planning to use mRNA as a therapeutic medicine—for the treatment of stroke and other serious conditions. But if mRNA was causing inflammation? Well, that was bad.

It was really, really bad.

ON THURSDAY, SEPTEMBER 9, 1999, an eighteen-year-old man named Jesse Gelsinger boarded a plane in his hometown of Tucson, Arizona. Bound for Philadelphia, he'd packed two bags for this trip. One bag was filled with clothing, the other with favorite videos: pro wrestling matches and films starring Sylvester Stallone and Adam Sandler. Jesse was a typical teenager in many ways: He liked hanging out with his friends. He worked part-time in a store. He loved motorcycles. He had a wry sense of humor. His dad, like many parents of teenagers, sometimes wished he had a bit more motivation in school.

Jesse also had a rare genetic condition, ornithine transcarbamylase (OTC) deficiency. Affecting roughly one in forty thousand people, OTC deficiency interferes with the processing of dietary proteins, causing ammonia (a waste product of protein metabolism) to accumulate in the blood. Untreated, the disorder results in coma, brain damage, and even death. It's often discovered right after birth; half of these early-onset cases are fatal. Jesse had what was considered a "milder" case of OTC deficiency; diagnosed at age two, Jesse controlled his condition with a low-protein diet and nearly fifty pills a day.

Jesse came to Philadelphia because he was a patient in a study evaluating the safety of gene therapy for his condition.

This study was organized by Penn's Institute for Human Gene Therapy.

Four days after arriving in Philly, researchers gave Jesse corrected OTC genes, which were delivered to his cells via trillions of disabled adenoviruses. These viruses were something of a Trojan horse: Instead of carrying the adenovirus genome into Jesse's cell, they carried only the gene that coded for OTC.

Unfortunately, the adenoviruses sent Jesse's immune system into overdrive; his immune system responded with a *cytokine storm*—a toxic flood of those immune system proteins—which in turn led to organ failure and acute respiratory distress. Eight days after boarding the plane in Tucson, Jesse died.

An inflammatory response, in other words, can be as serious as it gets.

Jesse's death would rock gene therapy approaches for decades. It rocked Penn, too. By January, the FDA had halted all human research at the Institute for Human Gene Therapy. Eventually, Penn paid a fine and shut the whole institute down.

When Drew told me that our mRNA had caused an inflammatory immune response, I was deeply alarmed. If mRNA caused an immune response, it could never be used as a therapy. An mRNA vaccine might still be possible—a vaccine requires an immune response, so it could be just a matter of calibration. But using mRNA as a clot buster, or a relaxer of vasospasm, or any of the other therapies I'd imagined? It would be impossible.

For a decade I'd been working toward the goal of thera-

peutic mRNA. In that time, I'd been ignored, belittled, demoted, and threatened with deportation. Not one of these things had upset me as much as this new fact: If we couldn't figure out how to keep mRNA from activating the immune system, my work would be useless.

BUT WHY WOULD MRNA trigger an immune response? That's the part Drew and I couldn't figure out. Our cells are jampacked with mRNA. For billions of years, every living cell has made massive quantities of mRNA without triggering the immune system. Every single cell in your body has an incalculable number of mRNA molecules inside it right now. This stuff may be astonishing, but it's also totally *ordinary*.

In the lab, we made mRNA from the very same materials found inside the body: We used ordinary building blocks, the very same As, Cs, Gs, and Us that exist across the kingdom of life.

And yet the data were absolutely clear: Every time we introduced mRNA to dendritic cells in cell cultures, we saw a secretion of inflammatory molecules. What could be going on?

When a good scientist encounters something that can't be easily explained by the known facts, there is just one thing to do: more research.

Sometimes, it takes a *lot* more research.

HAVE YOU EVER PLAYED the board game Clue? It's a murder-mystery game. Each player must determine three things: who committed a crime, where, and with what weapon. Players

take turns, each time asking a single question that is designed to test a hypothesis for how the murder might have unfolded ("Colonel Mustard, in the library, with the candlestick"). Over time, through the process of elimination, a picture begins to form.

This, I've been told, is a reasonable way to explain to non-scientists the sort of challenge Drew and I faced. To make our mRNA therapeutically useful, we would need to figure out what in the mRNA was causing the inflammation, what part of the cell was responding, and through what mechanism of action. To do this, we had only one tool available: asking yes-or-no questions, one at a time, in the form of experiments.

Of course, the game of Clue has just six suspects, six weapons, and nine rooms (a total of 324 potential solutions). Play the game long enough, and someone *will* solve the mystery eventually. We, on the other hand, had no such guarantees. We were dealing with staggering levels of biochemical complexity and processes that were unfolding entirely out of sight. Our tools were limited, and the universe of possibilities was unknown. We had no map for this work, no obvious place to start. Like players in the longest, most complicated game of Clue, we could ask only one question at a time.

OVER TIME, SUSAN LET go of her California dreaming. She toured Penn, talked to college counselors, and considered our very real financial situation. Over time, she grew more excited about Penn . . . then still more so. In December of her senior year of high school, she submitted her application for early admission to Penn.

She was a great kid, with terrific grades and strong recommendations. Even so, admission wasn't guaranteed. It felt as if we were all holding our breath for months. On the day she was supposed to receive the letter with their admission decision, she was so nervous she couldn't think straight. (I'll admit it: I was, too.) In those days, college notifications still arrived by the U.S. Postal Service, and we knew the mail wouldn't arrive until the afternoon. To distract us both, I took Susan out to a shopping center on Route 309.

We looked through racks of clothing. She tried on sweatshirts and jeans, things she didn't even need. I commented on them—*that looks nice, yes,* or *not worth the money.* I think we were each thinking the same thing, though: *Today is the day, today is the day, today is the day.*

When we got home, Susan leaped from the car before I'd even put it in park. She burst into the house. I followed, a shopping bag in my hand. Inside, we found Béla sitting at the dining room table.

"Did my letter get here?" Susan asked. In the doorway, I stood stock-still, too anxious even to set down the bag.

Béla stared at Susan. His face was blank. "Letter?" he asked, a little confused. Nearby was a pile of the day's mail. Nothing in the stack looked like a college acceptance letter.

Susan's shoulders fell. I could see her piecing together a chain of thoughts. Penn had been clear about when it would mail its acceptances. We knew precisely how long it took for a letter to arrive from Penn. If she hadn't received a letter . . . then . . . she must not have been accepted.

Oh. I let this sink in. *Susan wasn't accepted.*

I began to imagine the pep talk I'd give to her. *In life, we sometimes must face setbacks . . .*

"Oh, wait," Béla said. He said it like an afterthought, as if something had just occurred to him. Some twinkle appeared in his eye, the same spark I'd noticed in the face of the long-ago kid who'd snuck out of his high school dorm to enter a Szeged disco without a penny in his pocket. One side of Béla's mouth curled into a devilish grin. "You mean *this* letter?"

He lifted a corner of the tablecloth. There it was: an envelope, fat and bursting. This could mean only one thing. Susan had gotten in.

Susan screamed. She grabbed the envelope from the table and tore into it. Still holding the shopping bag I'd carried from the car, I smacked Béla in the arm. "Oh, you!" I was so relieved I could barely think straight. "How could you! How could you do that to Susan? Or to *me*!"

Six months later, Susan graduated from high school. The day began beautifully, but early in the outdoor ceremony, thunder cracked overhead. Soon a torrent of rain poured down on top of us. The school sent everyone home, even though students hadn't yet received their diplomas. We ran to our cars while lightning filled the air around us. Once home, Susan wept, brokenhearted that her high school graduation had been ruined. I did my best to comfort her. "Susan," I said, "I promise, this day is not the pinnacle of your life. You will do bigger things than sit through a high school graduation ceremony." (Apparently, she agreed on some level, because when the school held a make-up graduation a few weeks later, she didn't even bother to attend.)

That autumn, Susan started at Penn. She said goodbye to us with the same bright, fearless smile she gave us every summer when we dropped her at the airport for her solo trip to Hungary. By my calculations, these solo travels—about ten weeks per summer since she was five years old—had added up, over the course of her lifetime, to about two and a half collective years away from us. So as far as I was concerned, she might as well be halfway through her junior year.

"Work hard," we told her, and we believed she would.

DREW WAS A PRIVATE person, far more reserved than me. But we were similar in at least one way; he worked all the time. Sometimes I emailed him at three in the morning; I'd know he was up working, too, because he'd respond before four. We went back and forth, back and forth, day and night. Each of us scoured the scientific literature for any studies that might inform our work—any tiny fact that would narrow down what felt like a limitless expanse of questions. I went back *decades* in my reading. We thought about the questions we wanted to ask and the materials we had available, and we designed experiments around those factors. Even once we knew what kind of mRNA we wanted to make, I still had to figure out how to make it in the lab.

We ran experiments, then tried to figure out if we could trust what they showed us. If we weren't certain, we would start again. We tested, we tweaked, we tested again. We examined reams of data. There is a reason that research is so named. You're not just searching, you're repeating the search. You search, and then you re-search. Again and again and again.

Drew and I worked shoulder to shoulder as we did this work—sometimes in his lab, and other times in my lab in the neurosurgery department. Yes, I was still working in the neurosurgery department. Yes, my primary work was with an immunologist. Confused about that? Yes, so was the rest of the neurosurgery department.

Departmental boundaries seemed so arbitrary to me. From a management perspective, maybe they made sense, but from a scientific one? No. Everything interacts, subjects bleed into one another. In medicine, that's especially true. A heart attack can cause a stroke (this is, in fact, what happened to David's father), yet heart failure is treated by cardiologists like Elliot, and strokes by neurosurgeons like David. Inflammation is a subject for immunologists like Drew, yet chronic inflammation causes issues for the heart and brain, and in fact problems of the heart and brain cause inflammation throughout the body.

The body, like the world, is a *system;* it isn't divided into tidy categories between which sharp boundaries can be drawn.

I was a basic researcher. The whole point of basic research was to go wherever it took you. I was going where my research took me. I was too busy to worry about what department I worked in. Drew and I were working our butts off.

SUSAN, IN HER FIRST year at Penn, didn't seem to be working quite as hard. Her grades weren't great; the only class she did well in was Hungarian, a language she'd spoken fluently her whole life.

Occasionally, she visited me in the lab. She told me about

different activities she had signed up for—club field hockey, club basketball, a film screening club, a group that worked with local children. The activities seemed fine, but there was a flatness in Susan's voice when she talked about them. They occupied her time but not her spirit. They seemed to require no commitment, and she clearly had no commitment to them or to any of her courses. Sometimes, she confessed, she even skipped classes.

She seemed lost.

Whatever Susan was experiencing was something I couldn't understand. My whole life, I'd been so driven—compulsively, obsessively. I didn't know how to be anything *but* driven. Not understanding what Susan was going through meant I didn't have a clue as to how to help her.

Béla and I did the only thing we thought might help: We reminded her we weren't paying tuition so that she could screw around. We talked about the sacrifices we'd made for her, all the hardships we'd faced. We pointed out that we had given her a big opportunity, and that if we could work hard, she should, too.

THERE ARE SO MANY ways you can grow close to a person. Sometimes it happens quickly, as it did with me and Elliot; the two of us had such a warm, collegial connection right from the start. Other times, perhaps, you get a false start. I may not have connected with David right away, but before long the two of us were as eager and excited about our work as a couple of kids.

Sometimes, though, you grow close to someone in more subtle ways, so slowly you don't even realize it's happening.

Drew and I had been working together for years when one day I noticed he was wearing a bracelet. The bracelet had a metal plate, with some words etched into it. "What does that say?" I asked.

"It's the information people need if I ever become unconscious," Drew replied. When I stared at him, confused, he added, "I have type-one diabetes." He told me he'd had it since he was five years old.

All this time, Drew has had type 1 diabetes? Type 1 diabetes is a chronic condition that requires a lot of management—one must take sugar when blood sugar dips, administer insulin when consuming carbs or when blood sugar spikes. It requires constant monitoring, and even then, it can cause episodes of serious hypoglycemia, becoming a potential emergency quickly.

It's not that the diabetes mattered to our relationship. I just hadn't *known*.

But that's how it was with us. Drew and I might inquire about each other's families or mention what the kids were up to, but the conversations rarely became personal. He and I talked about cells. We talked about RNA. We talked about signaling receptors and cytokines and cloning techniques. We *worked*. But it turns out you can grow close to a person this way, too.

What do we talk about when we talk about science, really? Sure, we might use words like *ligand binding, epitope presentation,* and *translation factors.* But our meaning is always bigger,

more expansive, than the jargon we use. What we're really talking about is *how we think the world might work*. Designing experiments is a way of asking, "What if everything we assume is wrong?" and "What should we learn next?"

And when the two of you finally begin to piece together a picture of the world—*when you actually begin making discoveries*—you share something that most people never get to experience with someone else: *awe*. Biology is elegant and enigmatic, and you don't spend day after day, year after year, in this beautiful mystery without developing genuine trust, connection, and respect.

DURING THE SUMMER AFTER her first year at Penn, Susan confessed that she missed being part of an athletic team— a *real* team, that is, one in which all the players were committed to one another and to some larger purpose. Susan also missed the way the structure of a varsity team forced her to have good time-management skills. Team athletics, she now understood, had always snapped everything into focus for her.

She longed to play something for Penn. But Penn was Division I: It built its teams from recruited athletes, or at least from athletes who had won more than the Most Spirited award in high school. Maybe she could go out for track and field, Susan mused. She didn't especially enjoy running, but she had long legs, and the team sometimes took walk-ons.

At the end of the summer, Béla and I dropped Susan off for her sophomore year of college—she lived now in the quad, in a dorm room I could see from my lab. Soon after, she went to

an open track meeting. They announced that everyone would be running six miles to cheer on the cross-country team. Susan sighed. She just didn't want to do that.

"No, thanks," she said, and that was the end of her college track career.

There was another Penn sport, however, that took walk-ons, including those with little to no experience, and that likely wouldn't make her run distance: *rowing*.

"Rowing?" I asked. David had been a rower. The sport had always struck me as an elite sport, not for immigrant families like ours. After all, rowing required access to a *boat*.

"The catalog says anyone can try out!" Susan told me. "Mom, *I'm* anyone!" Then she laughed and got more serious; what the team really wanted was tall girls. Susan was tall, six feet two. So the following week, Susan took a deep breath and walked into an open meeting for the women's rowing team.

The moment she stepped into the gym, one of the women on the team pointed at her. "With your body type, you'll make a *great* rower!" The other members of the team whooped in agreement. Susan related the story to me over the phone, and I could hear in her voice everything that had been missing for the last year.

"Mom, they were all so friendly, and so encouraging!" she told me. "I think I could actually be good at this."

Okay, I told her. As long as she kept her grades up.

THE DAYS WERE LONG. Weeks became months, which eventually turned into years. Drew and I did a staggering number of experiments. Most important, we isolated different types of

RNA, and tested whether they all cause inflammation when added to dendritic cells.

Mammalian mRNA got a *small* inflammatory response.

Mammals also have RNAs walled off inside organelles called mitochondria. Mitochondria are like tiny power plants of the cell: They generate the energy a cell requires for its many biochemical reactions. Mitochondrial RNA, when removed from its cloister, triggered a *large* inflammatory response.

Most bacterial RNA produced a big inflammatory response. But bacterial transfer RNA (tRNA)—a very small type of RNA that helps translate mRNA's code into proteins—induced a very *low* response.

And most exciting to us: Mammalian tRNA caused *no inflammation whatsoever.*

Aha! So it *was* possible for RNA to cause no inflammation at all!

WE WENT OVER THE results again and again:

HIGHLY INFLAMMATORY:

✓ mitochondrial RNA
✓ bacterial total RNA
✓ our in vitro mRNA

LESS INFLAMMATORY OR
NON-INFLAMMATORY:

✓ mammalian mRNA
✓ bacterial tRNA
✓ mammalian tRNA

What did the former group have in common that the latter didn't?

As a matter of fact, there was something.

As you may recall from my work in Robert Suhadolnik's lab, nature is filled with tiny structural modifications to the A, C, G, and U building blocks. The differences allow the molecule to function normally while sometimes even conferring benefit.

But the modifications are real. And they are present in some RNAs.

When we considered the presence or absence of these nucleoside modifications, things started to get interesting:

MODIFICATION TO RNA NUCLEOSIDES		
	FEW/NO	MANY
Highly inflammatory	Mitochondrial RNA Bacterial total RNA Our in vitro mRNA	
Less inflammatory or non- inflammatory		Mammalian mRNA Bacterial tRNA Mammalian tRNA

Aha. Now, perhaps, we were on to something.

Maybe a lack of modifications in RNA was causing the inflammation! Maybe, somehow, the innate immune system— thought to be wholly generalized—can make a distinction

between RNA molecules *with* these structural modifications and RNA molecules *without* them.

Maybe, somehow, the absence of modifications sends an alarm signal to immune cells.

So we had a good working hypothesis: *Nucleoside modifications in mRNA are the key to evading an immune response.* Did we know this for sure? Of course not. It was just a hypothesis, and other possibilities couldn't be excluded.

We needed to test our hypothesis.

To do this, we needed to make two forms of mRNA—one with *modified* nucleosides and the other with *unmodified* nucleosides. Then we'd compare the inflammatory responses. This was a great plan, with one very big challenge: No one had ever made this kind of modified mRNA. I had no idea how I could.

SUSAN FELL HEAD OVER heels for rowing. She loved waking early and heading from a silent campus down to the Schuylkill River. She loved putting the boat into still water, then being out *on* the water, moving freely past the shores of the landlocked world. She loved propelling the boat using only her muscles, moving in sync with her teammates. She loved the power she felt when all their efforts came together at once, and suddenly they were moving faster than she ever thought possible.

"Magic." That's how she described the sport again and again to me and Béla. "It's magic." She meant it all: the teamwork, the camaraderie, the smells and sounds and sights of the water, everything she was discovering about herself.

When I was young, I felt so ordinary in school, nowhere

near as smart as others. But I'd thrown myself into learning and discovered that using one's brain is a way of growing one's abilities. Susan was now discovering something similar: She might have started as a novice rower, but by giving the sport everything she had, she had the chance to become good. Very, very good.

Susan had always been a competitive kid, but until now she'd lacked the skills to reach her potential. Now, at last, she'd found a way to unleash her inner competitor. In each practice, teammates competed against one another on the rowing machine; in her first months of practice, she watched her rankings rise with a thrill. She was still getting her body conditioned but she had flashes of tremendous speed. (She hadn't escaped long-distance runs entirely; sometimes the team had to run long distances while being timed. But she loved the sport so much, she didn't mind.)

In October, Béla and I took our places in the grandstands along the banks of the Schuylkill for the Navy Day Regatta— the first of Susan's rowing races we would ever watch. We sat near the boathouses, the very same boathouses that we'd seen lit up like a fairy-tale village the night we arrived in Philadelphia from Hungary. On that first night, everything had been so unfamiliar, these boathouses part of a landscape we could barely make sense of. Now we were part of the scenery. This was *our* life now, that was *our* daughter down by the river in her Penn uniform.

It was a spectacular autumn day, warm and bright. College teams had come from all over to compete, and the air crackled with energy. The rowers themselves, men and women alike, were as beautiful as the weather. Rowing uses every muscle in

your body, and the sport doesn't give you a break. So these rowers were the picture of health—long-limbed and muscular. It seemed almost as if a gaggle of supermodels had stepped straight out of a billboard and begun walking through the world.

Susan had always been a little embarrassed about her height. But among this crowd, she fit right in. I could see her standing taller now, moving with more confidence, as if she were fully occupying space for the first time in her life.

And what a thrill it was to see her move through that water!

I'd never paid much attention to rowing before. Until now, I'd never noticed that rowers move backward. This means they can't see where they are heading as they row. The only person in the boat who can see the finish line is a small coxswain who faces the rowers, directs their efforts, and steers the boat. Because Susan couldn't see the finish line, she had little sense of where she was in relation to it. There could be no calibrating her distance, no reassuring herself that she was almost there, no pacing herself to save something for the end. With every stroke, she simply had to go as hard as she possibly could.

It reminded me of my experiments, the way I never had a sense of whether a breakthrough would come or how long it would take. I simply had to trust that hard work, if I gave it my all, would get me somewhere, eventually.

Susan's assistant coach recognized quickly that her competitiveness brought its own sort of risk. He observed, wisely, that she was sometimes so afraid of making a mistake that she held herself back. "Test yourself," he encouraged her. "You might fail, and that's okay. The only way to really know what you're capable of is to let go of any fear of failure."

It was as if he had zeroed in on exactly the advice Susan most needed to hear: *Do not fear failure.* When she did as he said, the results were breathtaking. He'd even taken her aside and said, "Susan, you've got a real shot at the Olympics." When Susan told me this, I recalled her high school basketball games, the way she would do anything possible to avoid having the ball passed to her. "The Olympics?" I asked. "Really? Zsuzsi, that's fantastic!"

But even if she hadn't demonstrated so much potential in the sport, I'd have encouraged her to keep rowing. As soon as she joined the team, she began making the dean's list, and she didn't look back.

SEAN, THE NEUROSURGERY DEPARTMENT CHAIR, was growing impatient with me. He and I sat down at least once a year to review my work. It always went the same way. We started by talking about my research. I'd describe rapid-fire what Drew and I were figuring out, that we might be zeroing in on why mRNA was so inflammatory. Whenever Sean listened, his face did not change. Then he'd say something vaguely encouraging, such as, "Yes, it seems like it could be very important, Kati."

Then, more or less immediately, he turned away from my research to the metrics by which Penn evaluated my success: publication record (fine, not extraordinary), citations (some, but not nearly what others in the department were getting), and funding (still none).

"Kati," Sean explained, "the department is under pressure here. If we can't bring up our dollars per net square footage . . ."

Dollars per net square footage. Drew and I were on the verge of a breakthrough, and here was Sean talking about dollars per net square footage. "The department is doing fine," I retorted. It was a fact. Other members of the department were bringing in more than enough money for us all. One of the neurosurgeons was researching traumatic brain injury, a hot-button issue in the news. This guy had money pouring in—many millions of dollars every year.

"Kati," Sean pressed, "the university doesn't just look at departments. They go through this stuff at an individual-investigator level. Perhaps if you were a lead author in publications like *Nature,* I could make a better case on your behalf." With millions of monthly readers, *Nature* is the holy grail of academic publishing: widely read and widely cited.

"But you're *not* publishing in *Nature,*" Sean continued, "and you *also* don't get grants. So unless something changes, this isn't going to go well."

By this point, though, I was already tuning him out, my mind returning to the challenge that mattered most to me: How could I make modified mRNA?

SUSAN SPENT THE SUMMER after her sophomore year rowing for the Vesper Boat Club on Boathouse Row. This was a huge commitment, and a change for the whole extended family. From age five, Susan had passed the entirety of every summer in Hungary. This year, she would have to fit her visit to Kisújszállás into a couple of weeks just before the school year started.

That summer, she came home each night chattering excit-

edly about her practice and the great energy she experienced at the boathouse. As she talked, she devoured platefuls of food, replacing the energy she'd expended on the water. Then she crashed, sleeping hard until the early morning, rising in time to do it again. Susan rowed until her body ached, until her fingers blistered and bled. Sometimes she held up her hands for me. "Look, Mom!" she'd say, holding out palms that were torn to shreds. "Look how badass I am." Just looking at her wounded hands made my own hurt.

In her junior year, Susan lived off campus in a house with friends from the team. I saw her less often, but she called home all the time, telling me and Béla about which regatta she was off to and how the races had gone. When I had the chance to attend races, I was always introduced the same way: as Susan Francia's mom.

This is Susan Francia's mom.

Have you met Susan Francia's mom?

Oh, you're Susan Francia's mom!

Even if she hadn't kept me apprised of her rankings, her teammates' reactions to me—Susan Francia's mom!—would have made it clear: Susan was now one of the best rowers on the team.

Once she went to a day camp in Princeton, New Jersey, something she called an "ID camp." I didn't know what this was, but when she called home that night, she was bubbling with excitement. The coach of the USA national rowing team had been there. He'd taken her aside at the end of the day and asked if she was an American citizen. In fact, she was; she had become a citizen the summer after her sophomore year, in a July 4 ceremony. "He asked me that question because he thinks

I have what it takes to make the U.S. national team!" she exclaimed.

After her junior year, we drove her back to Princeton, where she spent the summer at a pre-elite camp, training with the best college rowers from around the country. Everyone there had huge goals and tons of energy. At the end of the summer, she went to row at the Royal Canadian Henley Regatta in St. Catherines, Ontario, a historic series of races whose course is an old shipping canal. There she earned a pile of medals. When she came home to Philadelphia and described her races, I allowed myself to imagine that her path might unfold exactly as she now hoped.

"Well, if you do get to the Olympics," I mused, "won't it be fun to return to the Canadian Henley after? By then, you'll win everything!"

Susan looked me dead in the eye. "Mom," she said. "I won't come back after the Olympics. The Olympics is the top achievement. When I get there, I'll have reached the top."

There was something in her voice as she said these words: a directness, a conviction, a certainty. Also, there was that word she'd used: *when*. That's when I understood: This was no longer hypothetical for Susan. This was no mere dreaming. Susan was serious. She planned to make it all the way to the Olympics.

DREW AND I PLANNED to test whether mRNA containing modified nucleosides would be non-inflammatory. But first I had to figure out how to *make* modified mRNA!

In nature, all RNA is made initially from the four basic

nucleosides. Once the RNA is made, selected nucleosides are then modified by enzymes. Most of these enzymes, in 2004, weren't even known! Even those that had been identified and characterized presented impossible technical challenges. So this approach was a dead end.

Another option was to purchase nucleosides that had already been modified, then attempt to make mRNA using those. But where could I buy such molecules? I turned to my old colleague János Ludwig, who by then was working for a ribozyme company in Germany. Following his advice, I purchased ten different modified nucleotide building blocks—all that were available at the time.

Five were not accepted by the RNA polymerase, an essential enzyme for mRNA synthesis. Just like that, our universe of possibilities was cut in half. Fortunately, five of them *were* accepted. This meant I could make five different varieties of modified mRNA.

With modified mRNA made, we were ready to get started comparing each variety to its unmodified version. Would the modifications make mRNA less inflammatory?

These experiments were exciting—incredibly so. Still, we could not have imagined the effect they would have someday—not only on our own lives but on the world.

SCIENTIFIC INQUIRY IS, as I have explained, a puzzle that never stops changing. Each new piece snapped into place changes the puzzle itself, opening entire new realms into which the puzzle grows. It will continue like that, I suspect, until the puzzle encompasses the universe itself.

But look closely at any one puzzle piece. You'll notice that the piece itself is a mosaic, composed of thousands of other discoveries, each made by scientists who came before you. (Zoom in further, on any one of those findings, and you'll see that they, too, are mosaics. On and on they go, discoveries upon discoveries, back to the time of the ancients.) There is a phrase you'll hear often in science: *We stand on the shoulders of giants*. And it's absolutely true.

Less than a decade before Drew and I began our work with mRNA, scientists made an important discovery about the immune system. Dendritic cells and other cells of the innate immune system contain "lookout" proteins, called *toll-like receptors* (TLRs). These tiny watchdogs scan the landscape for signs of potential danger. Because they're part of the innate immune system, they do not detect specific antigens. Instead, these tiny sentries identify molecular patterns that tend to be associated with danger.

A TLR is the molecular equivalent of a security guard who has been trained to recognize some telltale signs of a cartoon burglar: He might wear a black cap, a black mask over his eyes, and/or a striped shirt. He might carry a flashlight in one hand and a sack of stolen goods in the other. He'll probably have facial stubble, and will likely walk on his tiptoes. An actual intruder may not match that stereotypical description. But should the guard spy a striped shirt and flashlight, she knows to ring the alarm.

Could unmodified mRNA be a signal to any TLRs that danger was present?

When we ran our experiments comparing modified and unmodified mRNAs, we zeroed in on these TLRs. That's when

the picture became absolutely clear: Unmodified mRNA activated several types of toll-like receptors. But uridine-modified mRNA—in which the U nucleosides had modifications—did not.

This meant *that by modifying uridine, we could avoid the inflammation that until now had been associated with synthetic mRNA.* This was, at long last, the information we needed—that the whole world needed!—to begin developing safe mRNA therapeutics.

Eureka!

Again, we had no celebration, no champagne stored away in the refrigerator. As we reviewed the data, Drew sat up a little straighter, his eyes widening just a touch, as he had that day when I told him I could make mRNA. I remember that I murmured, "It's not immunogenic." (*Immunogenic* is a biologist's word for "induces immune reaction.") I said it several times, as if repeating it were necessary to make it true: "It's not immunogenic, it's really not immunogenic."

This was amazing news, but we would soon learn that our discovery went further than that.

SUSAN STARTED HER SENIOR YEAR. By now, she had matriculated into Penn's criminology master's program, so that she would graduate with both a bachelor's degree *and* a master's degree. She was determined to graduate in four years, too.

She worked constantly. She rowed, she attended class. She rowed, she studied. She rowed, she wrote papers. She slept and ate, then she rowed some more.

Sometimes she thought about the future. Maybe she would join the FBI. Maybe someday she'd go to California.

But mainly, her mind was fixed on 2008, the first Olympics she had a shot at making.

SO DREW AND I had made a big discovery: By replacing the uridine with a modified version of that nucleoside, we could get our mRNA to evade detection by the immune system. But how effectively would this modified mRNA be translated into proteins? This question prompted a whole new series of experiments.

The most abundant modified nucleoside in RNA is something called *pseudouridine*. Known to scientists for more than half a century, pseudouridine exists in many kinds of RNA, including tRNA. It's present in every cell in your body, and it's naturally occurring. RNA containing pseudouridine has the same base (uracil) as uridine does, but RNA containing pseudouridine instead of uridine is more stable and a bit more rigid in structure. The difference is subtle, but what a difference it makes!

When we tested mRNAs with different kinds of modified uridines, we noticed something that stunned us: mRNAs containing pseudouridine translated more efficiently, thus *ten times more proteins were produced from them.*

Swapping uridine with pseudouridine made our modified mRNA doubly beneficial. Not only did it keep our mRNA from causing a dangerous immune response, it also translated into much more protein!

Thirty years I'd been doing this work. A day at a time, an

experiment at a time, a lab at a time. And finally, finally, it was all here:

We had a way to make mRNA in the lab.

We could deliver that mRNA into cells.

We could protect our mRNA from degradation.

By incorporating pseudouridine into the mRNA, we could keep it from causing an inflammatory reaction. It also translated into a *great deal* of proteins.

I was absolutely elated. This was a paradigm-shifting discovery, one that could usher in a new era of medicines and vaccines. The whole world would be interested in this. Every journal. Every biotech. Every research institution. We were just sure of it.

Drew and I first submitted our findings to *Nature*—this was the preeminent journal, the publication that Sean had mentioned as the type of journal that could keep the university off my back. The journal's submission criteria require that papers be *previously unpublished research, of outstanding scientific importance,* and *of interest to scientists across disciplines.* The research Drew and I had done was all those things.

We heard back within twenty-four hours. Their editors rejected our paper outright as merely an "incremental contribution." That was the first time I'd heard that word—*incremental.* But when I looked it up, I was stunned. They considered this a "small" contribution, rather than anything of importance? Didn't the editors at *Nature* understand the implications here? All around me at Penn, I saw "incremental" research. What we had just sent them was a breakthrough.

Okay, then. Maybe a publication more narrowly focused on the immune system would understand its importance. We

sent it next to *Immunity*, a reputable journal that specialized in immunological discoveries. Here, our paper made it to the peer-review stage, during which three scientists scrutinized our work. But we didn't make it past this stage. Not at first. It took some back-and-forth and some more experiments, but finally *Immunity* agreed to publish it. At last, the world would know what we'd done!

The night before the paper came out, Drew said to me, with his characteristic solemnity. "Kati, get ready. Starting tomorrow, your phone is going to ring off the hook." He told me we would be asked to give lectures, to explain our work to other scientists and to journalists. People all over the world were about to take notice.

I nodded. Okay. After all these years, I was ready.

THE PHONE DIDN'T RING. Not the day the work was published, and not the day after that, or the week after that, or the month after that. In the several years that followed publication, I would get only two invitations, both in 2006, to speak about our breakthrough. First was the Sapporo Cancer Seminar, held in Japan. The second was at the 2nd Annual Meeting of the Oligonucleotide Therapeutics Society, held at Rockefeller University in New York City.

Rockefeller University is such an interesting place. Because it doesn't have an undergraduate program, Rockefeller isn't widely known among nonscientists. But it's an outstanding scientific institution, deeply respected by working biomedical scientists. The school has no departments, no department chairs. There's minimal administrative hierarchy of any kind.

Faculty are encouraged to collaborate across disciplines, wherever their research takes them. It's a model that has worked: In its one-hundred-year history, Rockefeller has employed dozens of winners of the Nobel Prize, dozens of winners of the Lasker Award, 132 members of the National Academy of Sciences, and many other award winners (one of these award winners, in fact, is Alexander Tomasz, the older brother of Jenő Tomasz, with whom I'd worked at the BRC; Hungarians are everywhere!).

I loved visiting Rockefeller—loved the way it was set down right in the city, on the bank of the East River on the Upper East Side, but it felt like a world unto itself. I loved the way everything there was *science, science, science,* just as it had been at the BRC. After I delivered my presentation, a scientist visiting from another institution approached me. She had a question about my work. I nodded, ready to answer all her technical questions, anything she might be wondering about experimental design, or her queries on the intricacies of modified mRNA synthesis, or about immune system responses.

"Who is your supervisor?" she asked.

I looked right at her. "Me," I said. Penn's organizational chart be damned, that was the most honest answer I had.

And then I went home. For a long while, that was it. In the place where we'd expected attention, acclaim, there was only silence. This groundbreaking discovery had been met by a collective shrug. Our breakthrough had apparently failed to break through to, well, anyone.

DREW AND I KEPT WORKING. We published more papers, found new ways to purify our synthetic mRNA. We also

formed a company, RNARx, which we incorporated in 2006. The company's mission was to develop new medicines using therapeutic mRNA. Our first product, we decided, would focus on anemia, a shortage of red blood cells. We would develop mRNA that coded for erythropoietin, a hormone protein that helps the body produce red blood cells.

We applied for an NIH small-business grant, and we got one: $100,000 in start-up funds, plus another $800,000 after we had success in experiments with mice. It wasn't the full funding we needed to get the business off the ground, but it would be a start. We approached investors, applied for additional funds. The answer was always no.

Maybe it was something about our presentation, I thought. Drew and I were scientists, after all. We had no experience giving sales pitches. Then the Wharton School—Penn's top-ranked business school—held an annual competition. Students in the MBA program looked through patents filed with the technology office. Each group was to pick one intellectual property asset and create a business plan around it. The winning business plans would be awarded funding.

Two MBA students selected our patent for nucleoside-modified mRNA. We told them if they got the funding, we'd be happy to have them on board to run the business side of RNARx. But they had no luck, either; their proposal was eliminated in the first round of the competition.

Even Elliot told us no. He and I had stayed in close contact through the years. I knew he believed in mRNA therapy and that he was impressed with what Drew and I had done. But when we asked him if he would be CEO of our new company, he looked as pained as the day he told me I wouldn't be pro-

moted. "I'll be an unpaid adviser," he assured me. "But I've got a good job now, and I'm too risk-averse for something like this. Kati, I'm sorry, but I just can't."

WELL, I MIGHT BE destined for a life of obscurity, but Susan was dead set on greatness.

After she graduated from Penn, she returned to Princeton for her second summer of pre-elite rowing camp. This was June 2004; it was an Olympic summer, and the U.S. team was in Princeton, too, doing its final grueling months of training. Everyone, including Susan, helped get them ready.

Susan was in the race boat—the one that challenged the Olympic team day after day. She was placed in the women's eight category (eight rowers, all moving backward through the water, plus the forward-facing coxswain). Every morning, Susan put on the shirt of a different nation. Every day, the Olympic coach would give them directions: "Next we're doing twelve two-hundred-fifty-meter sprints; go hard for the first five, then sell your soul for the sixth sprint and don't look back!"

The Olympic team beat Susan's race boat consistently, as she had expected. But sometimes on that sixth sprint, her race boat won. It must have felt surreal for her: After just three seasons of college rowing, *she was beating actual Olympic athletes.*

That summer, Susan would watch while the U.S. team she'd spent months racing won the silver medal in Athens. By then, the coaches were already looking ahead to the next Olympics. At the end of the summer, the coaches invited

Susan to be a part of the team that would train for the 2008 games, to be held in Beijing. There were three times as many rowers selected as there were places in the boat, and there were four years to go, but Susan could feel herself getting closer.

At the end of the summer, she returned to the Canadian Henley. This year, her boat dominated every race.

She would spend the next four years competing with and against thirty women for one of the eight coveted spots in the Olympic boat. Each day, Susan would call me at work with breathless updates about how she'd done in that morning's race. To her, every training race might as well have been the actual Olympic Games. When she raced well, she was elated. When she raced poorly, she despaired. The truth is, I dreaded her calls, unsure what would greet me on the other side of our connection, but I was always ready with some comforting talk.

"It's not good enough, not yet," she kept saying. "I want to be the best in the world."

BEFORE WE FOUNDED RNARX, Drew and I had filed a patent for our non-inflammatory modified mRNA.

Actually, that's not quite right. At a research institution like Penn, the *university* owns the patents for intellectual property filed by its faculty. So, in fact, *Penn* was awarded a patent for our modified RNA. Under the terms of our contracts, Drew and I could get a portion of any proceeds that came from the patent, but Penn decided how the patent would be licensed.

Obviously, for RNARx to be viable, we needed to be able to license our own intellectual property. We went back and forth with Penn over the terms. We negotiated. We *haggled*. We hired a lawyer.

Still, I tried to remain optimistic.

In the neurosurgery department, Sean continued to press me on my lack of funding.

"Kati, I'm just trying to explain reality," he said in one of our many meetings. "Penn has that dollars-per-square-foot cost requirement for lab space, and you have not come close to meeting it. For a while I was able to tell my superiors you were between grants, but at this point—"

"Cystic fibrosis," I blurted.

He stopped talking. "Excuse me?"

"We might be able to use mRNA to restore healthy lung function in patients with cystic fibrosis." When he didn't respond, I pressed him. "Think about it, Sean! Cystic fibrosis is caused by a missing or defective protein, called CTFR. So if we could make mRNA that coded for CTFR, and deliver it to patients therapeutically, their cells could make the exact protein they need. This would *help* people! It might even work in inhaler form. You see how important this is?"

Sean began using his patient, let's-just-get-through-this-meeting voice. "Kati, *everyone* in this department is doing important research. Doug's work on the cognitive impact of concussions, for example: This is having a big impact. But Doug's work is also funded. And I'm simply not in a position to deflect department resources to offset the work of those who don't meet their targets for . . ."

Dollars per net square footage again. As if that's what mat-

tered, as if the system in which we operated was above all what must be maintained. The fact was, I barely cost this department anything. I didn't get paid much; my salary was laughable compared with those of the neurosurgeons who surrounded me. I was now in my fifties, and I still did all my experiments by myself. I had no staff, no postdocs. All these years, ever since my demotion by Judy Swain, I'd been attending faculty meetings when I wasn't even a faculty member!

In front of me now, Sean was still talking. Not about science, not about all the ways mRNA might help the world, but rather, as always, about budgets. Funding.

". . . I hope you'll work with me to find a solution," Sean said, "because if not—"

"Sean," I said. "I need to get back to work."

IN THE SUMMER OF 2008, Susan called home with the mother of all news. After weeks of grueling trials, the U.S. national coach had invited her to his office, sat her down, shaken her hand, and said, "Welcome to the Olympic team."

In early August 2008, Béla and I met my sister in Hungary, and the three of us flew together to China. I'd never been to Beijing before, and what a time to be there! The city was wild with energy. China's economy had been open to foreign investors for less than three decades, so the event felt like a coming-out party for an entire nation. *Everyone* was celebrating, even those who had no official role. Locals flooded the streets, waving flags and cheering for anyone who looked like they might possibly be an athlete. Taxi drivers had learned English phrases for the occasion. Perfect strangers walked up to us to

hand us gifts. Again and again, people approached me, Béla, and Zsóka to ask if they could take a photo with us.

"Tall," they sometimes said as we stood smiling for the camera. "Very tall." Or, if they didn't speak English, they would sign it, by lifting their hands as if to reach for the top of our heads. "My daughter is one of the athletes," I would explain. It didn't matter if they understood. I was so eager to tell everyone. *I'm here because our Zsuzsi is in the Olympics. Our beautiful, determined girl is an Olympic athlete.*

Susan had told us the team to beat was Romania; they'd taken the gold in the women's eight category for the last three Olympics. Zsóka wanted to find a church so that she could light a candle as a prayer to bring luck to the U.S. team— something she'd done during many of Susan's World Cup and World Championship races. But in Beijing there weren't a lot of churches to find, and many streets were restricted to us. The three of us moved through the city, searching for any church, anywhere. As we walked, we took everything in: all the cranes rising toward the clouds, all those under-construction skyscrapers, the bulldozers knocking down the old, making room for the ultramodern. Things were changing so fast, we knew if we ever returned to Beijing, it would be a different city entirely. Still, for all our searching, we couldn't find a church for Zsóka's candle.

That night, when Susan called from the Olympic village, we told her about our fruitless search. "Thank you," Susan replied, "but I don't think we'll need that candle."

They are going to win, I thought. *She thinks they are going to win.*

It was sweltering on the night of the opening ceremony,

held in the Beijing National Stadium (the "Bird's Nest"). The humidity that night was near 100 percent. Still, the pavement outside the stadium was packed with locals eager to be close to the action, even if they couldn't get inside. The opening ceremony was dazzling. I have never seen anything like it in my life, and I'm sure I never will again: fifteen thousand performers in traditional costumes, drumming and moving with such ordered precision, it was as if they weren't individuals but rather parts of some perfectly calibrated machine or some massive new organism.

Sitting there in that crowd of ninety thousand, the seats filled with people from all over the world, with sweat pouring down our skin, I thought, *I am here because Susan is in the Olympics. I am Susan Francia's mom, and she is in the Olympics.*

As for Susan's races? No other team came close.

By the end of the final race, as the U.S. team skimmed across the finish line nearly a full boat's length ahead of any other, I just about collapsed with relief. Béla and Zsóka and I were out of our chairs, jumping up and down and screaming ourselves hoarse. We wept as we watched Susan, still in the boat, raising her arms in exhausted, elated victory. We were weeping still when we saw the team joyfully throw the coxswain, a spunky powerhouse named Mary Whipple, into the water—a rowing tradition. We cried, too, during the awards ceremony, and after it, as Susan and her teammates brought those beautiful gold medals to their lips.

I was *Susan Francia's mom* and my kid was bringing home the gold.

Another way rowing and science are similar: You just have

to keep going back to square one, starting anew—a new goal, a new experiment, a new chance to prove oneself, a new set of unknowns.

Even after winning the gold, Susan was, upon her return, just another rower competing for eight slots in the *next* Olympics. You get no extra credit for having been at the top of the world once. The only question that mattered after Beijing was whether Susan could help bring home the gold in 2012. This brought a new set of challenges.

Before 2008, when other rowers beat Susan in competition, it had been expected. Suddenly, she had new expectations for herself. If she lost a race, she had to beat back self-doubt: *Why are they beating me? Why can't I do this anymore? What if I've peaked?*

She struggled not only with doubts but also with injuries. Rowing is brutal on the body. She got a herniated disc and multiple stress fractures on her ribs. By 2011 the pain was so severe that sitting, driving, or even lifting a plate from the table was excruciating. Susan covered herself in heat packs and pain patches, then kept going. I told her to be careful, to listen to her body, to be smart. I reminded her that she didn't have to do this, she was an Olympic gold medalist already, and she'd also won four world championships by now. Susan responded with a voice full of defiance. "You and Dad should go ahead and buy tickets to the London games."

Oh, Susan, I thought. *You are so stubborn, like me.*

Meanwhile, I was facing my own questions, doubts, and private pains.

Years after beginning our negotiations with Penn, Drew

and I still hadn't succeeded in licensing the patent based on our discovery. In the meantime, Penn had begun to negotiate with a different company to license the patent.

In 2010—years into these conversations—I got a call from the CEO of a lab supply company, Epicentre, based in Madison, Wisconsin. The company sold biotechnology reagents, enzymes, kits, and other genetic sequencing products. The CEO hoped to license our modified mRNA to make stem cells in the lab. I explained I couldn't license the patent, as I didn't actually have it with RNARx.

"Whatever they do," this executive said, "please, please don't let them give out an exclusive license to anyone." He offered $300,000 for a license right to generate stem cells with nucleoside-modified mRNA.

I was thrilled. With that $300,000 license, Drew and I could finally have the money we needed to get our company going. We'd have money for an incubator space, equipment, and cell cultures and reagents, everything we needed to really get started in earnest! I called up Penn's technology-transfer office and told them they should come back to us and close a deal. We had a good offer from a company in Wisconsin. I gave them Epicentre's information, so they could do their due diligence.

The next thing I knew, Penn had issued an exclusive license to Epicentre for $300,000. No other company could use it—including RNARx—without paying a sublicensing fee to Epicentre (Cellscript by then). What a windfall that would become for that company someday!

In the meantime, RNARx was four years in. We'd mostly gone through our NIH small-business funding by this point

and hadn't found any investors. We had no patent, no lab space, and no prospects, and we were no closer to having a product than we'd been four years earlier.

Nor were we the only company in the modified-mRNA business. Months before, some researchers from Harvard and MIT had founded a brand-new start-up in Cambridge, Massachusetts. Their area of focus? Modified-mRNA therapies. That company, still unknown, had given itself a name that was a variation of modified RNA: ModeRNA. In fact, the vice president of the venture capital firm that financed Moderna had recently visited us at Penn, asking about our patent.

I sighed. I didn't have it, I explained.

Meanwhile, in the department, Sean was still tut-tutting about fiscal benchmarks and my lack of funding. I, in turn, had started asking Sean to reinstate me to a faculty position. But when Sean finally submitted my credentials to the faculty office for reinstatement, the request was rejected.

I personally went to the faculty affairs office to appeal. There an administrator told me that if someone has been demoted from the faculty track at Penn, the university won't promote her again. When I persisted in asking why, I was told that I was "not of faculty quality."

I considered this. "And how do you define 'faculty quality'?" I asked.

In response, the administrator shook her head. "I don't know," she said flatly. "But it was concluded that *you* are not faculty quality."

I kept my head up, kept going, just as Susan was doing every day.

———

SUSAN'S SECOND OLYMPIC TRIALS were harder than the first. Or maybe she just didn't remember how difficult they'd been, the way a woman forgets the pain of childbirth when labor ends. One night during the trials, Susan called me deeply discouraged. Her body was broken, and her spirit, too.

I did the only thing I knew how to do: I sang to her, the same song I'd sung to her when she was young, the same song I myself needed to hear:

> *But this luster can only be yours*
> *If you mine for it yourself.*
> *I know you'll realize it was worth it . . .*

I know it's hard, I was trying to say, but everything you ever earn will be so much sweeter, because you gave it your best effort.

Pain be damned, Susan made the Olympic team a second time.

A RACE IS A six-minute snapshot. It goes by so fast, it almost looks easy. What a spectator doesn't see is all the years that came before—all the weeks and months and days and hours and seconds that filled those years. The training, the pain, the blisters, the doubt.

What a spectator doesn't see is the grind, or the passion and drive a person brought to that grind.

Susan had poured everything into rowing, and it paid off

twice. For the second time—this time standing by Dorney Lake, near the picturesque Eton College campus in Buckinghamshire, England—I watched my child represent the United States of America, rowing with her back to a finish line she could not see. For the second time, I would see her boat cross that line first.

I am Susan Francia's mom, and I've seen her win the Olympic gold medal . . . twice.

IN MAY 2013, I showed up to my lab in the neurosurgery department and found my belongings in the hallway. There was my rolling chair, there were my binders, my hot plate, my posters, my boxes of test tubes.

What was happening?

In my lab, the neurosurgery lab tech was cramming my belongings into boxes. She had a giant trash bin, too, into which she was dumping things. *My* things.

"What are you doing?" I asked. There went my bench paper, a box of old pipettes.

"We need this place," she said simply. "Sean said we have to make room." She reached for a stack of assay trays.

"Don't touch those," I snapped.

She hesitated, just for a moment, then picked up the assay trays anyway.

"I said don't touch that!"

"Kati," she said. There went the assay trays into the garbage. "I'm afraid you've got to talk to Sean."

Sean was waiting for me in his office. "Kati," he said. To me, his voice sounded like that of an exasperated parent trying

to avert a tantrum. As if he were talking to a child. "We've talked about this. You've had plenty of time to get your numbers up. It's been *seventeen years*." He explained that he'd hired some new faculty. They had grants. That was just how the system worked.

But this was my lab. This was my everything.

"Don't worry," Sean tried to reassure me. "I found new space for you." He said I could use a tiny room near the animal house for my research. A terrible space, far too small for the conditions needed to work properly with RNA.

In the hallway, I could see people had started rifling through my belongings, as if they were all trash.

"I'm sorry, Kati," Sean said, "but I have done everything I can do."

"Sean," I hissed. It was the way he was talking to me, as if he were the one with all the answers, as if *I* were the one who didn't understand. Didn't he know how useful mRNA would be someday? Could he really not see it? "That lab *is going to be a museum one day!*"

Sean's face didn't change at all. "Well, that may be, Kati," he said, "but right now, I'm going to follow policy and give it to someone else."

It was that line about *policy* that did it for me. That line, and maybe, too, the dispassionate look on his face. As if it didn't even matter. Standing there, I thought, *I cannot do this anymore. I just cannot be here any longer.*

PART
SIX

—

*A Changed
World*

2022

THE STAGE LIGHTS ARE BLINDING. THE APPLAUSE, WHEN I take my place in the spotlight, is thunderous. The auditorium is packed, but I still can't make out faces. Whenever I step onto a stage from the darkness of the wings, it takes a moment for my eyes to adjust.

Moments before, Jon Batiste, the multi–Grammy Award–winning musical genius, sat where I now stand. He wore a trim, electric-blue suit, and he brought the house down with his rendition of "Don't Stop."

Don't stop dreaming, don't stop believing. . . . So with all you've got, don't stop.

Tim Cook, the CEO of Apple, was also on this stage a short time before. Soon John Kerry, the U.S. senator turned climate ambassador, will take his place in front of this crowd, too. Later Mindy Kaling will talk. Then Gabby Giffords, Bill Gates, Dwyane Wade, and many others. But right now it's my turn.

I try to get my bearings. Arcing across the ceiling of this sleek, wood-paneled theater—Lincoln Center's Frederick P.

Rose Hall near New York's Columbus Circle—is a semicircle of glowing red diamonds. From my place on the stage, it looks like a bright smile. Behind me, there is a massive projection: Time 100 Summit. The words are larger than I am.

Near the stage, a photographer dressed in black snakes down the aisle and points at me a lens so massive it might as well be a telescope capturing images of Jupiter. I take a deep breath, glance at the teleprompter, then back out to the audience. By now, yes, my eyes have started to adjust. I can see faces at last. Some are smiling up at me, others are more cautiously hidden behind masks.

In this room, waiting for me to speak, are some of the most influential people on the planet.

I begin. "I grew up the daughter of a butcher. . . ."

An awful lot has happened by now—in the world, and in my life.

In 2013, I retired from Penn, retaining an adjunct title and access to the library. I was ready for something different, and I began to look at the biotech industry.

By this point, something fundamental had changed. Moderna, the Massachusetts start-up whose financier had approached me about the patent that Drew and I weren't able to license, had raised nearly $300 million in early funding. (This would be just the beginning; by 2018, their public offering would generate nearly $2 billion, years before their first product even rolled out.)

At first I wondered if perhaps I could find a job at Moderna. I considered other private employers, too, all around the world. To my surprise, these organizations were eager to talk to me. They knew about mRNA, they'd read my work.

For the first time in my life, I didn't have to try to convince people about mRNA's potential. The people I was talking to—biotech leaders and pharmaceutical companies—saw that potential, they understood it. They were almost as excited about it as I was.

All these years, I'd been able to count on one hand the number of people I'd known in the "mRNA Believers Club." It had been, frankly, the club that nobody seemed to want to join. Now I was finding the club had chapters all over the world!

Of all the potential employers, I was most taken by a relatively small, quiet company named BioNTech, which operated out of Mainz, Germany. BioNTech's cofounders were physician scientists, a married couple, Uğur Şahin and Özlem Türeci.

Uğur was born in Turkey, near the Syrian border. When he was three, his family immigrated to Germany, where his dad took a job in a Ford factory. Özlem was from Istanbul, the daughter of a surgeon father and a biologist mother. Both families came to Germany as part of the guest workers program. Uğur and Özlem became doctors, and they met while working on a German cancer ward. Both had been disappointed by the lack of good treatments for cancer patients. The available therapies, they agreed, weren't precise enough, they weren't *fast* enough.

Both believed there was great promise in immunotherapy— a treatment that enlists the body's own immune system in fighting cancer. They'd founded BioNTech as a way to bring these medicines to bedsides quickly. The platform that they intended to use for their immunotherapy was mRNA.

In July 2013, when I was visiting Lucerne for one of Susan's races, my sister drove me and Béla to Mainz, where I delivered a lecture to BioNTech employees about my research. After my lecture, Uğur and I went to lunch, where he explained the premise behind their work.

Two individuals can have the same *kind* of cancer, but their tumors might be only 3 percent similar. Until recently, the available cancer therapies treated highly individualized tumors with one-type-fits-all options: radiation, surgery, and chemotherapy. Not only was this approach less effective than patients often needed but it also knocked out healthy cells. Immunotherapy based on mRNA, by contrast, had the potential to deliver *the precise proteins a patient needed to fight their individual tumors.*

We talked for a long time. He asked great questions, explained BioNTech's work effectively, and insightfully connected lab research with patient needs. His understanding of the science of mRNA was impeccable.

I liked Uğur right away. He was understated and humble, and when he spoke about the company's mission, his face lit up with a bright, gentle smile. Like me, he didn't seem to distinguish between his work and the rest of his life. His life's work was just that: his life *and* his work. I also appreciated that he was driven by the patients he could help, rather than by the investors he had attracted. In fact, even after five years of operations, BioNTech still didn't even have a website. (Okay, it officially had one: For years it said only "under construction.") It had made no press releases. It was in stealth mode, wanting to be absolutely sure it had the science right before making

any claims. It was the corporate equivalent of what I'd done with my publications.

Uğur offered me a job—a good one: vice president. I told him that I would consider the offer only if I could continue to work on nucleoside-modified mRNA. He agreed. But would Béla and I pick up our lives and move to another country yet again?

"Of course you have to do this," Béla said when we discussed it. "It's a great opportunity for you. But . . ." Béla hesitated here. "I'm not sure we should uproot our lives right now." I understood what he was saying. For decades, he'd seen me bounce from one lab to the next, always without any sort of security.

"If we were to sell the house, move to Germany," he continued, "and it didn't work out, then what? We'd have to come back to America and start from scratch all over again."

I thought about that first night in the United States, when everything, even a night full of fireflies, was unfamiliar. I thought about the home we'd made together, the way everything my eyes fell upon there had Béla's fingerprints on it, literally. *Here is the floor Béla laid down one plank at a time. There are the windows he installed. There are the shelves he made from scratch, the cabinets he installed, the drywall he attached to the beams he'd rebuilt. Here is his labor of love, the home where Susan grew up, where we celebrated holidays and tiny victories, this place that welcomed me home and gave me comfort even after my most difficult days.*

"You're right," I said. "I know you are."

We decided that Béla would stay in the United States. I'd

go to Germany and rent a small apartment there. I would work at BioNTech for just a year or two. "And when the first patient is treated with nucleoside-modified mRNA," I said, "I'll come home."

MAINZ IS SET ON the banks of the Rhine. It's a beautiful city, whose two-thousand-year history is evident in its grand cathedral, half-timbered houses, and cobblestone streets. I got a simple apartment there, which I filled with almost nothing— no decorations, no artwork, nothing that made it feel too much like home. I was fifty-eight, and my bedroom was a bare room with a single lightbulb hanging from the ceiling and a mattress on a frame. My home, the place that mattered, was on the other side of the Atlantic Ocean.

In the mornings, I'd wake early, around five, and run for an hour along the Rhine before work. In the evenings, I'd return home to my empty apartment. Sometimes at night, I talked to my mother, who would tell me about world events. She knew I didn't keep up with the news, so she took it upon herself to tell me everything Angela Merkel, the German chancellor, had done that day. *She gave an important speech to the UN about climate change. She and Obama met before the G7. She's taking a lot of heat for welcoming refugees, but she's standing strong.* "And you know she's a scientist, Kati," my mom might add. "A *physicist.*"

My mother was as sharp as always, though her health was declining. When we talked, I sometimes berated her: *Mom, you must eat healthier. Mom, are you exercising? It's important that you get your heart rate up every day.* I could hear in my own

voice the same thing that had been in her voice when I'd been sick as a child: worry, transformed into urgent scolding.

Every couple of months, I'd head back to the States to see Béla. I'd stay there for about two weeks, working remotely. Then I'd fly back to my spare apartment and work some more.

SUSAN RETIRED FROM ROWING. She was inducted into the rowing hall of fame in 2014. She did some coaching, public speaking, and modeling. She finally got to UCLA, too; she enrolled in an MBA program, graduating from UCLA's Anderson School of Management in 2018. In July 2019, Susan called to tell me that she'd met somebody. Ryan worked in construction, as a project manager for a commercial general contractor.

"Good," I said. "At least he knows how to build things." That had always worked well for me.

In September, just two months after they began dating, Susan and Ryan flew through the night to Germany. They arrived on my doorstep in the early morning. This trip, Susan would tell me later, was their seventh date. When I opened the door, I took one look at this Ryan—he was tall and boyishly handsome, and he looked as giddy as Susan. I threw my arms wide and hugged him. Then I pulled back, looked him in the eye, and asked him a question. "Would you like a shot of Jägermeister?"

Ryan hid his surprise and smiled at me with what I would come to learn was his signature southern charm. "Sure!" he said.

We walked inside, where I poured three shots, which we

promptly drank. This felt like a celebration, after all. Already, I could tell: This guy would be sticking around.

I LIKED WORKING IN the biotech industry. There was something so refreshing, so *honest,* about what we were doing and how we talked about it. We were a business. We were there to create products based on good science. We needed investor money to do our research, and we hoped to make even more money by selling the products that resulted from our work. It was straightforward, direct.

Money mattered in academic research, too. But there, so many people pretended it didn't. They papered over the influence of money with symbols of prestige: publication records, citations, committees, fellowships, alma maters, "influence."

There was such a practicality to industry, too. The science worked or it didn't. If the science was good, if the data supported one approach over another, that's what mattered. It didn't matter whether you spoke with an accent or whether you'd attended an Ivy League school or if you were good at schmoozing.

At BioNTech, employees came from sixty-five different countries. Not all of us spoke German, but all of us spoke science.

For the first time in my life, I no longer did every experiment myself. I led a basic science team, and together we did experiments to figure out how to improve our mRNA and its formulations. BioNTech made steady progress toward mRNA cancer immunotherapies. We also began working on mRNA

vaccines for various infectious diseases. This meant I got to keep working with Drew, too. BioNTech began funding Drew's lab at Penn, allowing him to make concrete strides toward a whole host of new vaccines. This included the HIV vaccine that had begun our journey of discovery. Although we were running clinical trials and had our own products, we also formed partnerships with other, larger companies. One of these was announced in 2018: a partnership with the pharmaceutical giant Pfizer to create an mRNA-based influenza vaccine. We began doing studies.

I liked working at BioNTech. I liked it a lot.

Not everything was easy. In 2016, I was diagnosed with cancer in my parotid gland, the gland that produces saliva. Susan came over from California to be at my side. Like me, she struggled to understand what the German doctors were saying. We peered at monitors, trying to piece together what they were recommending. I had multiple surgeries, the second of which would leave me unable to close one eye and paralyzed one side of my face for several months.

My mother passed away from kidney failure at the end of 2018. She was eighty-nine years old. On a sunny January day, standing in a cemetery covered with beautiful, fresh white snow, we placed her ashes where my father had been laid to rest thirty-four years earlier.

No, not everything was easy.

But there were so many good things. I enjoyed Mainz, and I liked where I worked. I was a part of something important. Susan and Béla, in California and Philadelphia, were happy and healthy. Compared to what had come before, things were going well, remarkably so.

Then one day in January, six years after I'd started at BioNTech, Uğur read an article in *The Lancet* about something unfolding on a different continent entirely: a new respiratory virus circulating through Wuhan, China.

I DON'T NEED TO tell you what happened next. If you were alive in early 2020, you have your own memories. Perhaps you recall the way the news reports seemed distant at first—*history happening elsewhere, to others*. Then one day, maybe you heard a report that made you wonder if this thing might happen *here*, to *you*. Maybe there was one report in particular that made your stomach lurch, as if the plot from some end-of-the-world film had leaped from the screen into reality.

Maybe you went to the store and found yourself making unusually strategic decisions about what to buy, and how much. (Maybe you were one of those who stocked up on toilet paper and cleaning supplies. Maybe you considered stocking up, then made a choice not to. Or perhaps you, like so many, arrived at the store to find all the supplies gone, the shelves already bare.)

You almost certainly remember your school or workplace closing—temporarily, they assured you, just a couple of weeks. Or maybe you were on the front lines, working in a hospital, or a pharmacy, or a transportation system, or a grocery store, and there was no shutting your doors (if this was your situation, thank you from the bottom of my heart).

But surely you remember the world changing. I don't have to tell you about any of that.

IT WAS A CORONAVIRUS, a type of spherical virus surrounded by a "crown" of spikes, which helped the virus enter cells. Picture a Styrofoam ball with golf tees stuck all over its exterior. The tees are the spike proteins, while the ball houses the virus's genetic information. Like every virus, this one hijacked the body's cells, ingeniously repurposing cellular machinery into a virus factory that made copies of itself.

Coronaviruses were first identified in the 1960s. Most of the time, the illnesses they caused were mild: the common cold, or gastrointestinal problems. A coronavirus might knock you out for a few days, but it was unlikely to be fatal. But the world had seen two near misses: In 2002–2003, SARS-CoV (what people called then simply "SARS" for "severe acute respiratory syndrome") caused eight thousand infections, mostly in Asia. While the number of those infected wasn't large, SARS was extremely virulent, with a 10 percent mortality rate. Even those who survived the infection got very sick. This virulence, paradoxically, was what kept the virus in check. When people were infected (and infectious), they were too sick to go out.

Middle East respiratory syndrome–related coronavirus (MERS), in 2012, also made people very sick. In fact, MERS had a mortality rate of almost 35 percent, even higher than that of smallpox! Fortunately, MERS didn't spread very easily *among* people, so the total number of confirmed cases remained relatively low, at 2,500.

This new coronavirus—what came to be known as SARS-CoV-2, or COVID-19 (short for coronavirus disease 2019)—

spread very rapidly, and it could be serious. Sometimes it made people so sick they needed to be hospitalized. Sometimes it made them sick but not dangerously so. Some died from the infection, while others showed mild or no symptoms.

Many people, upon learning that COVID-19 might be mild, and that some people were entirely asymptomatic, felt relief. *Even if I get it, it might not hurt me.* But when scientists and public health officials hear "asymptomatic," they worry *more*. After all, if people don't know they're infectious, there is nothing to keep them from spreading the virus.

COVID-19 had a lower mortality rate than SARS or MERS—between 1 and 3 percent—but this was hardly reassuring; 1 percent of the global population was still tens of millions of people. The virus was moving across the world quickly. Because this was a novel virus, *people had no immunity against it*.

We would need a vaccine, and fast.

BEFORE THIS MOMENT, the fastest vaccine ever made was developed in the 1960s, for mumps. The effort had taken four years. But in early 2020, the whole world was shut down. Entire economies were cratering. Frontline workers were exposed to this dangerous virus daily, while even those with the luxury of staying home were restricted from seeing their loved ones.

We didn't have four years.

But speed has always been one of the promises of mRNA therapies and vaccines: If we know the genetic sequence for an

antigen, we can make mRNA that codes for that antigen and get it into a lipid delivery vehicle very, very quickly. Uğur and Özlem made a courageous decision: 100 percent of BioN-Tech's resources would be put toward making a vaccine to prevent infection from this new virus.

They bet everything.

IN EARLY JANUARY 2020, Zhang Yongzhen, a Chinese virologist and professor, publicly released the genetic sequence of the SARS-CoV-2 virus. It was nearly thirty thousand "letters" long, a string of As, Cs, Gs, and Ts that collectively coded for a combined twenty-nine proteins. Together, these proteins allowed the virus to evade a host's immune system, enter cells, sabotage ordinary cellular processes, hijack the cells, and begin replicating itself in massive and sometimes fatal quantities.

Several weeks after Uğur read that *Lancet* article, BioN-Tech had entered into a verbal agreement with Pfizer to partner in the making of a COVID-19 vaccine. The companies went full steam ahead, proceeding in good faith, as if the details had already been worked out—an almost unprecedented degree of corporate trust that spoke to the urgency of the moment. Like every vaccine developer, we homed in on just one of the virus's proteins: the spike protein. Because the spike protein was on the surface of the virus, antibodies would bind to it, quickly neutralizing the virus. The platform for the vaccine they'd ultimately take to market was modified mRNA, in which uridine was replaced with N1-methylpseudouridine.

———

BÉLA'S BIRTHDAY IS MARCH 18. I'd always flown home for the occasion, and I'd planned to do the same in 2020; he'd be sixty years old. Months before, I'd booked tickets on Lufthansa for the occasion, departing Germany on Friday, March 13. The day I arrived, the U.S. borders were officially closed to nonessential travel. I would spend the next ten months in my home office, directing my team on another continent.

IT WOULD BE IMPOSSIBLE to fully capture in these pages the urgency and energy of the months of 2020. Entire books have been written about the development of the vaccine, including a book co-authored by Uğur and Özlem, and one by Albert Bourla, Pfizer's chief executive officer.

What I will say here is this: It was a stunning effort, one that required courage, expertise, decisiveness, and precision. I saw these traits not only at the highest levels of leadership— Albert, Uğur, and Özlem—but also among everyone who worked on this project: employees, contractors, suppliers, and other professionals.

If I was impressed by industry before, I was awed by it in 2020. What we at BioNTech together with Pfizer accomplished that year felt like nothing short of a miracle. It wasn't just a matter of creating a new vaccine using a new platform; this vaccine required new industrial machinery and equipment, mass freezer farms, new transportation standards, an entirely new global supply chain. Everything needed to be in place, more or less immediately, with no bottlenecks or pauses.

Whatever it cost, whatever it required, Pfizer's answer was always the same. "Okay, let's move."

The logistics of all of this were mind-boggling, the investment breathtaking. Pfizer made billions of doses of the vaccine, and somehow the first vial that rolled across the production line was the same as the billionth dose, right down to the last molecule. Every time a pharmacy or hospital or community center opened a new vial of vaccines, whether in Manhattan or Munich or Muncie, they could be reassured it was the exact same product.

Here was my life's work, moving far beyond me, out into the big wide world. I'd say it felt a bit like watching one's child heading off to school for the first time, but that hardly captures the scale and speed at which everything was happening. It was, perhaps, more like watching your child row across an Olympic finish line, having been supported by the best coaches and teammates in the world, then winning a gold medal with the whole world watching.

SUSAN AND RYAN GOT engaged in July 2020. They set the date for October of that year, in Charlottesville, Virginia, where they'd met. It was such happy news, but I had no time to celebrate, no time to help with planning, to think about floral arrangements or dresses or invitations or photographers. When Susan called me with details, I'd say perfunctorily, "Uh-huh, uh-huh," before turning the conversation to the latest paper I'd read. My mind was fixed firmly on work. I'd already calculated that every hour I didn't spend reading, I missed eleven valuable articles about this virus and the disease

it causes. I could *feel* those articles slipping past, could feel myself falling behind. By the time October rolled around, I'd barely thought about the wedding, hardly even absorbed it as a reality.

I hadn't seen Susan since Christmas, and when I walked into the rehearsal dinner—a tiny affair, just immediate family and closest friends—I was almost startled by the sight of her.

There she was, my Zsuzsi in the flesh. She leaned against a wall, an open bag of peanut M&M's in her hand. She was talking to a bridesmaid, another woman from the Olympic team. Susan's blond hair was swept back. She wore a floor-length dress, her rower's arms still so lean and muscular, her face golden from the California sun.

My fierce, beautiful daughter. Tomorrow was her wedding day. I paused there for a moment, just watching her. Susan popped an M&M into her mouth, smiled, and continued talking. She hadn't seen me yet.

Something, I realized, was different.

All at once, I rushed over to Susan, words spilling out of my mouth before I even had a chance to say hello. "When are you due?" I asked.

Maybe it had been some change in the shape of her face or in the fit of her dress. Maybe it was those M&M's in her hand. But a mother knows.

I knew.

MISTY RAIN, AUTUMN LEAVES. An explosion of blush roses, a horse-drawn carriage. Olympic bridesmaids, one wearing cowboy boots. A toast from Béla that began, "If you have any

questions about the vaccine, Kati can answer them to-
night. . . ." A love train, a barefoot electric slide, Béla dancing
in a crown of flowers. A not-so-secret new life, my grandchild,
snuggled safely behind layers of white lace.

And through it all, Susan and Ryan beaming, their whole
glorious lives ahead of them.

TWENTY-EIGHT DAYS AFTER SUSAN'S wedding, the results
of Pfizer/BioNTech's clinical trial came back. There had been
43,448 participants at 153 sites around the world, split evenly
into two groups. One group had received the vaccine, the
other a placebo. The study was blind, meaning that neither
those who received nor those who performed the injection
knew if the vaccine or the saline placebo had been given to any
specific individual. When any of the study participants had
symptoms such as fever, sore throat, etc., they returned to the
clinic for testing to determine if they had been infected by the
COVID-19 virus. Data were collected. Now it was time to
find out if the vaccine had worked: if those receiving the vac-
cine were less likely to get infected.

Under ordinary circumstances, vaccines and new drugs are
tested in sequential phases: First comes the preclinical work,
the basic research that precedes the making of a specific prod-
uct. Fortunately, much of this work had already been done,
not only at BioNTech and Pfizer in pursuit of the influenza
mRNA vaccines but also in the decades of work that had come
before—research on RNA generally, on mRNA specifically,
on lipids, on formulation.

Once the preclinical research is done, products enter clini-

cal trials, which include three phases. With each phase, the number of test subjects increases . . . as do the costs. Phase 1 is the assessment of safety. It asks, *Is this vaccine or therapy safe, and at what dose?* This phase includes healthy volunteers, and tests a few different doses. Phase 2 asks, *Does this work?* In the case of a vaccine, the question is, *Does this induce an effective immune response?* In phase 3, products are tested in the wider population—the more diverse the trial participants, the better and more reliable the results will be. In this phase, we're looking for effectiveness of the product and any problems that may have been missed in previous trials.

The COVID-19 vaccines went through all the same phases, using best practices for safety, research methods, and both quantity and diversity of participants. But we ran phases 1 and 2 together, which allowed us to get our results even faster. Even as these studies were being done, Pfizer had already manufactured millions of doses of the vaccine, which were sitting and waiting in ultracold warehouses.

If the trial showed that the vaccine had worked, these doses could start rolling out to the public almost immediately.

Many colleagues have reported being nervous before the data came in. I wasn't anxious. To the contrary, I felt I already *knew*.

November 8, 2020, was a Sunday. Béla and I quietly celebrated Susan's birthday at home. In the evening, the telephone rang. It was Uğur. He told me that he'd just learned from Albert Bourla that the vaccine worked. The results, in fact, were unequivocal: Our modified-mRNA vaccine had 95 percent efficacy against the virus strain then circulating.

When I hung up the phone, I turned to Béla. I felt so calm.

"It works," I said simply.

Then, for the first time in my career, I didn't immediately return to work upon hearing good news. Instead, I celebrated the best way I knew how: by opening a movie theater–size box of Goobers and eating the whole thing.

THE STORIES ABOUT ME came swiftly, surreally. First I was just a quick mention in more general news stories—one researcher among many who'd been a part of an extraordinary decades-long effort that resulted in the fastest vaccines ever developed.

On November 10, just one day after the results of the Pfizer/BioNTech phase 3 trials were announced, *STAT* ran an article titled "The Story of mRNA: How a Once Dismissed Idea Became a Leading Technology in the Covid Vaccine Race." A week later, *The Guardian* ran a story specifically about me: "Covid Vaccine Technology Pioneer: 'I Never Doubted It Would Work.'" There I was at the top of the article, in a photo with Béla and Susan at the London Olympics, all of us decked out in red, white, and blue. This piece was followed by a story in the *New York Post* ("This Scientist's Decades of mRNA Research Led to Both COVID-19 Vaccines") then *The Telegraph* ("'Redemption': How a Scientist's Unwavering Belief in mRNA Gave the World a Covid-19 Vaccine"). In December, I did an interview on CNN, during which then anchor Chris Cuomo introduced me as a scientist

who did "a type of research that I can't even explain to you." I blinked out at viewers from the room where I'd sat on Zoom for the previous ten months, and I did my best to answer Cuomo's questions, thinking all the while, *Goodness, this is strange.*

I had no idea.

JUST BEFORE CHRISTMAS, more than twenty years after Drew and I first collided at the copy machine, we received our BioNTech/Pfizer COVID-19 mRNA vaccines together. By then, Moderna's mRNA vaccine—which, as with the BioNTech/Pfizer vaccine, was developed based on our invention of modified uridines—had received Emergency Use Authorization and become available. We received the vaccine at Penn. In the hallway, healthcare workers were lining up—six feet apart—to get their vaccines, too. One of my colleagues from Penn shouted, "These are the inventors of the vaccine!" A roar of cheers followed, and my eyes grew misty.

Still, the claim wasn't quite right. We had made our breakthrough, sure, and that breakthrough had found its moment in a pandemic. But so many people deserved cheers. There was, of course, the long line of scientists who had come before us, whose work made our own possible: Those who glimpsed the cell, then the nucleus, who discovered DNA, then RNA, then the fragile messenger, X. Those who identified and articulated the sophisticated processes of transcription in the test tube. The other researchers who'd created the lipid formulation that helped the mRNA get into cells. Those who had discovered all the technologies required for our work.

Then there were the medical professionals and frontline

workers—doctors and nurses, technicians and cleaning staffs—who'd taken care of the infected patients, gone to work every day during the last year when there was no vaccine, all risking their own lives to save others.

There were all the people at BioNTech and Pfizer and the companies with whom we'd contracted: engineers and technicians and warehouse workers, people with expertise in things I'd never even imagined; manufacturing and machinery and shipping and logistics, which allowed us to make and deliver a vaccine in under a year. And, of course, there were the tens of thousands of trial participants, each of whom volunteered to test a new vaccine, using a relatively new platform, during a time of unprecedented fear.

All around me now were still others who deserved cheers: the people making this very vaccine drive possible. Volunteers just like them had stepped in from every community around this nation, and around the world. They'd come out of retirement, or they'd dedicated their days off to this effort, or they showed up at vaccine clinics after long days of work, working through the night to protect as many people as possible, as quickly as possible. They stood in the rain and the snow directing traffic, checking IDs. They opened vials, filled syringes, recorded details on vaccine cards, comforted the needle-phobic. They put needle after needle after needle in arm after arm after arm, tens into hundreds into thousands into millions into hundreds of millions.

There were too many people to count, too many sacrifices to absorb. As that needle filled with modified mRNA went into my skin, I began to weep. It was all so humbling. Mostly, I was honored to be a part of it.

———

I STARTED FIELDING CALLS from reporters, invitations from world leaders. I was featured on NPR, France 24, WBUR, in *Le Monde*, *The Boston Globe*, the *Los Angeles Times*, the *Hungarian Free Press*. *Forbes* named me one of the most inspiring immigrants of 2020. Stories about my work went around the world: Germany, Vietnam, Mexico, China, Turkey, Brazil.

Gina Kolata wrote a profile of me in *The New York Times*. That was *me* in the pages of the *Times*, standing in my driveway in a black wool coat, bare trees behind me, white snow on the ground. That story was followed up by an episode of the *Times* podcast *The Daily*. Suddenly it felt as if someone had reached deep into my quiet, obscure life and turned it inside out, as quickly as someone might invert a sock or a pair of jeans.

In December 2020, I had twenty Twitter followers. I'd been on the site for a decade, having joined to follow Susan's updates; these followers were mostly Susan's friends. Before long, that number would swell to more than forty-five thousand (as of this writing). I began to receive messages, letters, and cards from people whose lives had been touched by the vaccine.

Finally saw my husband in his nursing home . . .
My mother . . .
The isolation was . . .
I'd been so lonely . . .
So afraid . . .
Such a gift . . .
Saw my kids . . .
Finally held my new grandchild . . .

HELD MY NEW GRANDCHILD. Yes. I got to do that, too.

ALEXANDER BEAR WAS BORN in February 2021. He had long fingers, a round face, and huge eyes that seemed to drink in the world. Susan was a natural with him. I stayed with her and Ryan for two weeks, cooking heaps of Hungarian food and rocking "Bear" through the long night. This was a new way of working through the night. I loved every minute.

I BEGAN TO WIN prizes, often with Drew, or with Uğur and Özlem. Sometimes all four of us. I traveled the world to receive these, marveling that I was earning honors previously received by people like Jonas Salk, James Watson and Francis Crick, Jane Goodall, Louis Pasteur, Nikola Tesla, even Albert Szent-Györgyi, that Hungarian luminary to whom my biology class once mailed a letter addressed only with his name and "USA." At our ceremony for the Lasker Award, a fellow honoree was David Baltimore, whose landmark book about viruses had so captivated me when I started my work at the BRC back in Hungary; what a joy it was to tell him how his work had influenced me!

I was awarded honorary degrees from Duke, Yale, and Tel Aviv University, as well as my own alma mater, the University of Szeged (oh, Szeged, you will always have my heart). At Yale, I got to meet one of my heroes: Joan Steitz, who'd done pioneering work with RNA. At Tel Aviv University, I hung

out with co–honorary degree recipients Jodi Kantor, one of the journalists who broke the Harvey Weinstein story, and Cori Bargmann, a brilliant neurobiologist from Rockefeller University who advanced our understanding of how genes and the environment interact to influence behavior. The three of us talked about women in science, women in the world— the strides we have made and the challenges we still face, all the things we needed (childcare, mentors, affordable education) to succeed.

Drew and I were featured on the cover of *Time* magazine and named Time Heroes of 2021. I was *Glamour* magazine's Woman of the Year; a team from the magazine showed up at my house with cartloads of makeup and heaps of clothing for a photo shoot. I twirled in a black dress and posed in a bold yellow sweater and tinted glasses. None of it felt like me, but it was fun for an afternoon.

I traveled some more: to Brussels, Bangkok, and Hanoi, where I met up with my university classmates from Vietnam. I dined with Angela Merkel at her home. I dined with King Philippe of Belgium. I met Emperor Naruhito and his wife, Empress Masako, of Japan. I woke up every second day in a new city, in a new country, often on a new continent. Susan came with me to many of these events. She's a terrific travel partner, and she always has a bottle of water handy for me. Everywhere we go, she is now known as "Katalin Karikó's daughter," just as I was "Susan Francia's mom" when she was on the world stage.

I returned to Hungary, where I saw my old high school teacher Albert Tóth. I was so happy to see him. Mr. Tóth was into his eighties by now. He'd survived a bad bout of

COVID-19 before the vaccines were available, but he was still the same bright man he'd always been. I became an honorary citizen of the city of Szeged. The reception was in the Szeged town hall, where Béla and I had been married. Many of my university friends returned for this event, making it something of a reunion. Afterward, a bunch of us went back to the home of our old friend László Szabados, the one who'd had so many railroad adventures with us throughout our university years. After many years of working in South America, László had returned to the Biological Research Center.

My classmates were all over the world now, doing such good work. I was so relieved, amid the flurry of my world travels, to just sit and talk with old friends.

Lots of old friends showed up for me during this period. One morning, not long after getting my own vaccine, I was home in Philadelphia, just finishing a workout on my rowing machine, when I heard the doorbell. To my delight, Jean Bennett, my friend and colleague with whom I'd shared lab space during my earliest days at Penn, was standing on my doorstep! She, too, was in workout clothes, and she was as supportive and enthusiastic as she'd ever been. "Kati, I just *had* to come to see you!" she exclaimed. "I had to let you know how much I admire you and how proud I am to have worked by your side for so long." Jean, by now, had earned the great distinction of having developed the first FDA-approved gene therapy for humans, treating a rare form of blindness. Later, she and I would earn honorary doctorates from Yale together.

Although I didn't see him in person, I often talked to János Ludwig, with whom I'd worked at the BRC. Once, when we talked, I reminisced about the old days. "Do you remember,"

I mused, "when we used to play that silly 'odd or even' game while washing glassware in the lab?"

"I don't have time for these memories, Kati," he replied. "I have so much work to do."

The world might have changed, but it was nice to see that János hadn't.

IN BUDAPEST, ARTISTS PAINTED a mural of my face, 220 square feet, bold in color, titled *A jövőt magyarok írják* ("Hungarians will write the future"). We visited the mural with my sister, wishing my mother could see it, or my father. I wish I could have told my parents that my father was exactly right back all those decades ago: I *am* a *kutató*, a searcher. I had spent my life searching, and along the way I had found something, and it turned out this something was important to people.

I WORRIED, THOUGH. It was hard to keep up with my reading. I remembered the expert whose lecture I'd listened to years before. I remembered how disappointed I'd been when this hero had begun to speak and I'd understood that he hadn't kept up with the literature.

I didn't want that to happen to me. I don't ever want that to happen to me. But how could I keep up?

IN ALL THIS TIME, I opened champagne just once. An award gala that would require excruciatingly long travel was can-

celed, giving me a few extra days to breathe and read a couple of articles.

That, above all, felt like something to celebrate.

MORE LETTERS CAME IN, more messages:

Grateful for your work . . .

Saw my best friend . . .

Finally hugged my sister . . .

Held hands again . . .

Thank you to all the scientists . . .

But sometimes the emails and messages I received weren't so friendly. People had read things about the vaccines that scared them: *The vaccines alter your DNA. The vaccines give you COVID-19. The vaccine was produced too quickly. The vaccines make people infertile. The vaccines change menstrual cycles.*

Many of the things about which people wrote were untrue. The vaccines don't alter your DNA, of course; they don't get near it. That's the advantage of mRNA. Occasionally, though, I'd see falsehoods that were based on a grain of truth. For example, anything that elicits an immune activation *can* temporarily change a menstrual cycle. When the first vaccines were used one hundred years ago, this phenomenon was also observed and published. The changes are temporary, a sign of your immune system at work. They aren't dangerous, and before long, everything returns to normal.

I didn't—don't—blame those who were afraid. The science underlying these vaccines is complex. People often fear what they don't understand. Unfortunately, some people who

should have known better were actively promoting fear, using half truths or outright lies. Sometimes they were doing this to convince the fearful to buy something—often a product they claimed would "protect" them from the virus. Sometimes, though, they were doing it for other reasons, ones I will probably never comprehend.

But some of the fault may lie with those of us who understand the science but have failed to explain it fully. As I'm writing this, if I were to do an online search on pseudouridine, Google's algorithm would point me to one of the most frequently asked questions about that term: *Is pseudouridine toxic?* This question, I assume, appears because many people have turned to Google for information about a vaccine they are trying to understand.

Nowhere online can I find a simple, correct answer: *No, pseudouridine is not toxic. It exists already in every cell in your body. Your body recognizes it as friend, not foe.*

There is such a gap between what people *know* and what they would *need to know* to fully understand the vaccines and medicines that save lives. That gap, right now, is wide open for exploitation. We must somehow close it.

So when the questions came in, I tried to do what I could. I responded to hundreds of messages, maybe thousands by now. I pointed people to studies and data that explained why they need not fear. I didn't do this because I'm on "team vaccine." This isn't a football game. I did it because I'm a scientist. I have spent years scrutinizing data—my own more than anyone else's. I want people to understand what those data actually say.

A YEAR PASSED, then another. I moved through airports, I checked in to hotels, I delivered lectures and gave interviews and posed with prizes I'd never imagined I'd receive. It was one more thing after one more thing, now in a new way. In Princeton, I visited the Institute for Advanced Study, where Einstein once worked. There I met the CEO of Global Space Ventures, Laetitia Garriott de Cayeux. She wore a dress covered with images of women scientists: Marie Curie, Rosalind Franklin, Katherine Johnson, Maryam Mirzakhani, me.

I learned that a minor planet, discovered in 2002 by Zsuzsanna Heiner and Krisztián Sárneczky, two Hungarian researchers associated with the University of Szeged, was named after me: (166028) Karikókatalin. This asteroid orbits our sun between Mars and Jupiter, making one revolution every 3.7 years.

I was also honored to learn that a physician couple in Virginia named their second child after me. (Hello, young Windsor Katalin: I understand you're quite feisty. Good.)

I heard about more families reunited, more events reconvened, more hugs and handshakes and in-person smiles. In January 2021, a week after residents of the Meadowbrook Healthcare nursing home in Plattsburgh, New York, were vaccinated, the facility had an outbreak of COVID-19 infections. Seventy people in the facility tested positive. Thanks to the vaccines, everyone survived. That September, the nursing home held a Katalin Karikó Appreciation Day. The facility sent me pictures of residents wearing T-shirts with my pic-

ture. They also included photos from their Mother's Day event, when residents visited their loved ones in person for the first time in more than a year.

I looked at their smiling faces, bright in the sun, and thought, *No prize will ever mean more than this. Not ever.*

IN OCTOBER 2020, before the vaccines rolled out, I purchased hyacinth spring bulbs, set them in water culture, and kept them in a dark and cold place. When they were two inches tall, I uncovered them and placed them on my windowsill at our home in Pennsylvania. The bulbs did what plants do: erupt into color and bloom.

Sometimes I sat quietly and watched them, remembering my mother's garden, the flowers my grandmother sold at market, the illustrations in that book by Vera Csapody, the Hungarian artist-botanist whose work had so mesmerized me as a child.

I will forever be that girl who stood on the Hungarian plain and looked with wonder and astonishment at all the life exploding spectacularly around her.

IN CAMBRIDGE, ENGLAND, after I delivered the Professor Hawking Fellowship lecture, a young scientist came up to me. She was from Romania. She heard my presentation about my upbringing, about my simple life in an adobe house where four of us huddled together in one room. "I lived in that sort of house, too," she said. Her eyes brimmed with tears. "I lived that life, too."

This wasn't the first time I'd heard something like that.

When the first articles appeared about me—when it was public that I'd sewn money into a teddy bear to sneak it out of the country—I got letters and emails from my fellow immigrants.

I did this, too, the letters said.

I snuck money out, too.

I, too, left the only home I'd known to make my way in a new nation that I didn't yet understand.

May immigrants keep coming. May they continue aspiring to more, going wherever they must to get the opportunities they deserve. May they keep making their way, and in the process remake our world.

ALL THIS ATTENTION. I didn't need it, I hadn't asked for any of it. I'd decided early in my career not to place any value on recognition, to value only the work itself—to do my work well and trust in where it might lead, even if it got there long after my own lifetime. Now, in an instant, here it all was: so much attention and gratitude, offering itself up to an extent that felt unreal.

How does something like this happen?

How *does* it happen?

Standing on the stage of the Time 100 Summit in Lincoln Center, bright lights making it hard to see the audience, that is the question I pose now: "How did I go from the simple life of a single-room home with no running water to standing on this stage here in New York City with the most influential people in the world?" I ask. "It certainly wasn't my intention."

No, it wasn't my intention. More important, it easily could have gone a different way.

———

I USUALLY DON'T DWELL on what-ifs. But, still, they're out there. What if the Hungarian government, or the teachers I knew in Kisújszállás, hadn't cared to make an investment in a skinny, stubborn butcher's daughter? What if my chain-smoking Russian-language teacher, Mr. Bitter, had managed to block my acceptance to university? What if Robert Suhadolnik had been successful in getting me deported? What if I hadn't met Elliot? What if David hadn't jumped in to save my career? What if science journals had been available online a few years earlier, so that I'd never even met Drew at the copy machine?

What if, what if, what if?

These what-ifs extend even to things that didn't feel so fortunate at the time. What if I'd never lost my funding back in Hungary? What if Suhadolnik had been the kind of person for whom I'd wanted to work forever? What if Dave and Elliot had never moved on to new things, leaving me behind? Would the world be different now?

I believe my work made a difference. But for this to have been the case, so many things had to come together just so. There was so much luck involved. It makes me wonder: Who else was out there and didn't have such luck? Who could use a little luck right now? What are we missing?

AFTER I FINISH MY Time 100 speech, I meet Susan backstage. Together, we zip downtown, to the Flatiron District, to the Ross Prize Symposium. Drew is there, and more photogra-

phers. The event organizers whisk us through a reception where people are discussing NIH R01 grants, saying things like, "How are things at Cold Spring labs?" and "Yes, my paper's under resubmission now." Drew and I head outside, to a rooftop terrace. There we give some video interviews about our work while the sounds of traffic float up from the streets below.

Inside, we accept our awards and talk about the research we did together. Many people in the audience snap pictures. Most attendees I don't recognize. But one I do: a guy with a wide grin and the unflagging energy of a long-ago rower. He's gone a little gray at the temple, but there's not a question in the world who this is: David, my friend and colleague, who once saved my career.

David has had quite the career himself. He's now one of the few cerebral-bypass neurosurgeons in the country, internationally recognized. He's saved countless lives. He's been a hospital turnaround artist, too; he helped transform a sleepy Upper East Side community hospital into a major surgery center. In fact, it's possible that you, too, know David; he's become something of a celebrity. He's one of four physician stars of the Netflix documentary series *Lenox Hill*, as well as its spin-off *Emergency: NYC*.

David and I embrace. It's been a long, long time.

The following morning, I attend the ceremony for the Pearl Meister Greengard Prize. Alice Kuo, the lab tech and friend from Elliot's lab—the one who was present at the dot-matrix printer breakthrough—has come to cheer me on. There we listen to the science writer Dava Sobel describe how she, even after years of writing about women in the sciences,

somehow underestimated women scientists who worked at the Harvard College Observatory in the nineteenth century. "I always dismissed them as a cute, quaint episode in Harvard's history," she says. At lunch, we all reflect together on how much work still needs to be done to create equity in the sciences.

That night, Susan and I attend the Time 100 Gala. We walk the red carpet as a line of paparazzi snap pictures. Mostly, these photographers want images of celebrities: Andrew Garfield, Zendaya, Mary J. Blige. But when Susan notices a reporter for *Access Hollywood* scanning the crowd, she approaches her. "I have a very important person for you to interview . . . Dr. Katalin Karikó, she's a very famous scientist who is saving lives!"

"Of course!" says the reporter brightly. The woman holds out a microphone. Susan nudges me forward, and then I am off and running, talking about mRNA all over again.

THE MORNING AFTER THE Time 100 Gala, Susan and I head to the Rockefeller University campus for yet another series of events. Rockefeller is, of course, one of the two institutions that invited me to speak in 2006 after Drew and I published our landmark *Immunity* paper.

Today they are awarding me an honorary degree.

The day kicks off with a reception in the courtyard. It is summer, the sun is blazing hot. I glance around for a cooler spot to stand in. In a shady corner is a guy in a dark suit. He's wearing glasses, but still I can make out his eyes. Kind eyes. Warm eyes. The eyes of a good neighbor, a good citizen, a good colleague.

I'd know those eyes anywhere.

"Elliot!" I walk over, and for the third time since arriving in New York, I am hugging yet another dear old friend.

ANOTHER ARTICLE THAT WAS published about me was titled "The Karikó Problem." When I first saw that headline, I laughed. *Ah, so they have named a problem after me.*

The article, by Stuart Buck, the executive director of the Good Science Project, and published in *STAT,* makes some important points. Buck observes that it's easy to recognize the value of my work now, in retrospect. But how do we find the people who are out there *right now,* today, doing important work that is going unseen? How do we help get that work funded? Surely, Buck says, I wasn't the only one in 1985 who had an idea with potential.

No. That's the thing. Surely I wasn't.

THE MRNA MOLECULE EXISTS temporarily, to deliver a message. I hope this book, about my experiences with mRNA, can deliver a message or two as well.

My first message is this: We can do better. I believe we can improve how science is done at academic research institutions. For one thing, we might create a clearer distinction between markers of *prestige*—titles, publication records, number of citations, grant funding, committee appointments, etiquette, *dollars per net square footage*—and those of quality science. Too often, we conflate the two, as if they're one and the same. But a person isn't a better scientist because she publishes *more,*

or *first*. Perhaps she's holding back from publication because she wants to be absolutely certain of her data. Similarly, the number of citations might have little to do with the value of the paper and more to do with external events. When Drew and I published our landmark *Immunity* paper, it barely got any notice. It took a pandemic for the world to understand what we'd done and why it mattered.

We can also expand the criteria by which we measure our scientists. Most institutions define a scientist's value, first and foremost, by their funding. But most grants require a researcher to define at a very high level of detail what work they will do, what discoveries they might make. I'd argue that science, at its best, is about asking questions, trying things, and going wherever that inquiry takes you. It requires walking into the unknown—the unknown is the very point!

Finally, we can also be more up-front about the influence of money on academic researchers and its implications. Money mattered in the university setting, just as it mattered in industry. But in my experience, academia, uniquely, had the luxury of ignoring a good idea.

ANOTHER MESSAGE: THE COVID-19 vaccines opened the door to mRNA's practical application. But this isn't where it ends. Scientists are studying mRNA's potential for therapies against multiple cancers, cystic fibrosis, and rare metabolic disorders, as well as for vaccines against some of our most vexing infectious diseases. In the next decade, I think, we will see an explosion of new mRNA therapies and vaccines.

I'll be watching as closely as anyone.

———

AFTER I RECEIVE MY honorary degree from Rockefeller University, I head to a fancy dinner in a glass building overlooking the East River.

At the table, to my left, Susan chats in Hungarian with some brilliant Hungarian researchers I've met through the years—a neuroscientist at NYU, as well as a husband-and-wife astrophysics team from Columbia University who study, among other things, gravitational waves. Under the table, Susan touches her hand to her belly. My second grandchild, already on the way.

To my right, David and Elliot banter and reminisce. Together, they are like two kids—they lean in, heads together, laughing about old times. Before dinner is over, they begin brainstorming about potential new mRNA therapies. They are talking, at least half-seriously, about starting a company. I don't know if it will happen, but I'd bet on them.

Béla, at this moment, is at home in Philadelphia, putting the finishing touches on gorgeous glass-and-wood display cabinets, which he of course built by hand. By the time I come home, the cabinets will be lit up, every shelf filled with prizes I never expected to win.

Sitting here, I listen to the din of forks on china plates, the conversations of people I love and admire, the languages of my home country and my adopted country weaving together in the air around me.

This, I think. *I never dreamed any of this.*

In the morning, I'll wake early. A car will be waiting outside my hotel at four to take me to the airport. There will be

more travel, more hotels, more lectures. I'll go to Paris, Bil-
bao, Budapest, then Paris again, then still more far-flung des-
tinations.

This phase of my life won't last forever. I can already feel
the pull toward something quieter—a time when I can sit
down and begin to read science articles. The things I read
about will prompt new questions, and these questions will
yield new experiments.

But for now, I want to savor this moment just a while lon-
ger. I want to remember how it felt when we all were young,
just starting out. I also want to picture all the young scientists
who are just starting out now—the ones whose work I'll soon
read and who will someday make breakthroughs none of us
can yet imagine.

There is so much more to discover.

EPILOGUE

I BEGAN THIS BOOK WITH A NOTE TO TEACHERS—MY OWN
and the many I will never meet.

Teachers, I said, are planting seeds.

I'd like to end by talking to scientists—current, future, po-
tential scientists—as well as to anyone else who longs to con-
tribute to humanity's progress. I'm talking especially to those
of you who may not fit in with the status quo. Maybe you don't
look like the scientists in your textbooks. Maybe you are still
mastering a new language or speak with a thick accent. Maybe
you grew up never knowing a single scientist or you attend a
school no one has heard of, or you don't understand the invis-
ible rules that seem to drive so much of what happens in the
halls of power. I hope you, especially, will remember my words.

On an ordinary day on the streets of Szeged, as I walked
home from a clinic feeling horribly ill, I had a flash of insight:
No one would ever miss the contribution I didn't make. No
one would knock on my door and beg me to continue work-
ing. If I stopped, or if I pulled back my efforts one bit at a time
until I was giving less than my full potential, the loss would go
entirely unnoticed.

A world that's missing an important contribution looks or-
dinary. It is the definition of the status quo.

I don't know where my insight came from that day. But it carried me through years of being unseen, years when nearly every message I received, both implied and explicit, seemed to suggest the same thing: *This work is not for you, Kati.*

The insight kept me going. It made me stubborn where otherwise I might have given up.

Perhaps you will never be struck quite so suddenly by this same out-of-the-blue epiphany. So I want to be the one to tell you now: *Do not stop.*

Your future contribution might still be hypothetical. Please treat it like it's real. It matters. It matters even if you don't get to see the impact. That's not the part any of us gets to control. Just keep going with your one more thing, and your one more thing, and your one more thing after that.

Something I know for sure is this: Every seed gives rise to new life. This life in turn produces new seeds, which in turn give rise to still more. On and on it goes.

What I'm saying is, you must trust what's inside you. Nurture what you find there, even—especially—when no one else does.

What I'm saying is, keep going. Keep growing. Keep moving toward the light.

You are the potential. You are the seed.

ACKNOWLEDGMENTS

I AM GRATEFUL TO MY PARENTS FOR TEACHING ME THAT hard work is the way of life and to my wonderful sister, who cheered for me endlessly and always kept me positive. I'd like to especially thank my husband for always believing in me and "my science," and my daughter, who encouraged me through all of the ups and downs. I cannot imagine persevering without the unconditional love and support of my family.

Thank you to all who encouraged me to put my story on paper. I would particularly like to thank Ali Benjamin for her tremendous help in writing this book. Thanks to Madhulika Sikka for her careful edits. I am also thankful for the colorful and honest contributions from my friends, fellow students, and colleagues. I would like to thank the following people for their invaluable input to the book: my fellow high school student Ilona Súlykos; my high school biology teacher, Albert Tóth, and his son Csaba Tóth; my fellow University of Szeged biology students Zsuzsa Koncz and László Szabados; my University of Pennsylvania colleagues Jean Bennett, Elliot Barnathan, David Langer, Sean Grady, and Norbert Pardi; my Temple University colleague Robert Sobol; and our family friend Elizabeth Bagi. Thanks also for the encouragement from Mollie Glick and Creative Artists Agency.

DR. KATALIN KARIKÓ is a Hungarian American biochemist who specializes in RNA-mediated mechanisms. She is an adjunct professor of neurosurgery at the University of Pennsylvania. Her research has been foundational in the development of the Pfizer-BioNTech and Moderna COVID-19 mRNA vaccines.

Twitter: @kkariko